JOHN MARTIN,

HIS LIFE AND

By
MARY L. PENDERED
Author of "The Book of Common Joys," "The Fair Quaker," etc.

With 20 Illustrations and a Folding Map

NEW YORK:
E. P. DUTTON AND COMPANY
681, FIFTH AVENUE
1924

Printed in Great Britain

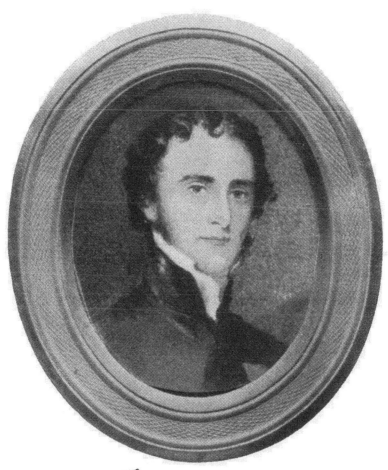

From a Miniature painted by Charles Muss. (In the possession of Colonel Bonomi.)

[Frontispiece

The Author desires to acknowledge gratefully the valuable help she has received from Mr. W. Roberts, the Baron and Baroness de Cosson, Colonel J. I. Bonomi, C.B.E., Mrs. Stephen Tayler, Mr. Alfred Brewis, Mr. W. Hardcastle, Mr. Thomas Hunt Martin, Mr. W. H. Ryland, Mr. M. T. Wigham, Mr. W. A. Cunningham, Mr. Ralph Thomas, Mr. Arthur Sopwith, Miss Fanny Bullen, Mrs. G. A. Anderson, Miss M. M. Scaife, Mr. Thomas Clemitson, Miss J. A. Middleton, and others.

She also wishes to thank the proprietors of the *Newcastle Weekly Chronicle* for permission to quote from Mr. Leopold Martin's Reminiscences; the Authorities of the British Museum for permission to photograph John Martin's pictures; and the Curator of the Laing Art Gallery, Newcastle-on-Tyne, for the fine reproduction of the portrait exhibited there.

v

CONTENTS

Contents

Contents

LIST OF ILLUSTRATIONS

FOREWORD

An old memoir of surpassing interest has fallen into my hands. It ran through the columns of a newspaper thirty years ago, and was written by one Leopold Charles Martin, author of *Illustrations of British Costume from William I. to George III.* and other works. Written on no definite plan, vaulting lightly backward and forward in its dates, it rambles agreeably through about fifty years in the reigns of George III., George IV., William IV., and Victoria, discoursing intimately, in the inflated language of its time, about a number of great men and women, and the London in which they lived.

It has no form to speak of ; it is diffuse, chaotic, and somewhat confusing ; but it is, nevertheless, vividly coloured and alive, painting with no uncertain hand a picture of the city that lay amidst green fields and market-gardens, peopled by those famous painters and writers whose names are household words, and who are presented to us in a wealth of anecdote in very clear and convincing perspective. We read of Scott, Dickens, Turner, Landseer, Hood, Moore, Campbell, Hogg, Wilkie, Godwin, Bartolozzi, Leigh Hunt ; with Mrs. Siddons, Mrs. Fry, the Hon. Caroline Norton, Letitia E. Landon, Madame Vestris, and a host of others, about whom the writer gossips pleasantly.

The subject of this memoir is the writer's father, John

Martin, who once ranked (as we read in the *Magazine of the Fine Arts* for 1833) " among the greatest geniuses of all time," and whose work, according to *Chambers' Encyclopædia* of 1891, " divided the suffrages of the many between Martin and Turner." It is scarcely necessary to say which of the two rivals thus placed in competition for public favour received the laurel wreath. The name of Turner is now known to everyone : the name of Martin is forgotten. We bow before the verdict of Time, but let us not forget that such verdicts have been reversed; that art has its fashions and critics are fallible.

It is nothing new to see a star emerge from the clouds of oblivion to shine in the firmament of art. Whether this may ever happen to John Martin, who can say ? Art critics would probably deny the possibility, basing their judgment on certain technical flaws from which John Martin was not free. It is a question upon which I am entirely unqualified to venture an opinion, but I would humbly submit my view that, when a man shows himself to be gifted with the imaginative power to conceive a sublime subject, and the creative power to execute his conception in such a form that it can impose emotions of awe and wonder on the unimaginative crowd, that man must be gifted with uncommon genius. Whether or not he succeeds in being an immortal artist is another matter, depending, perhaps, on further qualifications.

But my business is with the man rather than the artist ; with his home, his friends and many distinguished acquaintances, who are so sharply outlined by his son. His character alone is worthy of some study, and to that study

much intimate knowledge is lent by another old memoir (in manuscript) upon which I have been so fortunate as to alight. Written by a contemporary, one Ralph Thomas, Serjeant-at-Law, a very loyal friend and admirer of the artist, it shows, even more convincingly than his son's ' Reminiscences,' the strong individuality of John Martin, his undoubted power over the minds of all who were brought into immediate contact with him. That he was, apart from his genius, a man of very remarkable and exceptional character is incontestably proved by this evidence of one who knew him thoroughly, his weaknesses as well as his strength, and who had no desire but to draw of him a true, not unduly coloured, picture.

Martin's schemes for the improvement of London are alone worth noting ; his claims as an inventor might reasonably have brought him fame had they not been eclipsed by the power of his art. It is said that he was the first to propose a plan for the Thames Embankment and another for supplying Londoners with pure drinking water. He also conceived the idea of an underground railway. There can be no doubt that he had a scientific side to his imaginative and creative brain.

Strange to say, there was a very decided streak of insanity in his family. His brother Jonathan, in a fit of religious frenzy against the Church of England, attempted to burn down York Minster, and very nearly succeeded. William, the eldest brother, was so eccentric that he barely escaped the asylum in which Jonathan ended his days. John was wont to say, in despondent moods, that two of his brothers were mad and the third half mad, so that no

wonder folk concluded he was mad too! But there is no evidence to show that he was anything but sound of mind, and we do not find a single suggestion to the contrary in contemporaneous literature; unless we except Heine's classification of him, with Berlioz, as a "*fou de genie.*" The religious bias so pronounced in his work, the extraordinary imagination which made him visualise clearly and paint vividly scenes of mysterious awe and horror, never carried him beyond the bounds of reason. He was a great walker, a great fencer, fond of games, and altogether normal in his daily life. It is impossible to find any sign of eccentricity in his character or conduct.

In old houses to-day you may come across engravings, often spotted with fly-marks and mildew, generally framed in maple-wood and hung in bedrooms, of the works of John Martin. You may remember having seen them—*The Deluge, The Fall of Nineveh, The Day of Wrath, Belshazzar's Feast*—but the name of the artist will be unfamiliar to you. The original paintings were hung in the Exhibitions of the Royal Academy and in many of the larger art galleries of Britain. They were bought by kings and princes, who lavished upon the artist magnificent presents. From Nicholas I. of Russia, Louis Philippe of France, Frederic William of Prussia, and Leopold I. of Belgium he received medals, rings, jewelled snuff-boxes, and other valuables. He was made historical painter to the Princess Charlotte of Wales (whatever that may mean), and member of the Academies of Brussels, Antwerp, and Scotland.

His pictures were said to "reveal a greatness and grandeur which was never even dreamed of by men until

they first flashed, with electric splendour, upon the un-
expecting public," and Wilkie the artist described *Bel-
shazzar's Feast* as ' a phenomenon.' Charles Lamb, who
devoted the greater part of his essay on *The Imaginative
Faculty* to a severe criticism of this work, falling foul of his
figures and grouping, wrote of him :

" His towered structures are of the highest order of the
material sublime. Whether they were dreams, or tran-
scriptions of some older workmanship—Assyrian ruins
restored by this mighty artist—they satisfy our most
stretched and craving conceptions of the glories of the
antique world."

And Bulwer Lytton was even more enthusiastic. In his
book *England and the English* we find :

" Martin, as a painter, is, perhaps, the most original
genius of his age. He has taken a range, if not wholly new,
at least rarely traversed in the vast air of religious con-
templation. He has made the Old Testament—with its
traditional grandeur, its solemn shadows and ancestral
terrors—his own element and appanage. . . . Vastness is
his sphere, yet he has not lost or circumfused his genius in
its space ; he has chained and wielded and measured it at
his will. . . . In conception he is more original, more self-
dependent than either Raphael or Michael Angelo. They
perfected the style of others ; Martin has borrowed from
none. Alone and guideless, he has penetrated the remote
caverns of the past and gazed on the primeval shapes of the
gone world."

There is much more in the same strain ; and a critic in
the *Edinburgh Review* echoed it :

B

"That which chiefly distinguishes Mr. Martin from all other artists," he wrote, "is his power of depicting the vast, the magnificent, the terrible, the brilliant, the obscure, the supernatural, the beautiful. These are great and noble elements, and are used here (*Belshazzar's Feast*) with a masterly hand. No painter has ever, like Martin, represented the immensity of space—none like him made architecture so sublime through vastness. No painter like him has made light pour down in dazzling floods from heaven and painted the darkness visible of infernal deeps."

Even Ruskin, who did not admire his work, wrote of Martin (*Stones of Venic·*, vol. iii.) :

"I believe that the four painters who had, and still have, the most influence on the ordinary Protestant Christian mind are Carlo Dolci, Guercino, Benjamin West, and John Martin. Raphael, much as he is talked about, was, I believe, in fact rarely looked at by religious people. But a Magdalen of Dolci, with a tear on each cheek, or a Guercino Christ and St. John, or a Scripture illustration by West, or a dark cloud with a flash of lightning in it by Martin, rarely fails of being very deeply felt."

Well, mediocrity does not, as a rule, make itself very deeply felt. And I submit that it is no credit to us, as a nation, that the name of John Martin is to-day almost unknown.

MARY L. PENDERED.

John Martin, Painter,

His Life and Times

CHAPTER I

Fenwick Martin, tanner, fencer, rover. His wife and family of four sons and a daughter. Eccentricity of the eldest and insanity of the third son. The attempt to burn down York Minster. Literary and artistic aspirations, culminating in the youngest boy, John.

THERE is, perhaps, nothing more mysterious and perplexing than the sudden advent of irrepressible talent into an ordinary family. The word 'irrepressible' is used with intent, for it is the nature of ordinary families to attempt the repression of such talent when it appears. It is seldom recognised at first, and almost always suspect. The child who is odd, who shows strange tastes and moods, is not generally, to his parents, sisters and brothers, the swan of the proverb; but rather a poor, foolish, exasperating goose, to be, if possible, teased and crushed out of his foolishness. And the duller the family, the greater its dismay at, and misunderstanding of, the changeling born into it.

For the genius is sometimes born in dull families, defying the doctrine of heredity and supporting the doctrine of reincarnation. Musical genius has, before now, cropped up

in families that have been satisfied for generations with the
hymn tunes ground out of a wheezy harmonium every
Sunday by a player who scorns the bass part as superfluous ;
great painters have sprung from simple folk accustomed to
rest admiring eyes on graveyard scenes in garish colouring
and maidens embracing prayer-books with upturned eyes.
It is not the rule, but neither is it the exception, to find
these freaks. History is well supplied with them.

John Martin's father, William Fenwick Martin, was born in
Cumberland, where some cousins named Walton owned lead-
mines, and other members of the family lived about Hexham.
There is, or was, in Hexham churchyard tombstones of two
great-uncles who attained the ages of 104 and 108 respectively.
They were connected with the Fenwicks of Bywell, about
which family many romantic legends were attached. John's
mother, Isabella Thompson, was the daughter of a small
landed proprietor at the Lowland's End, in the neighbour-
hood of Haydon Bridge. Her mother was Anne Ridley,
said to be descended, through Nicholas Ridley, from the
martyr bishop. Miss Thompson's parents did not approve
of her ' somewhat wild suitor,' so he persuaded her to elope,
and she rode behind him on a pillion to Gretna Green, where
they were married.[1] They had thirteen children, only five
of whom lived.

We know too little about the respective families of
Fenwick Martin and his wife, the father and mother of
John, to be able to say whether there had previously been
any germs of artistic desire in them ; but it was certainly

[1] *Vide* John Martin's autobiographical notes.

not a dull circle into which the talented boy was born. Fenwick must have been a lively fellow, capable, adventurous, and high-spirited. We hear of him first as a journeyman tanner at Bardon Mill, in the parish of Haltwhistle, Northumberland, and then as foreman at an extensive tannery in Bridgehouse Yard, a short distance from the town of Ayr. He lived in a house at the end of Brig o' Doon (Burns's *Bonnie Doon*) for a time, but left Ayr during the American War. He enlisted, but was hurt in quelling a mutiny, and afterwards took a public-house in Hartley, Northumberland; but he did not stay there long, and we find him next at Newcastle-on-Tyne. After being woodman to a Mr. Tulip of Fallowfield he went to Highside, near Hexham,[1] and thence to East Lands-End at Haydon Bridge, where his youngest son, John, was born.

According to the chronicle of Serjeant Thomas (which he affirms was taken down from the lips of John Martin, and afterwards corrected by him), Fenwick Martin had some ado to get a living for himself and family, being such a veritable ' rolling stone.' " By birth," says John, " my station could scarcely have been humbler than it was, and when, at the age of fourteen, I had the strongest desire to become an artist, my father's means were very scanty. He had but a small pension, having been, when only three months in the Service, wounded in quelling a mutiny. He was a powerful man, of dauntless resolution, and an expert swordsman before he became a soldier. After his discharge

[1] Where he lived in Old Globe Yard on the Battle Hill and taught the sword and single-stick exercise.

he was generally at home, with little employment, so he could not afford to educate me in the arts."

This is the only record we find of Fenwick Martin as a soldier, but a further statement by his son, quoted by Serjeant Thomas, bears out other reports of his roving and adventurous disposition. In this John declares that his father would have been one of Robin Hood's men had he lived at that time—he so liked being in the woods—and that he travelled all over the country to get the kind of work he preferred and see what he wanted to see. He once invested part of his wife's fortune in wares and travelled the country as a pedlar, while on another occasion he turned drover for the sake of driving cattle to London and seeing the great city. This disposition, his son adds, kept the family always exceedingly poor.

It is elsewhere stated that Fenwick Martin was a good-looking fellow, bold, active, and " the best swordsman in the kingdom ; not afraid to face any man in the world as a fencer or pugilist." We are not told whether his wound interfered at all with his swordsmanship, but as it is known that at one time he actually earned his living by giving fencing lessons, it may reasonably be inferred that this was after he received his pension and gave up his trade as tanner.

In any case, we may safely conclude that Fenwick Martin was neither dull nor commonplace, and his wife even less so, judging from the little evidence we have of her. It was, indeed, probably from her side that the eccentricities of her sons derived ; for she is said to have prophesied to a niece, who nursed her on her death-bed, that her family's

name would sound from pole to pole, and that her first-born, William, had "a god-like soul"; and she heard heavenly music the night before she died, which she wished her family to hear, but would not have them awakened lest it was intended, " by the Heavenly Will," for her ears alone. From which we may assume that she was possessed of certain qualities liable to degenerate into religious fanaticism and morbid imaginings.

Out of her large family she managed to rear only four sons and a daughter. We hear little of the latter, but the four brothers were all highly individualised, and showed a definite tendency towards self-expression in different forms. William drew and engraved on wood a very striking portrait of himself, besides other woodcuts with which he embellished his amazing pamphlets. Both he and Richard wrote what they conceived to be poetry, by the yard, and they all gave to the world their autobiographies. John, indeed, declared that he had a passion for reading autobiography, and justified it reasonably enough.

" If a man has accomplished anything worth talking about," he said, " I like to know the how and why he did it : to know him, and to know him thoroughly. And how can you know him thoroughly without an acquaintance with his early history, cogitations, hopes and fears, crosses and joys, aids and obstructions ? All this you learn best from himself. If he worked miracles, it is advantageous to know how to set about them and to trace the steps of his progress ; to contemplate the boy Franklin secretly trying his strength at an article, or the boy Burns at the plough stringing rhymes together. To the self-revelations of

autobiography—call them vanity if you choose—we are much indebted. No reading incites more to noble emulation."

It is a pity that, in spite of this opinion, he wrote no autobiography worth the name, the sole account of himself ever published (which will be discussed in the next chapter) being very scant and written from memory in his later years. He seems to have been the only one of the four brothers who did not attempt to elucidate himself in a pamphlet. And he was certainly the only one who " accomplished anything worth talking about."

William, the eldest of the family, wrote a large number of tracts, which he called philosophical treatises. Their titles, and the title that he gave himself, " Philosophical Conqueror of all Nations," are sufficient to prove his unbalanced intellect, but he seems to have been harmless enough and sane on every point save that of his own importance. Mania being an acute form of egoism, we could hardly confine all its victims without putting about half the world under restraint ; but few people will doubt that William Martin was qualified for an asylum after reading such stuff as here follows :

" The Christian Philosophers' Explanation of the General Deluge and the Proper Cause of the Different Strata ; wherein it is clearly demonstrated that one Deluge was the cause of the Whole, which Divinity proves that God is not a Liar and that the Bible is strictly True."

" Diamond cut Diamond. The Defeat of Impostors by Common Sense Philosophy. To Bishops, Priests, Jews and Gentiles and all the World."

" The Thunder Storm of Dreadful Forked Lightning.

God's Judgment against all False Teachers that cause the People to Err, and those that are led by them are destroyed, according to God's Word. Including an account of the Railway Phenomenon, the Wonder of the World."

Was this Stephenson's new invention ? The pamphlet is dated 1836 and " The Rocket " made its first journey in 1829, the Liverpool and Manchester Railways being opened in 1830.

But perhaps the maddest of William's titles was " William Martin, Philosophical Conqueror of All Nations. Also a Challenge for all College Professors. To prove this Wrong and themselves Right, and that Air is not the great Cause of all things animate and inanimate. I say boldly that it is the Spirit of God, and God Himself, as the Scripture says God is a spirit and that spirit was never created nor made, or how could there be any creation ? This is clear to anyone that has Common Sense."

Mr. Richard Welford, author of *Men of Mark 'twixt Tyne and Tweed*, states that he has in his possession one hundred and forty-eight of these delectable pamphlets, and we may reasonably conclude that they do not represent the whole collection. Some of them were in verse—such verse as we find below :

" Martin has rushed out on a sudden, like a lion from his den ;
And the odds goes against him—it is a horse to a hen.
Cheer up, you Northumberland and British bards that can use
 the pen
And show your divine wisdom for the good of all men.

Cheer up, you Britons, your champion has the battle won,
All the world cannot penetrate the celestial armour he has him
 upon."

His egregious vanity and self-esteem did not end here. It led him to attack the British Association for the Advancement of Science, founded in 1831, in a pamphlet entitled, "The Defeat of the Eighth Scientific Meeting of the British Association of Asses, which we properly call the Rich Folk's Hopping or the False Philosophers in an Uproar," and, more personally, Sir Isaac Newton and other great men of science. He sent these absurd tracts to the most prominent men in the Kingdom, and was so sure of their being appreciated that he neglected to pay postage ! John Martin told Serjeant Thomas in 1832 that his brother Richard had just sent him two small pamphlets on perpetual motion, costing three shillings for postage, adding : "And this is the sort of thing he often does. But William does worse than this. William sends to the wealthy and great, who possibly know me or my name, and he always takes care to let them know that he is brother to John Martin ! "

One of William's obsessions was that wonderful inventions by him had been stolen by unprincipled men ; and there can be little doubt that he did invent things. All the Martins, apparently, possessed a certain inventive capacity, a more or less creative imagination, and one at least of William's inventions received a silver medal from the Society of Arts in 1814—that of a spring weighing-machine, which may be the one in use to-day. But he claimed also a safety-lamp, a fan ventilator, a life-preserver for sailors, a cure for dry rot in timber, a suspension bridge, and an improved velocipede, or 'dandy-horse,' as it was

then called ; all of which, he alleged, had been appropriated by thieving rogues !

We hear that he had " a noble presence," and, if we may judge from the portrait he engraved of himself, he had certainly a very strong and arresting face. Like his father, he was a fine swordsman—all the brothers seem to have been good fencers and athletes—and was for some years in the Northumberland Militia. It is stated by John that William enlisted in order to get the " bounty," by which he was able to pay off a distress entered on his father's goods. Apparently at this time he was normal, a bright, vigorous youth probably, like his brother John. But in later life he grew more and more eccentric, the laughing-stock of Newcastle, as he strutted the town, wearing a skull-cap of tortoise-shell mounted in brass, his breast covered with self-made decorations of gigantic size. He died in 1851 at John's house in Chelsea.

The peculiarities which made William Martin's name a byword in his town reached a further and dangerous height in his brother Jonathan. The same want of balance and religious fanaticism that we find in his pamphlets led Jonathan into the violent extremes of a madman, though his insanity does not appear to have developed early. He was apparently sane enough when he served his time as a tanner with his father and was ' pressed ' into the Navy. He tells us that he was present at the bombardment of Copenhagen, the blockade of the Tagus, and Sir John Moore's expedition at Corunna ; and it is said that he was, in turn, signalman to a gunboat, ' boarder,' fireman, and mortar-boat man ; also that he was captain of the

foretop in a prize ship taken by Lord Nelson from the Spaniards.

From all this we may judge that he must have been normal at that date. But after quitting his seafaring life, and taking unto himself a wife, Jonathan passed from religious enthusiasm to religious mania, and became a dangerous fanatic. He went to chapel and church by turns and proclaimed his warnings aloud in those places of worship. His indiscreet zeal caused him to be expelled from the Methodists and to be discharged from his employment. In one church he rose and denounced the preacher as " a whited sepulchre," and, a little later, threatened the assassination of Dr. Legge, Bishop of Oxford. For this he was brought before the magistrates, and, having admitted his guilty intention (probably boasted of it !), he was committed, as a lunatic, to Gateshead Asylum.

After three years' confinement he escaped, but was caught at Hexham and sent back. His wife died while he was there. He escaped again, and, this time, was allowed to go free.

Ambitious as his brothers to express his emotions in some form or other, he issued an amazing autobiographical pamphlet whose title sufficiently indicates its contents and its value.

" The Life of Jonathan Martin of Darlington, tanner, containing an Account of the Extraordinary Interposition of Divine Providence on his behalf during a period of six years' service in the Navy, including his wonderful escapes in the action of Copenhagen and in many affairs on the coasts of Spain and Portugal, in Egypt, etc. . . . Likewise

an account of his subsequent and Christian experiences, with the Persecutions he suffered for Conscience' sake, being locked up in an asylum and ironed, describing his miraculous escape through the roof of the house, having first ground off his fetters with a sandy stone. His singular Dream of the Destruction of London and the Host of Armed Men over-running England, etc." Illustrated by three curious pictures, viz. (1) a frontispiece, ' The Colossus of Rhodes,' (2) ' Jonathan Martin's Providential Escape from a Watery Grave in the Bay of Biscay four different times,' (3) ' Jonathan Martin's Providential Escape from the Asylum House.'

How is that for a title-page ? The woodcuts should have some value to-day as curiosities, for they are remarkably quaint. The first two editions of the pamphlet sold well, and Jonathan printed a third of five thousand copies.

As he married a second time, two years later, a bride twenty years his junior, it would appear that he was fairly prosperous ; but shortly after his marriage he became distraught again and resolved to burn down York Minster as a protest against the degenerate and frivolous lives of the clergy.

The story of this attempt is sufficiently dramatic to be recorded. He gave due warning of his intention. Some little time beforehand a letter was found tied to the iron gates of the Minster beginning, " Hear the word of the Lord, oh you Dark and Lost Clargmen, you desevers of the People," and ending, " Jona Martin, a friend of the Sun of Boneypart must Conclude by warning you again. Oh,

Repent! He will soon be able to act the part of his Father."

Another paper, in the same strain (and spelling) was found later, in which he apostrophised the " Clargy in York " as " blind Hipacrits, Saarpents and Vipears of Hell, wine Bibears and Beffe Yeaters."

And yet nobody in York seems to have taken any notice! The writer was obviously of unsound mind, and one would imagine that the authorities would have been on the look-out for Jonathan Martin, though the extra-ordinary spelling may have been an attempt to disguise his identity. But no suspicion of danger seems to have been roused, and on February 1, 1829, having provided himself with flint, steel, and tinder-box, Jonathan went to the afternoon service at the Minster and hid himself, when dusk set in, between a tomb and the wall. When organist, choir, and ringers had all departed and the great doors were closed for the night, he crept forth and made his way to the belfry, preparing his escape by cutting off some of the ropes attached to the bells. Undoubtedly there was method in his madness! According to his own account, and to the account of certain passers-by who stated, after the event, that they had heard strange sounds within the cathedral, Jonathan then shouted in exultation : " Hallelujah ! Glory be to God ! " and set to work with savage glee on his fanatical task.

With an old razor he first cut away some of the velvet and gold tasselling, and the fringe from the bishop's pew and reading-desks, which he made up in three heaps by the wood-work of the choir stalls, and then, striking his flint and

steel, fired them. Being dry and combustible, they flamed up quickly, and then the incendiary made his escape by means of the bell-ropes through one of the windows, which he broke for the purpose.

What a scene for the stage ! Imagination pictures the ancient church, growing more and more full of shadows as the last rays of the sun fall through its stained windows upon carved wood and worn, hallowed stone ; the crouching fanatic behind a tomb watching, with horrible glee in his mad eyes, for the last form to disappear, listening for the last footfall outside. Then the eager rubbing of flint on steel, the tinder spark, the flare and crackle of flame, the mounting smoke, the escape ! Picture, too, the horror of the choir-boy who first saw the flare of those grand windows in the murky light of a winter morning

The fire was not discovered until about 7 a.m. next day, and by that time it had made such headway that the bishop's throne, stalls, galleries, pulpit, altar-rails, tabernacle work, organ, and the roof of the nave were destroyed, from the lantern tower to the east window—a hundred and thirty-one feet in all. And before the flames could be extinguished several of the shrines and monuments were also irreparably injured. The fire burnt on till five o'clock the next afternoon, lasting about twenty-four hours Jonathan had done his work thoroughly.

The crime was instantly fixed upon him. Had he not given himself away beforehand ? A placard was posted up with a full description of his appearance, offering a hundred pounds reward for his apprehension. He was described as : " Rather a stout man, about five feet six inches

high, with light hair cut close, coming to a point in the centre of the forehead and high above the temples, and has large, bushy, red whiskers; he is between forty and fifty years of age and of singular manners. He usually wears a single-breasted blue coat, with a stand-up collar and buttons covered with the same cloth ; a black cloth waistcoat and blue cloth trousers ; half-boots laced up in front, and a glazed, broad-brimmed, low-crowned hat," etc.

He was caught near Hexham, and when taken to gaol seemed in quite good spirits Decidedly pleased with himself, his behaviour was rational and he gave no trouble whatever. Bits of candle, flint, tinder, and fragments of stained glass were found upon his person. On March 13 he was tried for arson before Mr. (afterwards Lord) Brougham, and made an extraordinary defence, alleging that, after he had written five premonitory letters to the clergy, the Lord had told him what was to be done to warn " those clergymen of England, who were going to plays and cards and such like," of their approaching doom. He declared that the Lord had deputed him to give a sign from heaven by burning down the Minster At a certain service he had been exasperated by hearing them singing prayers and amens which he knew did not come from the heart. " Then there was the organ—' buzz ! buzz ! '—and I said to myself, ' I'll hae thee down to-night ; thou shalt buzz on more,' " he boasted in court, and ended with the assertion that he had never felt so happy in his life as when he was firing the Minster, in spite of " a hard night's work and a hungered belly "

The verdict of the jury, " Guilty of setting fire to the

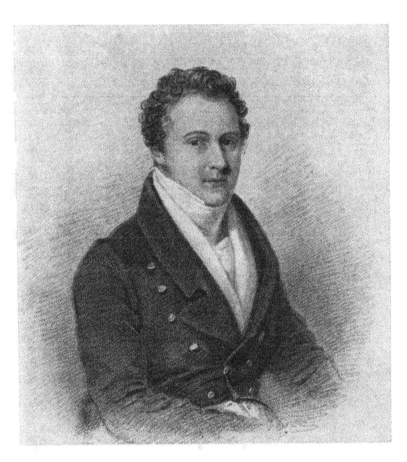

JOHN MARTIN IN EARLY LIFE.

(Portrait by Beeby-Thomson published in the " European Magazine," 1822.)

p. 32.

Minster while in an unsound state of mind," was changed by the judge to " Not guilty on account of insanity," and Jonathan was confined for the rest of his life in a lunatic asylum, where he lived nearly ten years, dying in 1838, at the time his youngest brother, John, was at the height of his fame.

Jonathan left one son by his second wife, and he seems to have inherited his father's disease, for he committed suicide in John's house. Serjeant Thomas has an interesting note of the tragic event, as follows :

" *August* 13*th*, 1838.—Yesterday I and Martin walked over the fields across Wormwood Scrubbs. The whole morning was consumed in the horrible narration of the frightful suicide in his house last Monday. Poor William, the only son of Jonathan, who died in Bedlam three months ago, went out of his mind on Saturday and talked incoherently on various subjects. Said he was going to have typhus fever and that his breath was poisoning the whole family and turning them all black. That he should not draw another sketch nor require money any more ; and many similar strange remarks, to which they turned a deaf ear, or took little notice of them at the time—except Mrs. Martin. She sent for the doctor and gave him medicine. As to going into the *narration* of the horrid suicide and the scenes described by Martin to me, I cannot ; though I can never forget them. The youth often accompanied us in our walks ; he was very quiet, sensible, diffident, and talented ; but very contemplative and silent. Martin had kindly adopted him, and he was always with them after his poor father was confined."

C

In another passage Mr. Thomas tells us that John Martin was put to great expense over Jonathan's trial ; from which it may be presumed that he paid for his defence.

Of Richard, Fenwick Martin's second son, we hear less. He served twenty-nine years in the Army, becoming Quarter-master-sergeant in the Grenadier Regiment of Foot Guards, and published a volume of poetry and some pamphlets.[1] He was sane, if eccentric, and John seems to have helped him up the social ladder, since we learn that his only daughter married the Keeper of Printed Books of the British Museum.

From these facts it may be seen that the mental aberrations of Fenwick Martin's sons bore no relation to that form of cerebral weakness known as imbecility. There seems to have been, rather, a superabundance of mental activity in them all, which probably, fostered by an atmosphere of Calvinism, led on the one hand to fanaticism and on the other to a genius which found its chief inspiration in the Bible. There may, or may not, have been on one side of the family a tendency to artistic talent or to brain disease, but of this we can learn nothing, and can only assume that the extraordinary degree of restless energy manifesting itself in Fenwick Martin was transmitted to John as creative power and to his brothers as a futile, combative fanaticism.

Genius, that strange compound of imagination, concentration, discrimination, and power of vivid expression, springs first of all from an abnormal spiritual and physical energy, and such energy may exist without the balance and

[1] He published in 1830 a volume of poems entitled *The Last Days of the Antediluvian World*, etc.

direction to make it vital. John Martin's brain was superbly balanced, and held fast to his aim by a single vision. His passionate devotion to the art of painting saved him from the fate of his self-sufficient and vainglorious brothers By that art he escaped from himself into the universal and eternal.

CHAPTER II

John Martin's boyhood at Haydon Bridge and early attempts at art. His migration to London in 1806 and life with Boniface and Charles Musso. His marriage in 1809, while employed at Collins's glass and china factory near Temple Bar. His first picture, a landscape, exhibited at the Royal Academy in 1811. First subject picture, *Sadak*, exhibited there in 1812. The tragedy of his third picture.

IT would seem that John Martin once contemplated writing his own biography, for I find among the papers kindly lent to me by his granddaughter, Madame de Cosson, the following notes, some in his own handwriting, some in the writing of his daughter, Isabella :

" John Martin, born at the Lowland's End, Haydon Bridge, near Hexham, Northumberland, July 19, 1789.

" Was the 12th child of his parents.

" His mother being unable to suckle him, he was put out to nurse. The name of his foster-mother was Mary French.

" At an early age sent to Haydon Bridge Grammar School, but often played truant and made little progress. His cyphering books still preserved, well written but scrawled with wretched attempts at drawing and with verses.

" When a boy fond of wandering in the woods and among the ruins in the neighbourhood of his home. Of

timid and nervous temperate [temperament], fearing to be in the dark and dreading ghosts and hobgoblins at every corner. On one occasion he climbed up to the top of the ruined tower of —— [illegible] Castle, and so dreaded coming down that he at last got into the chimney, and was nearly killed, having been obliged to be pulled down by main force, so tightly had he stuck.

" In his visits to —— [or Lumley] Castle he used to feast his eyes on pictures placed out of the way in the ruined tower as worthless. On one of these he painted the portrait of his grandmother's cat, with some colour procured from a house-painter, or any coloured earths he could find. One of his brothers had a box of water-colours too precious to be used by the little boy whose ambition was to possess one. He ultimately obtained his desire as a reward for some portrait attempt.

" Until this he occupied himself in searching for coloured earths in order to dry and prepare them for painting with."

A further account of himself appeared in the *Illustrated London News* (February, 1849), which has been called his ' autobiography.' He wrote it to contradict certain statements made in a biographical sketch of him, previously published in that paper by an anonymous writer. This writer was his son-in-law, Peter Cunningham (whose son has been good enough to furnish me with this private information), but I am unable to say whether John Martin was aware of the fact or not. Probably he was. His first contradiction is regarding his birthplace and education.

" I was born at a house called Eastland Ends, Hayden Bridge, near Hexham, 19th July, 1789," he says, " and

received the rudiments of my education at the well-known free school of the place "—two facts in conflict with Cunningham's statement that he had been born in Newcastle and educated at a Grammar School.

In this ' autobiography ' he skims over his childhood very quickly, and we have but scanty outside information about it. Tradition, however, asserts that while he was living in a thatched cottage on the north side of Haydon Bridge he would often draw upon the doors of houses or the school walls, or on coarse canvas stretched on long sticks, pictures that, even then, showed remarkable talent. Another story is that with the pointed end of a stick he would draw wonderful things in the fine sand of the river-bank. Perhaps at his school, as at others of his time, trays of sand were used as substitutes for slates, and he learnt to make pot-hooks and figures with a pointed stick in them. At all events, this legend of pictures in the sand derives from one who claims to have been John's school-fellow and constant companion.

It is also said that he rarely left the school-room during play hours, preferring to spend all his available time on drawing; and one result of this was a picture on the schoolroom wall of two boys fighting and one receiving chastisement over the master's knee, so lifelike that all the faces and figures could be easily recognised. But we are not told whether the master recognised the talent or birched him for defacing the wall !

" Having from my earliest years attempted to draw and expressed a determination to be a painter," he continues, " the question was how to turn my desire to profit-

able account, and it was ultimately decided to make me a herald painter—in consequence of which, upon the removal of my family to Newcastle, I was, when fourteen, apprenticed to Wilson, the coachbuilder of that town."

He does not give any definite reason for the move to Newcastle, but it is quite probable that his boyish determination to become a painter influenced his parents in this step. It would not take much to influence Fenwick Martin towards making any change whatever, since he possessed the roving, adventurous spirit, and possibly the idea of becoming a fencing-master in Newcastle, while John became a painter, captured his fancy. But, for all his adventurousness, we may conceive Fenwick as having a distinctly practical side to his character and recognising the necessity of teaching his boy some means of earning a steady living before permitting him to indulge in ambitious dreams of art. Indeed, even had there been an art school available at the time, there was, as we have seen, little money to spend on instructing the boy in what might prove to be a will-o'-the-wisp lure of fame. John must have a definite trade or profession on which to depend. He was therefore apprenticed to a coachbuilder on a seven years' term of service, and practised his 'prentice hand on the panels of coaches, as Thomas Sidney Cooper and other famed artists have done. It was certainly beginning on the lowest rung of the ladder.

We do not to-day perhaps quite realise what the term ' herald painter ' meant in John Martin's boyhood, when coaching was the great pastime of men of fashion, and stage coaches were still running from all the larger towns in a

network of travelling routes, chiefly converging toward London. And as every one of these coaches, public or private, bore a device of some kind on its panels—coats-of-arms belonging to towns or to aristocratic families, monograms, animals, and other distinguishing marks—there was plenty of work for the young man who manifested any talent in designing, or could qualify himself for the kind of painting required.

At first John seems to have been satisfied with the opening found for him, and worked well during his long hours of service. In his scant leisure, we are told, he would rove the town, looking at signboards, which he drew from memory when he got home. But after a year of such drudgery John fell out with Wilson, the coachbuilder, for a reason that he thought justified him. Peter Cunningham had alleged that he broke his indentures simply because he disliked the work, but Martin gives a more definite cause of dispute. He says :

" I worked with him [Wilson] for a year, in no small degree disgusted at the drudgery which, as a junior apprentice, I had to endure, and at not being allowed to practise the higher mysteries of the art ; when, just previously to the expiration of the year (from which period I was to have received an increase of pay). one of the senior apprentices warned me that my employer would evade the payment of the first quarter on the ground that I ' went on trial ' and that it was not in the indentures. As he foretold, so it turned out. After claiming the increase, I was referred to the articles and the original sum tendered. This I indignantly rejected, saying : ' What ! you're soon

beginning then, and mean to serve me as you did such an
one ! But I won't submit.' ''

With that he turned on his heel, and we may imagine
with what dignity the boy of fourteen marched out of the
office. His father took his part and declared he should
not go back. By this time Fenwick had evidently begun
to recognise his boy's promise of a brilliant future, and
encouraged him to draw and paint. John tells us that his
father gave him a shilling to spend on drawing materials,
and with these he made studies of the sky from his bedroom
window, attempting especially to produce impressions of
lightning flashes—studies that were useful to him later in
his awe-inspiring pictures. This was at the time that he
dared not venture out of doors lest he should be captured
and hauled before his irate master. But staying at home
did not save him from this dreaded fate, and one day when
he was drawing in his room the parish beadle appeared
before him armed with a warrant commanding him to
present himself at the Court of the Guildhall, to answer the
charge made against him of breaking his indentures.

He says that he was not frightened of the beadle, a
good-natured fellow, who " did not pique himself much on
his brief authority," and was rather inclined to stop and
admire John's pictures than to be hard on him. But he
was horribly afraid to face the Court, and wanted to run
away. 'Bobby the Beadle,' however, was very friendly,
and encouraged him to go before the justice, which he did,
and was glad afterwards that he had done so.

" I was dreadfully frightened," he writes in the ' auto-
biography ' ; " the more so as no one of my family was within

call to accompany me, and, entering the Court, my heart sank at sight of the Alderman and my master, with lowering face, and his witnesses. I was charged on oath with violence, having run away, rebellious conduct, and threatening to do a private injury. In reply, I simply stated the facts as they occurred. The witnesses brought against me proved the correctness of my statement in every particular, and the consequence was a verdict in my favour. Turning then to my master, I said : ' You have stated your dissatisfaction with me, and apprehension of my doing you a private injury. Under those circumstances, you can have no objection to return my indentures.' Mr. Wilson was unprepared for this, but the Alderman immediately said ᐧ ' Yes, Mr. Wilson, you must give the boy his indentures.' They were accordingly handed over to me, and I was so overjoyed that, without waiting any longer, I bowed and thanked the Court, and, running off to the coach factory, flourished my indentures over my head, crying : ' I've got my indentures and your master has taken a false oath ; and I don't know whether he is not in the pillory by this time ! "

It is a very distinct picture that he has thus sketched in a few sentences. One can see the excited boy flourishing his indentures before his admiring and sympathetic companions, all ground under the conditions from which he had broken free. They were iron conditions, and, under a hard master, apprenticeship in his day was not far from slavery. I have before me indentures made in 1858, fifty years after John Martin's were signed, running in this wise :

" This Indenture Witnesseth that So-and-so with the

consent and approbation of his Father as his natural Guardian doth put himself apprentice to So-and-so to learn their Art and thereafter the Manner of an Apprentice to serve from —— to —— unto the full End and Term of seven years from thence next following to be fully complete and ended During which Term the said apprentice his masters faithfully shall serve their secrets keep their lawful commands everywhere gladly do Shall do no damage to the said Masters nor see to be done of others but to his Power shall tell and forthwith give warning to his Masters of the same. . . . Shall not haunt taverns or Playhouses nor absent himself from his Masters' services day or night unlawfully. . . . And it is fully understood that the hours of Labour from April 6th to October 11th of each year of the said Apprentice shall be as follows from 6 o'clock a.m. to 7 o'clock p.m. and from October 11th to 6th April 7 o'clock a.m. to 8 o'clock p.m. less two hours each day for meals.''

And so forth. If these were the apprentices' conditions seventy years ago, we may conclude them to have been even harder a century back, and may draw an inference as to young John's probable hours of labour in Wilson's factory. It seems strange to us now that parents ever doomed boys of fourteen or fifteen to eleven or twelve hours' work a day for terms of three to seven years.

As soon as he was free, John began to apply himself seriously to the art he loved. He tells us that he roamed the hills at daybreak, '' exulting in the sublime grandeur of the surrounding beauties of nature, watching effects of light and shade, and trying to imprint these beautiful

images indelibly on my memory, which, upon my return home, I endeavoured to retrace upon paper." But the result of this application was inevitable. He soon began to be depressingly aware of his own ignorance, and a passionate longing for instruction invaded him.

"As the hart panteth after the water brooks," he said twenty-five years later, " so my soul thirsted for knowledge, and my joy was indescribable when I succeeded in persuading my parents to afford me a little education. . . . My father, thinking well of my talents and the progress I had made without aid, determined to procure me a master. He went one morning in search of one, and returned apparently much elated, saying : ' Come with me, John, for I have found a gentleman who can teach you everything, a cele- brated Frenchman' (father thought every foreigner a Frenchman), ' so bring your drawings and come with me.' I took my drawings, saw my future master, and, father having agreed with him on terms for a quarter's tuition, I was directed to come the next day. I did so, and continued to take a lesson in drawing twice a week for the next quarter."

Admit there was something admirable about this Fenwick Martin, journeyman tanner, soldier, expert swords- man, roving adventurer, who yet possessed an inner vision of art and could recognise genius in the bud. I like the honest Northumbrian countryman so much that I would fain linger over him. His brilliant son never failed to pay him the tribute of profound affection, gratitude, and esteem. The greatest regret of his life was that success came too late for him to render his parents pecuniary aid when they most needed it. They both died while he was struggling

in London, and he expresses his sorrow thus to Ralph Thomas :

" One hope of my life, ever present with me, was to do something to please them and to help them in their old age. It would have been a great joy to me to have had them see me in my present condition ; how delighted they would have been, and how easily I could have spared them a comfortable maintenance ! "

But this is a digression. The master Fenwick Martin found for his son was an Italian artist named Boniface Musso, who had attained some fame in Newcastle as an art master. He exhibited a drawing at the Society of Artists in 1790, and his son Charles (known as Charles Muss) was a successful glass and china painter in London, showing also some talent in enamels. For many years the lives of these two men were bound up with that of John Martin, and there was a deep and abiding friendship between them. Martin always averred that he owed his position in the art world to the Mussos, father and son. He was certainly much indebted to them for many years.

And John was not ungrateful. According to him, Boniface Musso was little less than an angel sent from heaven to help him in the hour of his greatest need, and his admiration for the Italian was unbounded, both as artist and man. He regarded him, we are told, as an universal genius as well as the noblest of men, the most perfect of gentlemen, and the most disinterested of friends.

When, after his first quarter's tuition, Fenwick Martin found that he could no longer afford to pay for John's lessons, Musso offered to teach the boy for love, and not

only that, but treated him as a friend and equal. The boy
went to him daily for instruction, and also spent most of
his evenings with him. He tells us that he went surrep-
titiously to Musso's house on Sundays, when his mother
supposed him to be at church, because on that day of the
week only Musso painted in oils, and John was eager to
learn oil-painting. This went on for over a year, and during
that time John painted, he says, many portraits, " receiving
as much as seven shillings each " for them, which, he adds,
" till I had exhausted my sitters, considerably helped to
support me."

The story of one commission, as told by his son Leopold,
is amusing. It was for the portrait of a boy, the son of a
widow of some means. This son was about to join the
Mercantile Marine service, and the mother was anxious to
obtain his portrait as a sort of reminder during his absence
at sea. The head was to be sketched on canvas, and as
the material, being of charcoal, was so soon likely to be
injured, it was to be framed and glazed—a great distinction
for a first commission, when not a painting but only a ' black-
and-white.' The drawing, the frame and the glass complete
were not to cost more than twenty-five shillings. This did
not leave much for the artist. The boy attended sitting
after sitting ; no one was allowed to be present, and, the lad
being a good sitter, the work progressed to the full satis-
faction of my father, who gave it every attention.

" The drawing was at length completed quite to the
satisfaction of the artist. His father was truly delighted
with the result, and so were those companions who had
been allowed to inspect it. The portrait was duly carried

home to the widow in full expectation on the part of the
artist of giving perfect satisfaction and of receiving pay-
ment and being complimented upon his great success.
Oh, the glory of a first commission! But what was his
dismay, wrath, indignation, and disgust when the mother,
on glancing at the portrait, exclaimed, ' I will have none of
it—it is not my boy! *That* boy squints! *That* boy gleys!
My son has no squint.' "

John tells us that Musso thought the likeness very good.
" 'Tis very like, it squint jus' like de fellow," he said ; but
Leopold remarks that the boy's mother had never noticed
the squint till she saw it in the portrait, and then her in-
dignation knew no bounds. She not only refused to pay
for the picture, but threatened John with personal violence,
and he had to escape hurriedly from her presence. " Thus
ended," says Leopold, " the first real commission of John
Martin, and with it all inclination to be a portrait painter."

At the end of John's year with Boniface Musso, that artist
was persuaded by his son to leave Newcastle and take up
his abode in London, a move which John must have regarded
with the greatest grief and consternation. One can, there-
fore, imagine his rapture when Musso suggested that he
should join him there and find employment in the great
city.

He tells us that at first his parents were very averse from
the idea, that a good deal of coaxing, both on his part and
on the part of Musso, was required before they would agree.
His mother was hardest to move. She had, he says, many
misgivings about letting him go. London seemed a very
long way off in those days, when the ' Flying Machine,' at

its giddiest pace, did not exceed ten miles an hour, and
the gay city was regarded as a sink of iniquity by most God-
fearing country folk. She had also some distrust of the
Italian's religious views. But we can imagine that the
boy gave his parents no peace till they consented, and in
September of the same year he went to town.

According to Peter Cunningham, he went with only
five shillings in his pocket, but he refutes this statement
in the 'autobiography,' and says elsewhere that his father
gave him fifty shillings for his expenses, besides a complete,
or, as he calls it, 'almost inexhaustible' outfit. He took
his passage in a Newcastle trader (Cunningham calls it
a Newcastle collier), and there was robbed of all his
loose cash, so that he found himself in London almost
destitute.

He had some difficulty in finding his friends' house in
Cock Court. Confused and frightened, no doubt, by his
first sight of the swarming city, he lost his way 'among
the thousand windings of the vast metropolis,' and did not
reach his destination till about eleven o'clock at night.
The warmth of his welcome, however, made up to him for
all the trials of the journey, and he rested happily content
with his kind friends.

It must have been somewhat disconcerting next day
to learn, as he tells us, that the employment Charles Muss
had expected to have, and to obtain for him also, was not
forthcoming, the department for which he had engaged to
work at the china factory not being ready for him. A
letter had been dispatched to John suggesting that his
journey should be postponed, but it had not arrived at

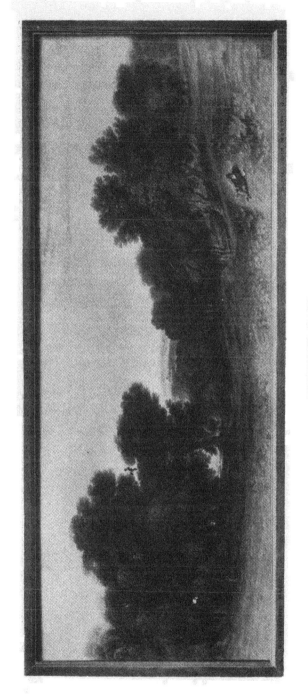

RICHMOND PARK.

(From a painting in the Victoria and Albert Museum.)

p. 48.

Newcastle in time to stop him. For some months, there-fore, he had an anxious time seeking work, generally accompanied by Charles Muss, who was also out of employ-ment. Despair began to set its fangs in the poor boy, whose resources were exhausted, who loathed the idea of writing home for more money, and loathed still more spong-ing on his good friends, who were not affluent but afforded him bed and board with unfailing generosity.

"How often, sighing, have I said to myself," he told Ralph Thomas, "'this is indeed to me an ever-enduring lesson. Here is a man to whom I am debtor, who owes me nothing, and is yet of benevolence the spring, flowing from a pure heart, all generosity, sharing his pittance with me. Why should I rob him? What am I to him? Still he daily aids me and appears to delight in his untiring, in-explicable goodness. What throes of love do I feel towards him! Oh, generous friend! May my conduct through life be as yours: I ask no better gift. . . .' Thus have I often on my pillow, in tears, thought and felt; poignantly sorrow-ing that I could not better my circumstances to aid him."

The above rings sincerely, and serves to show the bitter experience that the poor ambitious and independent-spirited boy must have gone through at this period.

He tells a story of their extreme penury not without humour:

"I remember returning home one evening, fatigued with walking, depressed by repeated denials and faint with long abstinence. Each of us sat near the place where, occasion-ally, we had enjoyed the blaze of a fire. The only ray to gild the present gloom was the cheering aspect of my friend's

D

countenance. ' Here ! ' he said, ' we must not despond while we have one of these left,' presenting a shilling to my view—I knew it was his last—adding : ' I'll go to our mutual friend, the pump, while you go for the staff of life, and let it be a large one.' "

He tells us that he took the shilling and ran to the nearest baker's shop, seized the biggest loaf he could find, and presented the coin to the churlish-looking baker, who looked at it suspiciously and rang it on the counter.

It was a bad one !

How he lay awake for nights planning what to do in his despair is graphically described in this memoir, and that he set himself to draw feverishly, from memory, scenes of Northumberland rock and fell, which he hawked about London till he finally managed to dispose of some to the picture-dealer, Ackermann, who had a shop in the Strand.

At first Ackermann refused to look at his sketches, saying," We have such a large stock of dese tings at present ; we are quite full and over-stocked—quite." But as Martin turned to go out of the shop he changed his mind, and said, " You can show dem to me if you like "; whereupon the young artist exhibited his pictures (three drawings in Indian ink), and the wily dealer gave him twelve shillings for the lot. He had asked a guinea.

He says that, as he was hurrying off with the money, Ackermann called him back, asking if he had any more drawings to dispose of ; upon which he (Martin) drew himself up haughtily and replied : " Want reduced me to request you to purchase these drawings, hunger compelled me to dispose of them for this inadequate sum ; but you

have not used me well, sir, and I will never deal with you again." And this we can well believe of the fiery youth. But it was not by any means his last transaction with Ackermann, who must have made a tidy fortune out of his engravings when Martin was at the height of his fame, paying him in some cases as much as £500 in royalties. But he never knew that the great man was the poor boy he had so beaten down, for John was too proud to tell him.

His friend Muss rebuked him for his hot words to Ackermann, and he was afterwards sorry for them, as he came to realise that the dealer was one of the most decent of his kind and treated him much more fairly than others to whom he showed his pictures. But he was new to the unpleasant task of hawking round his work, and had not learnt to dissemble his feelings.

He struggled on in London thus for a time doggedly, and sometimes wretchedly, but never without faith in himself and a secretly-nourished certitude of success in the future. "Many a day, after fruitless efforts to dispose of my designs, have I returned to gaze upon them and feed myself with hopes; for, under all circumstances, I entertained the belief that I should some day be rich and independent. I never mistrusted myself or despaired of better fortune," he declares, "my hope of success buoying me up, even when I was starving."

At this, the lowest ebb of his fortunes, he must have been often hungry, for he lived on ten shillings a week and contrived, out of that, to help his brother Richard, who was in London and often applied to him for pecuniary aid. But after a time his prospects improved. He found employment

with Charles Muss, who had apparently gone into part-
nership with another man in a glass and china business,
for he tells us that he agreed to serve them for five years
at £2 a week, half of which he volunteered to pay back for
the necessary instruction in the art of designing and painting
on china.

Charles Muss lived in Cock Court, in the house Wilkes
had lived in, and John slept in the bedroom that the famous
iconoclast had occupied. But after staying there for a time
he had "some little differences with the family," and
cleared out to a lodging in Adam Street, Cumberland Place.
Perhaps his habit of sitting up till two or three o'clock in
the morning, studying perspective and architecture, did
not please Mrs. Charles; and he tells us that this is what
he did, after working all day at china-painting. But there
seems to have been no rift in his friendship with Muss, for
whom he continued to work as long as his business held
together.

Not very long afterwards, however, in 1809, the ' estab-
lishment ' of Charles Muss and Co. was broken up, and those
employed had the option of seeking independent employ-
ment or following the fortunes of the different members of
the firm. John followed his friend, and when he obtained
a wage of £2 a week, continued to pay £1 to Muss, as stipu-
lated in his agreement, until he married.

Charles Muss opened an exhibition in Bond Street,
which was a dead failure, and he became bankrupt. He
was glad to accept employment, therefore, in what must
have been a rival's factory, namely, in the service of one
Collins, who had a flourishing glass and china business near

Temple Bar. Martin was also engaged by the same firm. Muss received £6 a week, and Martin, as already stated, £2.

Of Muss it is only necessary to say a few words before dismissing him from this chronicle. He attained some distinction in enamelling, was made enamel painter to William IV., and had many commissions from him. From 1800 to 1832 he exhibited enamels in the Royal Academy, some being unusually large; and he executed a copy of Rubens' *Descent from the Cross* for St. Bride's Church, Fleet Street. He died in 1834, and John Martin undertook to direct the completion of his unfinished works in glass and enamel, doing all in his power for the widow and children, who were left badly off. Thus he was able to discharge his debt, as far as possible, to his friend and benefactor.

In 1809 John Martin married Miss Susan (or Susannah) Garrett, of Crundal, Hampshire, a lady nine years his senior. He was then under twenty and must have looked a mere boy, for he was not great of stature. They were wedded at Marylebone Church, and his son comments on the match as follows:

" My father formed an attachment to, and afterwards married, a friend and constant visitor at the Musso's, a lady who, for nearly forty years, proved a dear and devoted wife . . . she who made my father's home and life supremely happy, a true and loving helpmate, not only the pride and deeply beloved of a numerous family, but the esteemed of all."

Mrs. Martin must indeed have been a cultivated and

capable woman, if all that her son asserts be true, and we have no reason to doubt it. For he continues :

" As a wife none could have been more inspiriting, encouraging, or devoted. Engrossed as my father was in his art pursuits, he had but little time for the perusal of the ordinary literature and news of the day. The Bible, Milton, and Byron were nearly the only works he read by himself, but to listen to an accomplished reader was with him a passion, and it was one my mother never failed to satisfy. Scarcely any publication of the day, of any note, escaped her ; hardly an author of the period was unknown to them. Hours each day were passed in this trying occupation—for reading aloud is really such. Her voice was charming, her style perfection ; poetry and prose came to her alike. With such advantages, few were better informed about the literature of the day."

The family of eight came quickly, four boys and four girls, Isabella, the eldest, being born in 1812, and Jessie, the youngest, in 1825. Two sons, John and William, died in infancy, the rest grew up, and all married except Isabella. With the babies coming every year or two, living from hand to mouth, as they must have done (for John tells us he had a hard struggle to make ends meet for some years), Mrs. Martin can have been no ordinary woman if she yet found time to cultivate her mind and to read aloud to her husband for several hours a day. She must have been clever enough to manage her boy husband too, and a genius is not generally easy to manage ! John was irritable and irascible we know. Perhaps she had not a very enviable time, but no doubt she ruled the house, and ruled it well.

When Martin married, Muss refused to take any more money from him (as indeed he had no right to do, the agreement being terminated by the closing down of his business), although John wished to continue until the end of the five years stipulated, and was perfectly sure that he could keep a wife and himself on a certain income of £1 a week, with what he could earn outside. But he soon discovered this optimistic error, and the struggle began again in earnest. He tells us that the friends and patrons he made while at Collins's were invaluable to him, giving him orders which kept the wolf from the door, and all might have gone well had he been able to remain in that business on a rising scale of wages. But, unhappily for his needs of the moment (although, perhaps, to his higher interests in the end), he lost that employment twelve months later. And this is how he states the reason of his losing it; a reason that is of some interest to us to-day :

" My fellow-workmen," he says, " finding my productions the greatest favourites and fetching the highest prices, sought to injure me. They found out that I had not been regularly bound apprentice to this business, that I had not served the required term, and they determined to put an end to my employment. They therefore struck against me, placing me suddenly in the most painful position. Perhaps this was in part brought about by the fact of my never having mixed with the men. Their tastes, habits, and views were discordant. They drank and smoked and wasted their lives in public-houses ; in short, they were content to stagnate, whilst I wished to progress." [1]

[1] Quoted by Mr. Ralph Thomas.

It was ever thus with him. As a boy he tells us that
other boys shunned him, and he could not get on in their
society. They thought him a prig, no doubt, and he
thought them infinitely dull and boring, with their petty
interests and narrow outlook.

" I saw that I was crushed and there was no help for
me," he continues ; " I was too proud to contest against
such antagonists. I resigned, and was thrown upon my
own resources once more, with a wife and child to
support."

But on the day of his leave-taking he exploded his
views upon them in a manner that must have been startling
and impressive. After telling them that they had done
their best to ruin him, he continued :

" Your conduct is tyrannous and unjust. I pity you,
as you act in ignorance. I feel that it is not simply to
injure me, but you think it is for your own general good,
and I see you are ready to sacrifice yourselves and your
masters to vindicate your opinion. I think you are wrong
and I can prove it. . . . Your blind vengeance will recoil
on yourselves. I can prove this to the thoughtful and
attentive. My designs have caused emulation and excite-
ment among you that, of itself, has improved your work
and gained you better pay. My works have been sought
for and paid for highly. Persons have bought them who
would not have desired to possess such articles unless
executed with taste. So, by my knowledge, your business
has been benefited, buyers have increased, prices have been
raised ; more work and better pay for you has been the
result of the demand. I have also proved that a long

apprenticeship is unnecessary and this may result in a saving of your time."

He ended by declaring that he would seek some more liberal business, where industry and ability would not be met by tyranny; that restrictions argued weakness and mediocrity, and that competition and improvement were the heart and hope of all trade, the advancement of all commerce and progress.

It must have been a very remarkable harangue from a boy of twenty-one, if Mr. Thomas reports it accurately. In later years he formulated his creed that "the best antidote to small wages is self-improvement. Improve your power of action and you improve your condition," and this he ever carried into practice, never relaxing from his efforts after the highest standard it was possible to reach.

Upon his marriage he took rooms in Northumberland Street, Marylebone, but soon moved again to the High Street, and there started, he tells us, to paint pictures in the evenings, at first water-colour drawings and then " in odd hours to paint in oils."

His memory with regard to those first pictures seems to have become somewhat confused and misty when he wrote the autobiography, for he tells us that his first big picture ever exhibited was *A Clytie*, and that he sent it to the Academy in 1810. But in the full list of his pictures sent to the Academy [1] we find it was not hung there till 1814, where it appeared under the title of *Clytie*, with the words :

[1] *Royal Academy Exhibition*, Graves, vol. v.

" All day, all night, in trackless wild, alone
 She pin'd and taught the listening rocks her moan."

The following year, 1815, it was also shown at the British
Institution.

He does not claim that it was accepted in 1810, but
says : " It was rejected for want of room, as I afterwards
learnt. . . . I therefore sent it again in 1811, when it was
hung, in a good situation, in the Great Room." This was,
of course, at Somerset House, where the Royal Academy
held its exhibitions at that period.

There may have been two *Clyties*, but we do not hear
of one being exhibited before 1814 ; and his son states
plainly that *Sadak in search of the Waters of Oblivion* was
the first picture painted by John Martin for exhibition.
But a " landscape composition " is chronicled as being hung
in the Academy in 1811, and, as John states that he sent
two landscapes with the *Clytie*, he may have painted one of
the lady that was rejected and never appeared ; or was,
perhaps, hung in an anteroom and escaped notice. It does
not matter to us now. The important point to be sure of is
that *Sadak* was really his first exhibited *subject* picture.
With regard to it he writes :

" Having now lost my employment at Collins's, it
became indeed necessary to work hard, and, as I was then
ambitious for fame, I determined on painting a large picture,
Sadak, which was executed in a month."

If his memory had not again misled him, that was indeed
a wonderful feat. For we are told that it was " an original
and striking composition," although the small central
figure of Sadak was so lost in the immensity of a rocky land-

scape that it was barely visible. Martin himself, writing of the picture, humorously observes : " You may guess my feelings when I overheard the men who were placing it in the frame disputing as to which was the top of the picture ! " But it was sufficiently impressive, whatever its flaws, to command a good deal of notice from the press (to his great delight, as he tells us), and was bought by a Mr. Manning, a director of the Bank of England, and patron of art, for fifty guineas—a sum which must have seemed a fortune to the struggling young artist.

Of the *Clytie*, exhibited two years later, Leopold relates a tragic story, and dates from it his father's animosity towards the Royal Academy. After asserting that the picture was " a grand ideal ; a bright and lovely landscape, an effort to portray the beauty of Claude, when at his best and happiest, combined with the charm of Turner," he tells us that it was fairly hung at Somerset House, though rather low down, and his father was satisfied with its position. He retouched and varnished it and looked forward to the effect it might create at the private view and usual dinner to Ministers and patrons of art. But unfortunately :

" Above my father's picture of *Clytie* were hanging some smaller works, either by Royal Academicians or Associates of the Royal Academy. Thus it happened . . . that one of the privileged painters, when varnishing his picture, contrived—we must hope unobserved—to upset a quantity of dark varnish, which ran in a thick stream directly down the centre of the bright landscape of *Clytie*, thereby cutting it completely in two, and in every way destroying the beauty of the clear landscape and the anticipated effect my

father hoped to excite. The accident was presumed to be unperceived, and the dusting of the rooms took place previous to the private view and dinner. Blacker and blacker became the streak of varnish; more and more disfigured became the picture; all its brilliant beauty paled! The ' private view ' arrived, then the dinner, and the picture of *Clytie* passed unnoticed—all the startling effect having been quite destroyed. Months of work and thought had been wasted. A whole season was quite lost, with the incidental losses in the shape of income and reputation."

" The first Monday in May—the public opening day—came. My father hastened to Somerset House full of every hope and expectation. Fancy his chagrin, his indignation, his disappointment, at finding all his hopes crushed! Appeal was now of no use; it was too late. All chance at the Exhibition was gone."

He goes on to say that the President, Benjamin West, sent his son to apologise for the accident, which he had not noticed till the opening day, but it is clear from this account that neither John Martin nor Leopold were satisfied, or believed the neglect had been unintentional. It is certainly strange that no one should have let the artist know what had happened to his picture between varnishing day and the opening of the Exhibition.

Leopold concludes : " One may date my father's enmity to the Royal Academy from this unfortunate accident, which he never overlooked or forgave."

CHAPTER III

John Martin's next two pictures, *Adam's First Sight of Eve* and *The Expulsion*, exhibited at the Royal Academy and British Institution in 1813. His home in Marylebone High Street. Some glimpses of Old Marylebone; the deer forest and hunting-lodge, village, manor house and farm. Dairy-keepers and farmers of St. Pancras and Kentish Town. Duels on Primrose Hill. Marylebone Spa. The founders of the Botanical Gardens. The Golden Dustmen of Victorian London. The painting of *Joshua Commanding the Sun to Stand Still*. Prince Leopold of Belgium and the Princess Charlotte. Martin's three first children born.

In 1813 Martin sent out two large pictures for exhibition, one to the Royal Academy and one to the British Institution. To the former he sent *Adam's First Sight of Eve*, with the quotation from Milton :

" Nature herself, though pure of sinful thought,
Wrought on her so that, seeing me, she turned."

and to the latter, *The Expulsion of Adam and Eve from Paradise*, with four lines from the same source :

" The world was all before them, where to choose
Their place to rest, and, Providence their guide,
They, hand in hand, with wandering steps and slow,
Through Eden took their solitary way."

Both were accepted, and the former was sold to a Mr. Spong for seventy guineas.

Everyone may not know that the British Institution

was founded in 1805 for the encouragement of British
artists, and a building raised in Pall Mall on a plan by Sir
Thomas Bernard. The lease of the premises expired in
1867. The fund in the hands of the trustees to be devoted
to the promotion of the fine arts had amounted to £24,610
in 1884. From that fund John Martin received several
premiums, the first being awarded to him, as we shall see,
in 1816.

After informing us with some pride that his Adam and
Eve picture had been hung in the Great Room of the
Academy, Martin goes on to say : " My next picture, *Clytie*,
though a picture which has stood the test of criticism during
many years, was in 1814 placed in the anteroom of the
R.A." ; which certainly leads me to suppose that he painted
two *Clyties*. The first may have been the one we find
under the title of " A Landscape Composition," at the
Academy in 1811. But no picture of his seems to have
made an appreciable stir till, in 1816, his painting of *Joshua
Commanding the Sun to Stand Still*, from the text, " The Lord
discomfited them before Israel " (Joshua x. 10-12), was hung,
much to his disgust, in the anteroom. The following year
he sent it to the British Institution, where it attracted
great attention and received the chief premium of the year
—one hundred guineas.

It was not sold, and we find it again exhibited at the
British Institution in 1849, when a critic writes :

" The most important contributors to the present
exhibition are Mr. John Martin, Mr. Lee, Mr. Sidney Cooper,
etc. . . . Mr. Martin contributes a large picture of *Joshua
Commanding the Sun to Stand Still*, a commission, we

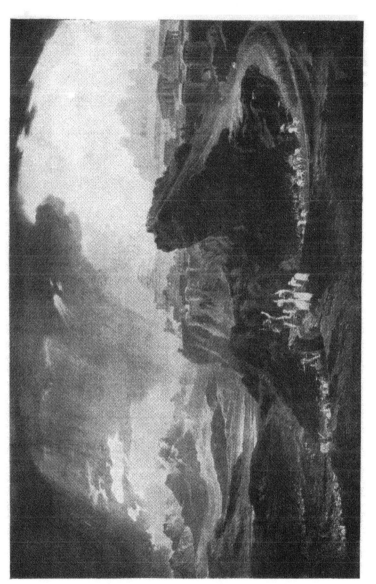

JOSHUA COMMANDING THE SUN TO STAND STILL.

p. 62.

believe, from a well-known patron of English art. The incidents and combination are the same as in the large engraving, but the painting is certainly superior to anything which we remember to have seen from Mr. Martin's easel for several years. The distances are admirably managed and the whole conception brought out in a wonderful manner. It is, perhaps, a little too blue." [1]

John Martin tells us that the picture was not sold till some years afterwards, when it went as a companion to *Belshazzar's Feast*, both pictures being bought by a Mr. Charles Scarisbrick, of Scarisbrick Hall, and afterwards sold at his sale at Christie's, to Capt. Leyland (afterwards Col. Naylor-Leyland), of Hyde Park House, Albert Gate. We find them in the list of loan exhibitions [2] in 1862, when they were shown at the International Exhibition, and *Joshua Commanding the Sun to Stand Still* appeared, with three other paintings by Martin, at a Wrexham exhibition in 1876. For many years they have been hanging at Leighton Hall, Welshpool, the country house of Mr. J. M. Naylor, by whose order they have again been sold at Christie's this year (January, 1923). These once famous pictures have been since then—and may be still—on view at Mr. Drake's gallery in St. Mary Axe.

Whether he painted a second *Joshua* for the Exhibition in 1849, or whether its owner allowed it to be exhibited then, as representing Martin, we do not know. It is treated in the above notice as a new picture, although the engraving of a presumably earlier one is mentioned. On March 10 of

[1] *Illustrated London News*, Feb. 17, 1849. [2] Graves, vol. ii.

the same year a rough print of the picture is given in the *Illustrated London News*, with a full description of the subject, and the biographical article by Peter Cunningham which roused the painter's ire. If the picture had been painted twenty-two years before and attracted great attention, it seems strange that we find it cropping up again as an important work of art only a few years before Martin's death, and receiving the descriptive treatment of a new and original picture. Of it Martin writes :

" Down to this period I had supported myself and family by pursuing almost every branch of my profession —teaching, painting small oil pictures, glass enamel paintings " (does he mean glass *and* enamel ?), " water-colour drawings ; in fact, the usual tale of a struggling artist's life. I had been so successful with my sepia drawings, that the Bishop of Salisbury, the tutor to the Princess Charlotte, advised me not to risk my reputation by attempting the large picture of *Joshua*.[1] As is generally the case in such matters, these well-meant recommendations had no effect ; but, at all events, the confidence I had in my own powers was justified, for the success of my *Joshua* opened a new era to me."

To the first mention of this picture (*Joshua*) we find a parenthetical note given : " (Historical Landscape Painter to their Royal and Serene Highnesses the Princess Charlotte and Prince Leopold)," and concerning this his son writes :

" My father and his devoted wife resided in rooms at a quiet house in High Street, Marylebone, a portion being at

[1] I possess one of these, a scene from *Ivanhoe*, dated 1829, with its text below in Isabella Martin's handwriting. It is exquisitely drawn and certainly lends support to the Bishop's advice.

the same time occupied, in an equally unpretending manner, by Prince Leopold of Saxe-Coburg, then nearly unknown, but subsequently the husband of the Princess Charlotte of Wales. Both princess and prince subsequently proved truly valuable patrons. The princess became his pupil in drawing, as well as a liberal patron, never overlooking the once fellow-lodger of her royal husband. The prince, when King of the Belgians, not only conferred the insignia of Leopold upon my father, but distinguished him in many other ways." [1]

There seems to be a little doubt as to the date on which John Martin's first child, William Fenwick, was born, but it was probably in 1810. The date of this boy's death is given as 1813, and the birth of Isabella, the eldest daughter, as 1812.

Then came another son, John, who died in 1814.

Leopold states that Isabella was named after her mother's mother, Isabella Thompson, of Low House, Haltwhistle; adding, with a little crow of obvious pride : " the Thompsons claim uninterrupted descent, or nearly so, from Nicholas Ridley, Bishop of London, Christian Martyr, burnt A.D. 1555." It is an interesting note as, if true, it bears on the religious bias shown in the Martin family.

We may conclude that Martin had one child when his ' Landscape Composition ' was hung in 1811, and two children at the time he painted *Sadak*. He was then living at 77, High Street, Marylebone, in the house partly

[1] He was godfather to Leopold Charles Martin, John's second son.

occupied by Prince Leopold of Belgium ; and I will beg
your leave to step off the running line of narrative for a
while in order to consider the Marylebone of that date, and
the surroundings in which the young painter worked.

A very interesting part of our capital city, Marylebone,
has been strangely neglected by most writers upon London.
Lambert, in his *History of London* (1806) says : " Maryle-
bone was a small village almost a mile distant from the
nearest part of the Metropolis ; indeed it was formerly so
distinct and separate from London as not to be included in
most histories and typographical works devoted to the
Metropolis," a fact which may account for this neglect.
The whole district formed part of the great Forest of Middle-
sex, at one time an oak forest which, according to Fitz-
stephen's *Survey of the Metropolis* (1170-82) was "full of
lairs and coverts of beasts and game, stags, bucks, boars
and wild bulls," but seems to have been deforested early
in the thirteenth century, though we read that the old
Marylebone fields once contained a large number of these
oaks, which were used for shipbuilding.

From the remains of this great forest Marylebone Park
came into being. We find the survival of its name in St.
John's Wood, the first church there (in Tybourne village)
being dedicated to St. John. And it was Marylebone Park
up to the time when it underwent an artificial change and
was re-christened the Regent's Park in honour of ' the First
Gentleman of Europe,' who concerned himself in its
reconstruction.

In the time of Elizabeth Marylebone Park was at the
height of its glory as a hunting ground, and she appointed a

" Lieutenant of the Chase and a Keeper for Maribone " at salaries of £12 13s. 4d. and £10 respectively. The Manor House, a very beautiful Tudor building, according to old prints of it, was built in the reign of Henry VIII., and used by him as a hunting-box. It is to be regretted that it was demolished in 1791.

The name of Marylebone, called by early writers Maribone and Marybourne (or Mary Bonne), by Pepys Marrowbone, and in *Dr. Syntax*, Mary-boune, was taken, as most Londoners know, from a church dedicated to the Virgin, built by a brook or ' bourne.' About the year 1400 it took the place of a church dedicated to St. John, and was situated on the eastern side of a rivulet that started in Hampstead and ended near Vauxhall Bridge. This rivulet, called the Tye, or the Ty-bourne, Eye-burn, Tybrook, Eyebrook, etc., had, as its source, the Shepherd's Well, near the meeting of Fitzjohn's Avenue with Lyndhurst Road, now converted into a public fountain. The present lake in Regent's Park, a piece of low-lying, marshy ground, was fed mainly by the Tybourne and its branches up to a century ago.

But the chief interest of this stream, and the forgotten village named after it, lies in its notoriety as a famous— or infamous—place of execution. The ' Tyburn Tree ' stood there once, though it was shifted many times and finally established a few yards west of the present site of the Marble Arch, according to one authority. Another states its site to have been on the spot where Edgware Road and Bayswater Road meet.

Standing in that busy thoroughfare now, it is not easy to imagine what Marylebone was like at the time of which

Leopold Martin writes. The gallows may still have reared its ugly head at Tyburn when John Martin took his bride to the rooms in Northumberland Street, and when green fields stretched about Marylebone Park Farm, of which several old prints are still extant, showing that as late as 1807 the district was still quite rural. There is a picture in the National Gallery which even shows the particular breed of cattle for which the Park Farm, Marylebone, was remarkable! In 1794 the park was divided up into forty-three fields, 543 acres in extent, and was held by three tenants.

Thus when Leopold Martin tells us that his father's house " nearly opened upon green fields, St. John's Wood and Hampstead," we know he wrote truthfully, though it seems impossible now that either Marylebone Road or the house in Allsop's Terrace, into which John Martin moved, could ever have been in the country. Regent's Park has done its best to keep up the rural character, it is true, and further along, up in Hampstead and Highgate, one feels the country air and enjoys the country green. But Marylebone suggests nothing save bricks and mortar to one's mental eye.

The old Manor House, after being turned into a school, was pulled down in 1791, at a time when many changes were made in Marylebone. Hedges were uprooted, old lanes done away with, farm buildings demolished. Certain names survive to tell us what was once there—Green Lane, Chalk Farm, Primrose Hill, etc. We have reason to believe that Primrose Hill was actually the haunt of primroses at the time when, a lonely and unlighted district, it was often chosen as a duelling-ground. As late as 1821 we have the

record of a duel fought there by the editor of the *London Magazine* and a contributor to *Blackwood's*, when the former was severely wounded and died at Chalk Farm a fortnight afterwards. And if John Martin and his wife did not hear the shots, they must have shared in the thrilling sensation of the moment.

" Have you heard the news ? " one can imagine Mrs. John Martin saying to her husband at lunch-time when he appeared, dishevelled and perhaps attired in a dressing-gown. " Another duel on Primrose Hill last night. Oh, what fools men are to think they can establish their honour by killing one another ! "

I feel quite sure that Susan Martin would say that, and John, still lost in *Belshazzar's Feast*, would agree with anything at the moment.

One does not need a superabundant imagination to reconstruct the life of that young couple living in High Street, Marylebone, at a time when it was the edge of the green country and Euston Station was still undreamed of. Euston was, by the way, the first railway station built in London, its lines beginning to run between that city and Birmingham in 1838. No doubt John and his wife would stroll in the fields on fine evenings, when the twilight put an end to his painting, and perhaps visit the Chalk Farm Tavern, where all manner of entertainments went on ; though Susan would never venture there alone, as the place had not a good name.

There was another place of amusement at the back of the Manor House, in the reign of Queen Anne, known as Marylebone Gardens and frequented by rank and fashion.

Waters of medicinal virtue were discovered there, and a
spa was the attraction. Pepys mentions Marylebone
Gardens and a house attached known as the "Rose of
Normandy," which was closed in 1776. The house after-
wards occupied by Charles Dickens in Devonshire Terrace
is said to have been opposite this Marylebone spa and the
Old Manor House.

"Since landscape painting has been an important
branch of the English school," observes Leopold Martin,
"Hampstead has seldom escaped the notice of our chief
oil or water-colour painters. It was at all times a spot
much frequented by my father. The walk from town,
through fields and wooded lanes, was most pleasant. The
Eyre Arms Tavern, now the centre of St. John's Wood
district, was then on the outskirts. It was well known as
a place for athletic sports, and for the annual meetings of
the Westmorland and Cumberland Wrestlers.

"I have a perfect recollection of one walk with my
father, who had for a companion Mr. Raffaelle West, eldest
son of Benjamin West, at one time president of the Royal
Academy. . . . As we were passing the above-named
tavern we were startled by friendly shouts from one of the
upper windows. This proved to be occupied by a party of
painters of some note. We noticed Mr. Linton, Mr. Heaphy,
and Mr. Glover, all to some extent known to my father.
Mr. Linton was president of the Society of British Artists.
Mr. Heaphy was highly distinguished as a water-colour
painter, and had served from 1812 on the staff as artist to
the Duke of Wellington during the Peninsular War."

He goes on to relate how they continued their walk,

passing Old Belsize House and grounds, " a mansion truly interesting and historic," close by the "charming and secluded residence of Mr. Thomas Longman," founder of the publishing firm ; and how they called upon Mr. John Constable, the Royal Academician.

" Mr. Constable was then living temporarily at a part of Hampstead termed ' Holmwood,' not far from the rustic cottage for a time occupied by Charles Dickens, while engaged in writing *Barnaby Rudge*. He received us in his usual kind-hearted, homely manner. In person, as was his wont, he was untidy, for he lived, like an equally great painter, Salvator Rosa, constantly in the wild, splashy, wet, dripping woods, during storm, rain, and wind, all of which have been so perfectly depicted by the great ' splashy ' painter, justifying the remark made by the immortal artist, J. M. W. Turner, when directing his servant to bring him an umbrella, as he was going to call on Mr. Constable. The house at Holmwood had lovely surroundings. Mr. Constable's favourite sketching ground, a place that went by the name of Child's Hill, was near at hand. It was a woody spot, distinguished as the semaphore, or telegraph station, being the first from London to Portsmouth and working directly with the Admiralty at Whitehall. The electric telegraph had not come into operation.

" Having an appointment with one of my father's earlier friends then residing at Hampstead, we could not extend our ramble with Mr. Constable. Mr. Thomas Alcock, the friend named, was the distinguished surgeon to St. Thomas's Hospital of whom I have spoken elsewhere. The object of the appointment was to inspect an interesting

garden cottage, then to be let, which Mr. Alcock was rather disposed to take. It was old, with good gardens and grounds, and nearly adjoined those of Belsize Park. The chief interest in the eyes of Mr. Alcock lay in the fact that it had, at a former date, been occupied by Charles Sedley, the wit of Charles the Second's Court, and subsequently by Sir Richard Steele. It retained the name of Steele Cottage. It no longer exists, but the district roads bear the names of Sedley and Steele."

We get a number of little sidelights upon various celebrities of the day, with these pictures of old Hampstead and its houses, from this garrulous Leopold.

" There were lanes," he writes, " within a walk of our house, with the scent of sweet old-fashioned flowers, wild roses, honeysuckle and the like, leading to the wonderfully rich and beautiful districts of Twyford, Castlebar, and Hanger Hill, the chief sketching place of my father. Hanger Hill House, a charming spot, was then the residence of Lady Byron, the widow of the poet. Lady Byron formerly resided at the foot of the hill in a charming old house named Fordbrook, once the residence of Henry Fielding, the author of *Tom Jones*. Ignatius Bonomi, brother to Joseph Bonomi, who married my younger sister, Jessie, took as wife Cecilia Fielding, daughter of Henry, by which our family became immediately connected with that of the great novelist," and he goes on to tell us more of Lady Byron and her daughter.

" Lady Byron, mother of Ada, ' sole daughter of my house and heart ' as Byron wrote, then a timid, delicate, but beautiful, child-like girl, was often seen by us walking her

pony in the rustic lanes of Hanger Hill. She (Ada) was by
far too timid to trust without a leader at the bridle to
guide. Who then could have contemplated that this
delicate, timid daughter of the great Lord Byron would
develop into the distinguished mathematician, Ada, Countess
of Lovelace ? Well do I remember seeing the funeral of
her father in 1824. The body lay in state for two days
at No. 25, Great George Street, Westminster. The whole
place was blocked up from early morning with spectators
and I followed the procession as far as the New Road, near
Regent's Park."

Further on we have the following sketch of a character :
" My father's friend, Mr. Welling, was at one time the
chief dairyman and cowkeeper for the West of London,
farming all the open country of Marylebone Fields, Camden
Town, St. Pancras, even on to Hampstead, together with
the open spaces of St. John's Wood, all combined and known
as ' Welling's Farms.' One of Welling's farms is now
known as Regent's Park. It really extended to Hampstead
and included the fields of Kentish Town. . . . At the
period of which I write Mr. Welling occupied Twyford
Abbey, the owner of which, rather than subject himself
to the poor, and other like rates, had no fixed residence. All
servants and others employed on this estate were paid by
the year, receiving annual notice to quit, so as to preclude
any claim on the parish for relief in time of need and
destitution."

What would the good gentleman have said to our in-
surance and employers' liability measures ?

In Mr. Webster's delightful work on Regent's Park and

Primrose Hill, we find it chronicled that the ancestors of Cecil Rhodes were " the largest farmers in St. Pancras and rented a portion of the Park, near the York and Albany, at Gloucester Gate."

The largest farmers in St. Pancras !

Two other celebrities of Marylebone, the nurserymen Jenkin Brothers, a sketch of whose very quaint cottage has been preserved in the Sowerby family (James de Carle Sowerby being the earliest secretary of the Royal Botanical Gardens), are mentioned by Leopold Martin as follows :

" Blandford and Hareweed Squares were the site of extensive nursery gardens occupied by the brothers Jenkins, keys being paid for by subscribers. The Jenkinses subsequently removed to the inner circle of Regent's Park, and really founded the gardens of the Royal Botanical Society."

But his most interesting account of old Marylebone is in his story of the original Golden Dustman, upon whom Dickens must have based his conception of the cruel miser, Harmon.

" From the early companionship of Charles Muss," he says, " my father's friendship with so many celebrities can be traced "—here follows a string of names—" Great was his enthusiasm for the charming daughters of Bartolozzi, Madame Vestris and Mrs. Anderson. But few were more appreciated than the four distinguished daughters of a certain Major Clark, constant visitors at Mr. Muss's. The Major, when young, had married the only child of a well-known character in the parish of Marylebone, a Mr. Porter, sweep, scavanger, and dustman, who, on the marriage of his daughter, endowed her with a mountain of dust, then

tanding in the New Road, said to be valued at £10,000.
This mountain stood on the site of what was originally one
of the great pestholes at the time of the Plague. In Mr.
Porter's time it was an open space of parish ground, at
present (1889) occupied by the Metropolitan Railway, and
known as the Portland Road Station. Mr. Porter's dower
is said to have been the origin of the term ' coming down
with the dust.' "

Compare Dickens :

" The man," Mortimer goes on, " was the only son of a
tremendous old rascal who made his money by dust."

" ' Red velveteens and a bell ? ' the gloomy Eugene
inquired.

" ' And a ladder and basket, if you like. By which
means, or others, he grew rich as a Dust Contractor, and
lived in a hollow in a hilly country entirely composed of
Dust. On his own small estate, the growling old vagabond
threw up his own mountain range, like an old volcano, and
its geological formation was Dust, coal dust, vegetable dust,
bone dust, crockery dust, rough dust, and sifted dust—
all manner of Dust. . . .

" ' He chose a husband for his daughter, entirely to his
own satisfaction, and not the least to hers, and proceeded
to settle upon her, as her marriage portion, I don't know
how much Dust, but something immense.' "

We can hardly realise the state of things now, but it is
a wonder there was not another Great Plague in London in
Victoria's day. For we read that " early in the century the
great dust-heaps of London (where now stand Argyle, Liver-
pool, and Manchester Streets) were some of the disgraces

of London ; and when the present Caledonian Road was
fields, near Battle Bridge were heaped hillocks of horse
bones. The Battle Bridge dustmen and cinder-sifters were
the pariahs of the Metropolis. The mountains of cinders
and filth were the *débris* of years, and were the haunts of
innumerable pigs. ' The Russians,' says the late Mr.
Pinks, in his excellent *History of Clerkenwell*, ' bought all
these ash-heaps to help rebuild Moscow after the French
invasion.' The cinder ground was eventually sold, in 1826,
to the Pandemonium Company for £15,000, who walled in
the whole and built the Royal Clarence Theatre at the
corner of Liverpool Street." [1]

Here, then, lived John Martin and his wife, between dust
mountains and green fields ; and we can see him painting
hard all day at his *Joshua*, giving lessons at intervals to the
gracious Princess Charlotte—England's hope at that period
—and other pupils ; while Susan probably sat in a corner
of the studio (what kind of studio could it have been ?)
rocking the cradle with her foot and either stitching baby
clothes or reading aloud to him the works of Defoe, Richard-
son, or Goldsmith. In March, 1816, the second girl and
third child, Zenobia, was born. Susan must have had her
hands full, and the hundred guineas awarded to her husband
for his picture must have been a godsend for which she was
devoutly thankful.

[1] *Old and New London.*

CHAPTER IV

John Martin's exhibited pictures between 1814 and 1818. His several changes of address and distinguished neighbours. Love of chess and games generally. His irascible temper. Friendship with Leigh Hunt's Brother. An interview with Turner. Hazlitt's criticism of Martin's pictures.

IN 1814 we find the mention of a smaller picture in the list of exhibitors at the British Institution. It is called *Salmacis and Hermaphroditus*, and bears the explanatory motto he was wont to attach to his pictures :

> " But oft would bathe her in the crystal tide,
> Oft with a comb her dewy locks divide,
> Now in the limpid stream she viewed her face,
> And dressed her image in the floating glass." (OVID.)

At this time, if not at all times in his career, Martin seems to have loved painting the nude, and heaven alone knows how he managed to do it. In no chronicle that has come into my hands is there any reference to his studying from the human model. His first teachers, the Mussos, father and son, were landscape painters by profession, and although he tells us that he sat up at night studying architecture and perspective, he does not say anywhere that he ever drew from the cast or from the human figure. Critics fell foul of his figures, complaining that they were defective and lacked dignity. But the fact that such pictures as *Adam's First Sight of Eve, Clytie,* and *Salamacis*

and Hermaphroditus were accepted by the judges of the Royal Academy and British Institution gives them a certain sanction and suggests that their defects were not radical. How he learnt to paint the human form at all must remain a mystery.

The mark made by his *Joshua* on the public mind, the notice it received from the Press, and the hundred guineas received as a prize from the British Institution, must have been a great stimulus to Martin, for we find him very fruitful in 1816 and the two following years. *The Bard* was hung in the Academy in 1817, with its motto :

> " Ruin seize thee, ruthless King :
> Confusion on thy banners wait."—GRAY.

and at the British Institution in 1816-17 he is represented by no less than ten pictures, namely : *View of a Lane near Hampstead, Carisbrook Castle, View of Kensington Gardens, Another View in Kensington Gardens, View of the Entrance of Carisbrook Castle, Evening* (" The Curfew tolls the knell of parting day "), *Landscape Composition, Another View of Kensington Gardens, The Hermit* (" Turn Gentle Hermit of the Vale ") and *Joshua Commanding the Sun to Stand Still.*

He also did for Ackermann a series of etchings on copper of English forest trees illustrating a book issued in 1816 under the title of *The Character of Trees.* This is the first we hear of John Martin as an etcher, and again we are impelled to wonder where he learnt the fine art of etching. Possibly the success of this first attempt led him later to undertake the engraving of his own pictures.

Martin seems to have lived in two different houses in

High Street, Marylebone. Under his name in the British Institution list it stands as No. 77, but later (in 1816) below one of his pictures, *View of the Entrance to Carisbrook Castle,* it is stated as No. 75. And in the Royal Academy list we find his *Landscape Composition* sent from 77, High Street, while *Adam's First Sight of Eve* is sent from 75, High Street. We may therefore conclude that between 1811 and 1813 he shifted camp, and there are reasons for assuming that it was at No. 75 he found himself under the same roof with Prince Leopold of Belgium, his first, and perhaps his most loyal, patron.

In 1816 we find him styled for the first time in the catalogues " Historical and Landscape Painter to their Royal and Serene Highnesses the Princess Charlotte and the Prince Leopold," and from that date, apparently, John Martin's star began to ascend. In 1817 he took a house of his own, persuaded to do so by his old friend, Boniface Musso. He tells us that he had no money for such a venture, but was induced to borrow from the Mr. Manning who had bought his *Sadak.* We read the story of that purchase in Serjeant Thomas's memoir.

Sadak had been returned to him unsold after its exhibition at the Royal Academy in spite of the flattering notices it had received in the papers, and he had been much depressed. But when he went home one evening, tired and dejected, after trying to sell some sketches, he found that a gentleman had called upon him to ask the price of *Sadak,* and had left his card. Weary as he was with tramping the London streets, John set off to find his patron, but, making some mistake in the address, failed to

do so and returned home once more, worn out and des-
pairing.

Next morning he tried again, and succeeded in finding
Mr. Manning, who received him very politely and requested
to know the price of the picture, *Sadak*. Said John in
trembling accents : " ' My circumstances are very reduced
and therefore I will sell it for considerably less than the
price I had fixed. I put one hundred guineas upon it in
the Exhibition, but you shall have it, sir, for fifty guineas.'
Mr. Manning readily acknowledged the price was far less
than its merits deserved, and in paying it observed that
he considered himself Mr. Martin's debtor, and hoped he
would command his services at any time he needed them."

It transpired later that his son, who had recently died,
had been so enchanted with the picture that he went to the
Academy frequently to gaze on it, and the bereaved father
wished to possess it for the young man's sake.

When, therefore, John had seen a house in Allsop Terrace
that he fancied, his friend Musso suggested that he should
take Mr. Manning at his word and ask for a loan sufficient
to pay the first year's rent and help to furnish it.

The sum decided upon was £200, and as Mr. Manning
proved as good as his word, the house was taken, not
without misgivings on Martin's part, for he had a horror
of debt, and was very loath to borrow. But he seems to
have been persuaded into the venture by Boniface and
Charles Muss, who thought it necessary he should make a
little show in the world. The wisdom of this view was
afterwards proved, for although John suffered agonies of
mind for some months, seeing ruin and debtor's prison ever

»efore his eyes, he began to prosper soon after moving to ‹is first *whole* house.

" Allsop Terrace," Leopold writes, " was then of con- iderable consequence. Rows of mansions were hardly ‹nown and Westbournia was unbuilt. Fitzroy Square was ‹ fashionable locality. Dorset Square was the Lord's ‹ricket Ground—Lisson Grove was really a grove, St. [ohn's Terrace being its termination. My father's new ·esidence " (they always resided in residences in Leopold's lay ; to live in a house would have sounded rather vulgar)— ' opened on, or nearly opened on, the green fields of St. [ohn's Wood and Hampstead. It was here, in the back garden, he built his first painting room, with an outlet into ‹ back lane ; and subsequently, upon its foundation when ‹ebuilt, a substantial private painting establishment and convenient painting room, attached to the house by a long gallery and supported by iron pillars."

John tells us that the house pleased him very much, as ‹t had north and south aspects and he could get into the fields, park, or Kensington Gardens in a very few minutes, adding : " These places were to me like my own garden. I frequented them so much and painted them so often."

He had a number of distinguished neighbours. Leigh Hunt, William Beckford, Macready, Turner, Charles Wesley, Mrs. Siddons, Lady Byron, Mrs. Fitzherbert, and Charles Dickens are some of those mentioned. And before he left the district he seems to have known most of them.

Owing to the almost entire absence of dates in his son's memoir, it is not possible to say when John Martin's friend- ship with the Hunts began, but it was probably before he

F

became famous. At all events, we learn that the weekly gatherings which afterwards became famous as ' evenings at home,' were first started by John Martin and John Hunt (brother to Leigh and editor of the *Examiner*) for the purpose of indulging their passion for chess. John Hunt lived in " a pretty cottage in what was then known as Black Lion's Lane, but now designated Queen's Road, Bayswater," and his wife, as well as Mrs. Martin, seems to have been a chess-player, for the two couples met alternately at each other's houses once a week to engage in this solemn pastime. After a time others begged for admittance, and by degrees the original object of the meetings was lost, music and conversation usurping its place.

Apropos of his father's love of chess, Leopold tells an amusing story of John Martin in later life that throws some light on the painter's temperament. He prefaces it by saying that chess was the only amusement which really had any serious effect on the usual even temper of his father, and continues :

" An arrangement had been come to with a very old friend, a truly amiable man, magistrate for the county of Middlesex, and a very good chess-player, to make two or three weeks' tour in North Wales, chiefly for the purpose of sketching, but also for general amusement. The chess-board, of course, formed an important portion of the contents of the portmanteau. On arriving at a romantic village in a remote district in North Wales, the friends enjoyed the usual chops and tea. The chess-board was then produced, and the game was won by my father, whose friend, in not an unusual way, remarked that the game had

een lost through an unfortunate oversight at a certain point of the game. This was a matter of dispute with my father. The game was thereupon played over again from the point indicated, and with the like result, but the same opinion was still maintained by my father's friend. It was, therefore, again replayed, and temper was lost! The friends left the table and retired to their respective rooms without their usual glass and good-night! Before breakfast next morning my father's portmanteau was packed and he was off to complete his tour alone, leaving his old companion to return home or go elsewhere as he pleased."

Serjeant Thomas relates more than one instance of John Martin's violent temper when roused :

" We were throwing the javelin at a mark on a tree, in a pleasant avenue about six miles up the Paddington Canal," he says, " Leopold, his partner, Alfred, Charlie, and myself. We were all of opinion that he had missed the mark, but Martin was positive he had hit it. He grew wild at contradiction, spoke passionately, and finally became infuriated. . . . But," continues Thomas, after some heated dialogue, " as we bent our way home he stopped suddenly, came to a sense of his folly, and said, ' How foolish, how very weak, to throw myself into such a vulgar passion about such a thing—to make a fool of myself over such a trifle ! ' " Again, in another place, we read : " I dined with Martin, and Peter Cunningham dined with us. We argued about poetry, and Martin, as he usually does if crossed, got into a towering passion."

Nevertheless, Ralph Thomas, no less than Leopold, does not accuse the painter of being an ill-tempered man.

These fits of rage were not common, we may believe, and only to be expected from a man of his excitable temperament and immense vital energy.

He was, according to his son, a great lover of games and exercise of all kinds. Fencing was a daily amusement, and he took lessons from a professional teacher in the art that seems to have fascinated all the Martins. The javelin-throwing to which Mr. Thomas alludes, appears to have been a game of his own invention, in which he was very keen. It was, says Leopold :

" As novel as it was athletic. For practice he had attached to his ordinary walking canes heavy iron heads, or cones, weighing about six or eight ounces, and forming, as it were, spear heads. The procedure of the game was to select a well-developed tree growing in some secluded spot, to mark out a target with chalk on the bark, and then, at a given distance, say twenty yards, to hurl the javelin, as it was termed, at the bull's eye, counting the marks in the ring as usual. As one took, at each throw, a step back until a considerable distance might be obtained, the exercise was a capital one, even for an athlete, and one which brought out favourite actions (often depicted) in my father's paintings, especially in the pictures of *The Fall of Babylon* and *The Fall of Nineveh*. Many fine trees may yet be seen in quiet spots in the outskirts of the west of London with the ' target ' very evidently marked on the bark."

He was also a great walker. From Queen Street, Cavendish Square, through Hyde Park and Brompton to Chelsea was but ' a pleasant ramble ' to him, and one such walk, as recorded by Leopold, may be quoted in this con-

nection, although it must have been taken at a later date than that to which we have so far pursued him ; at a date, in fact, when his second boy was old enough to walk so far with him. The occasion was a visit to Turner, and this is how our observant and voluble memorist describes the great man and his surroundings :

" J. M. W. Turner then resided at Queen Anne Street, Cavendish Square. The house was a gloomy, detached, five-windowed, large-doored abode. An extensive studio occupied the back of the residence. We found the great painter at work upon his well-known picture, *The Fighting Téméraire*. Mr. Turner hardly struck one as a man who was producing works so full of poetry and art. His dress was certainly not that of a refined gentleman and painter. A loose body coat, very open side pockets, with a dirty paint rag stuck in one of them ; loose trousers, unbraced, and hanging under the heels of his slippers ; a large rosewood palette on his thumb with a very big bunch of brushes of various sizes in his hand, and a rather old hat on his head—such was J. M. W. Turner at work. The studio was dark and gloomy, in every way like that of an untidy man, and not at all what one would have expected from so great a painter.

" Mr. Turner intimated that, on my father's arrival, the was on the point of walking over to his small place a Chelsea. If inclined for a walk, would he accompany him ? This my father willingly agreed to do. Crossing Hyde Park, Brompton, and so on by the footpaths through market gardens to Chelsea—a very pleasant ramble—Mr. Turner introduced us to a small, six-roomed house on the banks of

the Thames, at a squalid place past Lindsay Row, nea
Cremorne House. The house had but three windows i
front, but possessed a magnificent prospect both up an
down the river. With this exception, the abode wa
miserable in every respect. The only attendant seemed t
be an old woman, who got us some porter as an accompani
ment to some bread and cheese. The rooms were ver
poorly furnished, all and everything looking as though i
was the abode of a very poor man. Mr. Turner pointe
out, with seeming pride, the splendid view from his singl
window, saying, ' Here you see my study—sky and water
Are they not glorious ? Here I have my lesson night an
day ! ' The view was certainly very beautiful, but hardl
of that description one would have expected the grea
Turner to glory in. Effect was all he required. Mind gav
the poetry of the picture.

"At Chelsea, Mr. Turner saw no one. He was quit
unknown, passing under another name—that of his ol
housekeeper. His life was that of a recluse, one of abjec
poverty. When in Queen Anne Street, the only visits
except chance calls like my father's, were those of patron
or connected with professional requirements. No member
of the fair sex were ever seen to enter the house. In person,
not only in his study, but at all times, Turner was untidy
a sloven and unwashed—one that might well have been
taken for a Hebrew ' old clo' ' dealer, but certainly not fo
the greatest poetical landscape painter of his age."

It is interesting to observe, in the little private criticism
of Turner's work which follows this account, a curious
resemblance to Hazlitt's verdict on John Martin's pictures.

Says Leopold : " Turner was once without a rival ; all that his fancy whispered his skill as an artist executed. At a later day, however, he forsook the beautiful and applied himself to the fantastic. He no longer sympathised with nature, but coquetted with her."

And Hazlitt observes of John Martin : " He strives to outdo nature, to give more than she does, or than his subject requires or admits. . . . The only error of these pictures is, however, that art here puts on her seven-league boots and thinks it possible to steal a march upon Nature."

But we must return to the time before Martin had put on his seven-leagued boots and begun to steal his march upon Nature ; the time when he built his first studio and started on his new big pictures, *The Bard* and *The Fall of Babylon.*

CHAPTER V

Martin's Change of Address—*The Fall of Babylon* exhibited at the British Institution and sold for four hundred guineas. Breakfast with Sir Walter Scott and his visit to Martin's studio to view the picture *Macbeth*. Martin's resentment against the Royal Academy, and criticism of its methods. Friendship with Leslie. Sir George Beaumont, art patron and connoisseur. Story about Wilkie. Visit of Mrs. Siddons and Charles Young to the Studio.

SPURRED by the debt hanging over him and the shadow of the wolf at his door, John Martin started on a new painting, *The Fall of Babylon*, we must believe, as soon as he was settled in his new house at Allsop Terrace. Whether he finished his previous picture, *The Bard*, there or not, it is impossible to say, but it was exhibited at the Academy the same year (1817), sent from the new address, and the following year at the British Institution. It was a large picture, eight feet by seven, but it seems to have made no very distinct mark, and although shown at two such important exhibitions, to have found no immediate purchaser.

The Fall of Babylon (in 1819), however, was more fortunate. A smaller picture than *The Bard*, it must, nevertheless, have been more impressive, for it captured the fancy of a rich art connoisseur, Mr. H. T. Hope, who paid him four hundred guineas for it, the price Martin had

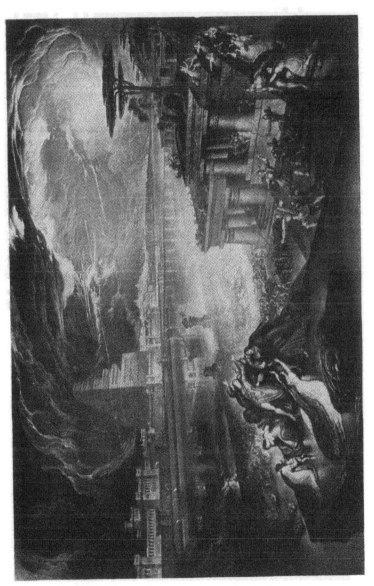

THE FALL OF BABYLON.

put on his picture. His delight at this success was un-
bounded.

" Mr. Hope saw, admired, and bought my picture," he
says. " He at once sent me a cheque for the four hundred
guineas in a letter that fills my breast with rapture now, and
whenever I think of it. Four hundred guineas! A sum
which is enough to set me free, to unmanacle me from the
chains of debt, to place me above want ; aye, to secure me
a year's affluence. . . . No prisoner liberated, no manu-
mitted slave, ever tasted a more exquisite relish of happiness
than I did at the moment I read that sweetest of all epistles.
. . . I lost not an hour in redeeming my bond from Mr.
Manning and paying the debt with the interest due ; thus
cancelling the monetary part of the obligation, but the
grateful remembrance of it never. If I had not succeeded
now, I must have sunk. Increased rent, increased expenses
everyway. . . . I felt as much joy, and glut of delight, at
painting a picture on which I put four hundred guineas,
and getting it, as Wellington must have felt in conquering
Bonaparte. I had thirsted to succeed as a Painter. Was
not this success ? If not with the world, it was for me
and my family, my friends, my creditors, and my encourage-
ment."

The depth of this gladness and gratitude seems never
to have been wholly discharged. At a dinner-party some
years afterwards, in returning thanks for a toast, he spoke
with simple boyish fervour of his debt to Mr. Manning and
his joy at repaying the loan borrowed. Some of his friends
appear to have taken him to task afterwards for his plain
speaking and warned him that it is prudent to avoid speaking

in public of one's early struggles; for he is reported to have said : " I have always tried to uphold, by argument and example, the speaking of your genuine thoughts and the acting upon your conscientious beliefs " ; and we find that, all through life, John Martin remained unaffected, unashamed of his humble origin, simple and impulsive as a boy.

His pride was all vested in himself, in his own talent and work ; he was the prouder that he owed nothing to the position in which he was born ; and that pride was deeply hurt by the way his pictures were treated by the Royal Academy authorities. Reasonably so, we may conclude, since the picture considered of sufficient merit to win the hundred-guinea prize of the British Institution was hung in the anteroom at Somerset House.

It is not surprising, therefore, that he sent *The Fall of Babylon* to the British Institution (1819), although we find a number of his less important works in the Academy list In 1818 he had four pictures there : *View of the Fountain, Temple and Cave in the Grounds of Sir C. Cockerell, Bart., M.P. ; View of the Farm belonging to Seizincot House, the Seat of Sir C. Cockerell ; South Flank of Seizincot House ;* and *View of the Fountain of Seizincot House.* These may have been water-colours, and were probably commissions. In some quarters John Martin's landscapes were preferred to his subject paintings, but two only have been preserved —scenes in Richmond Park. They are in the Victoria and Albert Museum, South Kensington.

In 1820 he was again represented in the Academy by trivial work, *View of a Design for a National Monument to*

Commemorate the Battle of Waterloo, Adapted to the North End of Portland Place, while his subject painting of *Macbeth* (meeting the Weird Sisters on the blasted heath) was hung at the British Institution.

He calls the latter " one of my most successful landscapes. Ralph Thomas informs us that it was one of the pictures he partly repainted some years after its exhibition. " Martin," he says, " was always retouching and improving his unsold pictures, and sometimes even those he had sold." (He was touching up *Edwin and Angelina*, for instance, the property of Mr. Thomas Alcock, a distinguished surgeon of St. Thomas's Hospital, at the same time as *Macbeth*.) The figures of Macbeth and Macduff did not satisfy him— he had probably given more attention to the landscape at the time he painted the picture (a large one five feet eight inches by eight feet)—and it was the same with another early picture of his, *Love Among the Roses*, in which, he said, the figures were originally too large.[1] Rather oddly, he dated them as finished in the year he revised them !

His son tells us that Sir Walter Scott was interested in the painting of *Macbeth* when he visited John Martin's studio in 1831, just before his last journey abroad. The artist and his son were invited to breakfast by Mr. Lockhart, Sir Walter's son-in-law, at his house in Sussex Place, and afterwards :

" Sir Walter accompanied Mr. Lockhart and my father to his studio in New Road, Sir Walter supporting himself with a stick on one side, and with my shoulder on the other.

[1] This picture does not seem to have been exhibited.

On the way the novelist was much interested at the sight of the abode of Mrs. Siddons in Upper Baker Street. The great actress was very ill and died shortly after in the same year. Sir Walter Scott made a rather long stay in the studio, the last of any artist visited by him previous to leaving England, till he returned in 1832 to die. One feature of the visit was the special interest he was pleased to take in one of my father's early works, one of the few still in his possession—the picture of *Macbeth*—expressing great regret at his inability to purchase it, as he would so like to place it on the walls at Abbotsford. My father's like inability to offer it as a gift was also a great regret."

We are sure that it must have been. From every source we learn of John Martin's generous instincts.

" I heard my father state," Leopold proceeds, " that during the painting of this picture two of his friends were greatly interested in the correct pattern of the tartans of Macbeth and Macduff, and, with much kindness, procured patterns of both tartans, which they expressed anxiety to see strictly copied. These friends, he informed Sir Walter, were the brothers John Sobieski and Allan Hay-Allan Stuart, claiming descent from the royal line of Stuart through Cardinal York, brother of Charles Edward, the Pretender. The brothers, John and Allan, were well known in certain circles in London, and were much honoured and respected. John published a history of the ' Tartans of the Clans.' I remember them well : they had much to call to mind the true Stuart blood.

" The St. James's Hotel, in Jermyn Street, was the last London lodging of Sir Walter Scott after his return from

the Continent. The writer of these reminiscences well and painfully remembers the deep, heart-felt feeling of sympathy and sorrow exhibited by those who saw Sir Walter carried from his hotel to his carriage. How distressing was the sight—the prostrate figure and vacant eye! There was many a tear on the occasion of his removal from the hotel on the 7th July, 1832."

The fact that Martin's picture of *Macbeth* and his more important *Feast of Belshazzar*, the following year, appeared at the British Institution Exhibition, and not at the Royal Academy, suggests that it was in this year his resentment against that body was at its height. All his life he seems to have been more or less at feud with the Academy, although many of his greatest pictures were hung there later, and we have constant allusions to this bitterness of spirit in the journals of his son and Ralph Thomas.

Yet the latter tells us that the President, Benjamin West, was a good friend to Martin at the outset of his career, and that Martin always remembered his encouragement with gratitude. It would, indeed, have been surprising if West had not sympathised with an artist whose taste for scriptural subjects was so like his own. But it is possible that, after Martin's first successes, he may have felt himself superseded as a religious painter; for his glories certainly paled in the light of Martin's dazzling and original conceptions.

However that may have been, it is clear that Martin nursed a deep resentment against the Royal Academy, and we have on record many bitter speeches against it. " Benjamin West," he said, " introduced me to Leslie, the talented

young American, and I continued very intimate with him
till he became an Academician ; but the Academy spoiled
many a good man ; as now constituted, it lowers and
degrades men. Leslie, since he got into the Academy,
has kept among them, and aloof from the outside artists.
Different parties, at different times, have waited upon me
to invite me to try and get into the Academy ; but I said
from the first that I would not try while they were so
badly constituted and had such unjust and illiberal laws."
Serjeant Thomas believes that he did once put his name
down at the Academy, or that someone did so for him, but
only once ; never a second time.

At this date it is impossible to judge between Martin
and the Academicians of his day. He was indubitably
arrogant, self-satisfied, and irascible ; the startling origin-
ality of his work was likely to breed distrust in a body of
men bent on preserving classic ideals and more conventional
in its standards, doubtless, than any Academy since. And
as, perhaps, the chief office of academies is to maintain a
classical standard, they could hardly be blamed for dis-
trusting any daring innovation.

Serjeant Thomas tells us that John Linnell shared
Martin's opinion of the Academy, and had cause for an
even deeper grudge against it, since he sent in his name as
a candidate every year for twenty-seven years in vain.
" I have had," he told Martin, " all that time only
moderately good prices ; my pictures were bought occasion-
ally by the best of the collectors, Mr. Baring and others,
but I did not get a third of the price that Collins got, because
I was not R.A. One told me I should give dinners and

make the Academicians my friends in that way. Others told me I should get a more fashionable tailor and assume more style. No one ever said, ' You must paint better to get into the Academy.' "

We have heard all this in our own day. Whether it be just or not, I leave others to judge. But that John Martin managed to offend some of the Academicians there can be no doubt. Nevertheless, he continued to send pictures to the Academy at intervals all through his life, and the reason he gave for this apparent inconsistency was that he considered it the property of the public and therefore claimed it as a right to have his pictures hung in its exhibitions.

(It should be remembered that originally no charge was intended to be made for admission to these exhibitions. It was only in the year 1780, the twelfth oi its existence, that the following notice appeared : " As the present Exhibition is a part of the Exhibition of an Academy supported by Royal Munificence, the Public may naturally expect the liberty of being admitted without any expense. The Academicians therefore think it necessary to declare that this was very much their desire ; but they have not been able to suggest any other means than that of receiving money for admittance to prevent the rooms from being filled by improper persons, to the entire exclusion of those for whom the Exhibition is apparently intended.")

Returning for a moment to Leslie, it is interesting to note that he and Martin were for a long time on terms of intimacy.

" Leslie was once a true friend to me," John is reported

to have said, " in time, too, of need. I loved him dearer than a brother ; we were like brothers in our continual friendship. He lent me some money and sent me some at a time of great distress, and I shall never forget these actions of kindness while I live."

His son tells us that, after Charles Muss, Leslie was, perhaps, his father's oldest and most valued friend. He gives us some rather interesting details of the American artist's home and studio that I may be forgiven for quoting.

" My recollection dates as far back," he writes, " as when Leslie resided in Portland Place, Maida Hill, one of a row of houses with a south aspect, the painting-room facing south. This circumstance, unusual with artists, accounted, perhaps, for the tone of warmth and colour of his early works, many of which became cold and chalk-like in tone on his removal to a studio with a northern aspect in Abercorn Place.

" Once, on calling with my father, we found him engaged with Sir George Beaumont, his hands encumbered with pieces of various coloured silks, with the object of instructing Mr. Leslie in the mystery of *contrast of colour !* Sir George illustrated his ideas with the various tints in the different silk patterns. Mr. Leslie was only too glad of our interruption, being then engaged on his picture of *The Widow*, a black, grey and white painting, requiring very few of Sir George's suggestions.

" Being at a loss for a model, I was requested to become one for the widow's son, and I well remember passing many tedious hours, acting as model in Mr. Leslie's painting-

room. It was quite perfection in the way of accessories. There was more than one lay figure of perfect French manufacture, also fine casts from the antique, armour, various costumes, etc.

" Mr. Leslie was a tall, gaunt man, with hard, dark features, recalling the followers of the founders of Pennsylvania. His dress was at all times black and never without broad-banded black and white socks. He was every bit an American ; kindly in manners, good-hearted, and friendly, but cold to a degree. His house was open to any American of note. My father often mentioned meeting there Washington Irving, Washington Allston, and Gilbert. He also met Stuart Newton, since an R.A., but chiefly known for his paintings of *Sterne and the Grisette*, *Macheath in Prison* (both in the National Gallery), and *The Return of Olivia*, from the *Vicar of Wakefield*, now at Lansdown House. In his well-known *Importunate Authors* the importuned patron is a portrait of my father, who, as a kindness to Mr. Newton, stood for it. The face is like what it must have been when he was young. Mr. N. P. Willis (or ' Namby-Pamby Willis,' as Lady Blessington designated him) was often seen in Mr. Leslie's studio with Bayle Bernard, the playwriter, and many well-known Americans."

Leopold does not attempt to explain how a man can be " kindly in manners, good-hearted, and friendly," yet " cold to a degree." But he gives us a curiously clear portrait of this scion of the Puritan Fathers, and one can visualise the two artists side by side ; the American tall, gaunt, and somewhat severe of countenance, the Englishman

G

much shorter, handsome, vivacious, and full of enthusiasms which he never hesitated to express.

Serjeant Thomas quotes a story Martin used to tell against himself, as a candidate for Academy honours, at the time he was friendly with Leslie. They went to a concert together and when, at the end, the National Anthem was called for and cheered, Martin hissed. It was the time when there was a very strong feeling in the country on behalf of Queen Caroline against the King, and Martin was, characteristically, a partisan of the unfortunate lady.

" I hissed more," he said, " and hissed at Leslie for cheering, forgetting ' God save the King ' altogether. Leslie was horrorstruck and fairly ran out of the room. He said to me afterwards that he regretted to have been with me on such an occasion. I was hurt, for Leslie's sake, and said : ' Well, I am sorry I did it, Mr. Leslie, but it shall not occur again.' Leslie was then aiming for the Royal Academy, and soon after got it. This alone was enough to keep me out, for, in a few hours, this incident spread like wildfire, got to the King's ears, and I was a marked man."

Another story tells how, later on, when Leslie was an Academician, he visited Martin's studio and, after looking coldly at all his finest pictures, chose a small one in a corner as the sole object of his admiration. This was a copy of one of Martin's most insignificant subjects by his son, Charles, then a boy, and Martin believed that the slight was intentional. If so, it probably dated the end of their friendship.

Sir George Beaumont mentioned by Leopold, was well

known at the time as an art patron, and for the active part he had taken in the foundation of the British Institution for the Promotion of the Fine Arts, first opened on January 18, 1806. He also made an important bequest to the National Gallery of sixteen works of art, valued at £8,000, in 1826. He was a staunch friend to John Martin, Leopold tells us, and paid his studio frequent visits. Apparently he was very fond of giving advice to artists, and fancied himself a wonderful judge of colour. Leopold quotes a story told him by his father of how Sir George Beaumont advised him to change the colour of a certain robe in one of his pictures from blue to green, which was immediately done to humour him—and washed out again on his departure. Then, on exhibition of the picture, Sir George pointed to his friends the important improvement in effect as a result of his suggestion of the substitution of " *blue for green !* "

" But," says Leopold, " the visit to the studio of Sir David Wilkie by Sir George is more interesting and affords a very good illustration of his (Sir George's) hallucinations. Wilkie, at the time of the visit, was engaged in painting, and was deeply immersed in his work ; so much so, indeed, as quite to ignore the presence of Sir George. The latter, after a time, reminded him of his presence by a slight touch ; but Sir David seemed like one paralysed or convulsed, with face nearly black, so intensely was he absorbed. Sir George afterwards stated as a fact that ' Wilkie had *forgotten to breathe.*' He often recited the story, his faith in which was certainly undoubted."

We may picture John Martin, in 1820, amid a growing

circle of distinguished friends and patrons, painting his next big picture, whose phenomenal success was to blazon his name through two continents. If his son's word may be credited, it was talked about long before its public appearance, and the artist was inundated with letters from many persons distinguished in the world of science, all expressing opinions and anxiety as to the novel experiment he was about to make. Some of these came from mathematicians of high standing, chiefly professors at Cambridge.

We may take this with as much salt as we please, but the description of one visit to view the work is perhaps worth quoting.

" Flattering as these letters may have been," the urbane Leopold continues, " certain visits to his studio gave even more pleasure—especially a call from the great actress, the wonder of the age, Mrs. Siddons—accompanied by Mr. Charles Young, known and distinguished as an actor, but subsequently as a master at Eton College.

" Mrs. Siddons was enthusiastic in her admiration of the painting of Belshazzar. My father, however, expressed some doubt as to the action, or attitude, of the chief figure, the Prophet Daniel. Mr. Charles Young at once threw himself into what he was pleased to say was *his* idea of the action, of which Mrs. Siddons expressed her decided approval. My father at once saw his way out of a difficulty which had given him much anxiety. . . . In dress Mrs. Siddons was, at this period, almost Quaker-like in her simplicity. Though advanced in years, her face was wonderfully striking. In spite of a very evident moustache, traces yet remained of her former queen-like, perfect, and

splendid beauty ; her conversation retained all the sparkle and interest of her early days ; her fascination and charm, indeed, were wonderful. Mr. Charles Young was known as the chief representative the stage had yet produced of *Hamlet.*"

As Leopold was a very small boy at the time, all this description must have been quoted from his father, who would not be likely to forget the visit paid to his studio by the famous actor and actress. Nor is it likely that he invented it.

We may safely assume that the picture they were anxious to see had already excited some attention in artistic circles.

CHAPTER VI

The sensation created by *Belshazzar's Feast* and its reception by the critics. Charles Lamb's criticism. Exhibition at the British Institution Galleries and premium of two hundred guineas awarded to Martin. Coloured transparency shown in the Strand. Other pictures between 1821-7 : *The Destruction of Pompeii, Seven Plagues of Egypt, Creation, Deluge,* etc. Martin's family life at the time. His landscapes. French view of his art.

PERHAPS no picture ever painted has made so great a sensation as *Belshazzar's Feast,* or brought to its creator a more instant fame. It was hung on the line at the British Institution exhibition in 1821 and won the prize of two hundred guineas presented for the best picture of the year. The enthusiasm created by it was profound and phenominal. So great was its popularity that the authorities of the British Institution were obliged to erect a railing round it, to protect it against the pressing crowd that flocked to see it, and the exhibition was kept open three weeks longer than usual in order that all who wished could see the wonderful painting that had set all London talking.

Martin's triumph was augmented by the fact that Collins, his old master, who had paid him two guineas a week only a few years before, offered him a thousand guineas for the picture ; and he felt a very natural satisfaction at the knowledge that the men who had refused to

p. 102.

BELSHAZZAR'S FEAST.

work with him would now be made aware of his quality and their own folly. But, as he told his friend, Ralph Thomas, he had good cause to be grateful to them after all, since, by driving him to desperation, they had done him a service. He might otherwise have been still plodding contentedly at china-painting.

The picture was evidently painted while he was in a condition of almost intoxicated enthusiasm, for Martin believed himself to be inspired in his subject. He tells how he was spending an evening with the American, Allston (introduced by Leslie), and they discussed the story of Belshazzar's Feast, after which he went home and began to sketch his conception. Allston, he says, had already tried his hand at it, but not, Martin contended, in the right way. He submitted his own design to the American artist and it was approved.

Nevertheless, he says, Leslie urged him not to paint it. We are not given any reason for this advice, and can only assume that the American artist thought the subject beyond Martin's power to execute. But nothing could shake the fiery Englishman's resolve. " I mean to paint it," he declared, " and the picture shall make more noise than any picture ever did before. Only don't tell anyone I said so." His conviction and prediction were alike justified. The ' noise ' was tremendous !

Undoubtedly, Martin liked making a noise in this sense ; his weakness was the weakness of his family, a certain passion for display behind his artistic passion for perfection. But his prophecy need not be taken as inspired. Every possessor of creative faculty feels, in his first frenzy of

enthusiasm at the conception of a new idea, a conviction
of success, a dazzling vision of the world's outstretched
arms. Most of us are doomed to disappointment and failure.
Martin was gifted with the executive power in addition to
the conceptive ; and with these, naturally, sublime self-
confidence.

It is stated, by the way, that Martin derived much
help in his conception of *Belshazzar's Feast* from the reading
of a Cambridge prize poem by T. H. Hughes ; but this is
not mentioned in the intimate memoirs before me.

Collins had the wonderful picture reproduced on glass
and exhibited as a coloured transparency in his window in
the Strand, and we may believe that the crowd continually
before it had to be ' moved on ' frequently by the police.
In the *Dictionary of National Biography* we read of it as
follows :

" *Belshazzar's Feast* is generally regarded as Martin's
finest work, and its masses of colossal architecture, retreat-
ing into infinite perspective, its crowd of small figures, the
glitter of huge gold candelabra and other details of the
feast, all seen in a strange variety of light and gloom,
enhanced by the vivid writing on the wall—produced an
overwhelming effect on the public."

It seems, indeed, from all accounts, that the dear people
of London went mad about the picture, and no doubt it
required courage for any critic to fall foul of it. We feel
this in reading contemporary criticism. There is a certain
distrust and distaste under much of the praise evoked by
the painting, partly due—perhaps chiefly due—to its
extraordinary originality, but little downright denunciation.

It was, in some instances, a grudging admiration that Martin's work received, but it was admiration of a kind.

Even Lamb, in the essay that appears to have been called forth by *Belshazzar's Feast*,[1] pauses now and again in his disapproval of Martin's methods to eulogise his remarkable gifts. His criticism is not in the least technical, by the way, since the objection he raises is what we should call to-day a psychological one. He complains that the people in the picture are not acting up to his conception of what human beings would naturally do under such exceptional circumstances. After stroking the artist with a bland appreciation of his "stupendous architectural designs," as "of the highest order of the material sublime, satisfying our most stretched and craving conception of the glories of the antique world," the gentle Elia goes on to say :

"It is a pity they were ever peopled. On that side the imagination of the artist halts and appears defective."

He then proceeds to tell the story of a puerile trick played by the Prince Regent in his pavilion at Brighton, where, in the midst of a banquet, he had all the lights turned off, and illuminated writing cast upon the wall, with the words: "Brighton—Earthquake—Swallow up alive," and declares that the figures in John Martin's painting have no more tragedy or dignity than if they had been the victims of such "a paltry trick."

It does not seem to occur to Lamb that the first shock of such a startling phenomenon might well be as effective, for the moment, in its operation on the minds of the Regent's

[1] On the Imaginative Faculty.

courtiers as upon those of Belshazzar. Reason would be
paralysed in either case, and " the huddle, the flutter, the
bustle, the escape, the alarm—the consternation—the vulgar
flight, the mere animal anxiety for the preservation of their
persons," etc., to which he so scornfully objects, would be
alike in both cases.

He does not think that the " supernatural terror, caused
by the Finger of God writing judgments," would manifest
itself in mere vulgar flight, but would have been met by
the withered conscience in a different way.

" There is a human fear and a divine fear. The one is
disturbed, restless, bent upon escape. The other is bowed
down, effortless, passive."

Perhaps. But Lamb must have forgotten that the
artist can seize only a given moment of the emotional
crisis, the moment of paralysing shock, before the " withered
conscience " can separate its human from its divine fear.
And thus his criticism on this point seems rather futile.
But his contention that the earlier masters, who treated
kindred subjects—Angerstein, Veronese, Titian—would have
given more dignity to the human figures is more just.
The whole essay is valuable and should certainly be read
by anyone interested in the work of John Martin.

Plainly he was at this time a personage in Lamb's eyes,
not only as a public idol but a painter of such quality as to
challenge comparison with the immortals in art. *Bel-
shazzar's Feast* forms the pivot upon which the " Essay
on the Imaginative Faculty " revolves, and John Martin's
artistic or psychologic errors serve to illustrate the author's
pet theories.

THE DESTRUCTION OF HERCULANEUM AND POMPEII.

(*From the picture in the Tate Gallery.*)

p. 106

Leopold Martin informs us that the Duke of Buckingham and Chandos was anxious to buy *Belshazzar's Feast*, and made an offer of eight hundred guineas for it, after it had been sold to Collins. He then commissiond another picture. *The Destruction of Herculaneum* (sometimes called *The Destruction of Herculaneum and Pompeii*), a picture which remained at Stowe until the memorable sale there, when it was, says Leopold, purchased by the Government for the nation.

There can be no doubt that *Belshazzar's Feast* made a powerful impression, not only on the general public, but on connoisseurs and critics as well. In the *Magazine of the Fine Arts* (vol. i.) we find :

" The most dazzling and extraordinary work in the exhibition is Martin's *Feast of Belshazzar*, and one of the most original productions of British art. The principle of this painter's work differs from those of all preceding artists. He appears ambitious to grasp an immensity of space, to congregate innumerable multitudes in his scenes."

The critic then proceeds to attack the flaws in the picture, halting between praise and blame in a manner that clearly shows the paralysing effect of the picture on his judgment :

" The ill-drawn and unexpressive figures of the composition detract, however, very little from its merits, while the perspective in which the multitude diminish, or fade, in the lengthening halls of these stupendous temples is an important beauty of the work. The artist has much to learn with regard to colour. The present subject required a great contrast of broad shadow, dark and broken tints in

the foreground, to give effect to the glare of the super-
natural handwriting. But Mr. Martin has filled his fore-
ground with the most gorgeous tones and the most intense
light ; more powerful indeed than the artificial means
employed would account for,[1] and displays tints that are
only visible when very close and illuminated by the strongest
light of day. Nevertheless, the work is, on the whole, a
noble effort, and we have much pleasure in congratulating
the artist on having dared boldly, and realised, a grand
idea."

One reads between these lines the state of the critic's
mind, wavering between emotional admiration and technical
disapproval. He is amazed at the imaginative conception
of the painter, his prodigious force of execution, and still
more prodigious daring, while endeavouring to set down
in words all the painter's shortcomings.

Martin was by this time thirty-one years of age, and
had had eight children, six of whom lived to grow up. The
youngest was a year old. The house at Marylebone seems
to have been a happy and prosperous one, and his children
were a source of joy and stimulus to him. He entered into
all their games with zest. Leopold writes :

" The childish pleasure with which my father joined us
boys in a game of marbles was really extraordinary. The
painting-room was the place of encounter, generally on
days when the weather prevented him from leaving the
house. Against the wall hung long lance-wood rulers for
the purpose of perspective drawing. . . . These were brought

[1] Surely Martin accounts for the light by his blaze of unearthly
illumination from the Divine writing on the wall.

into requisition, being placed round the end of the room in a half-circle. A ring was struck with chalk on the floor, marbles were placed in a circle, for 'knuckle-down' and all the ordinary rules of the game were enforced with the strictness of school-boys and with, occasionally, much warmth. My father was quite as particular in his marble as the most enthusiastic boy fresh from school. I have known him play for hours, and with all the glee of the youngsters."

I give the little picture as it stands, a happy foil to the gloom of his great pictures, whereof his admirer, Bernard Barton, a 'poet' of his day, and friend of Charles Lamb, wrote :

> " The awful visions haunt me still !
> In thoughts by day, in dreams by night,
> So well has art's creative skill
> There shown its fearful might.

> " Light and shadow, death and doom,
> Glory's brightness, horror's gloom,
> Rocky heights of awful form,
> Grandeur of the bursting storm."

and so forth, into many pages.

The painter, whose imagination rioted in scenes of terror, showed a very different side to his family and friends, and through different accounts of him we are able to see him distinctly, with his family growing up round him, and an ever-increasing circle of friends, many of distinction, visiting him at his weekly 'evenings' and, no doubt, supplying the appreciation and encouragement every artist desires.

The wife, who bore his children, somewhat over-hastily, must have been a very admirable woman and the best

possible helpmate for John. She kept, we may be sure, all the sordid cares of her household out of sight ; soothed him, as Leopold says, by her beautiful reading aloud, played chess with him, entertained his friends, and brought up her family in obedience, love, and reverence. It is not so easy to be the wife of a genius successfully that we can afford to pass by her excellencies without a word. The wife has a powerful rival in her husband's art, a rival that absorbs, commands, and makes him oblivious to everything else in the world. Makes him, too, apt to be irritable, captious, careless of domestic regulations, and abominably self-centred.

I feel certain that John Martin was never punctual to his meals ; that he would walk out of the house and stroll in the fields just as the joint was being dished up, and that he would be irritably impatient if the baby cried when he was holding forth on his pet subjects or trying to achieve a certain effect in a picture requiring great concentration ; that he would be subject to paroxysms of wild elation and sink immediately afterwards to the depths of suicidal despair. But there is every reason to believe that he was less moody and *difficile* than many of his kind ; that he had a naturally sunny temperament, and could paint gloom and terror without being gloomy or terrific. His children were never frightened of him.

He was painting steadily and his fame was spreading over the Continent. As a French critic wrote a little later : " *Le Festin de Belthazar* fut déclaré la merveille du siècle . . . et chaque année parassait un nouveau prodige : en 1822 *La Destruction d'Herculaneum*, en 1823 *Les Sept Plaies*

d'Egypte, en 1824 *La Creation* et *Le Deluge* 1826, *La Chute de Ninive* 1828." [1]

But these were not the only works produced in those years. The following are chronicled in the official lists of the Royal Academy and British Institution exhibitors.

British Institution :

1823.—*Adam and Eve Entertaining the Angel Raphael* (" Son of Heaven and Earth attend : that thou art happy owe to God ; that thou continuest such, owe to thyself."— Milton).

1824.—*Syrinx.*

1826.—*Two Studies from Nature.*

Royal Academy :

1821.—*Revenge* (" Revenge impatient rose. He threw his bloodstained sword in thunder down."—Collin's *Ode to the Passions*).

1823.—*The Paphian Bower* (" The Graces there were gathering posies, and found young Love among the roses ").

1824.—*Landscape Composition* ; *Design for the Seventh Plague of Egypt.*

There were doubtless other pictures exhibited in other galleries and unchronicled. Many landscapes, certainly, for he painted a great number. Fourteen were sold at Christie's in 1861, the property of Charles Scarisbrick, Esq., besides seven subject-pictures, including *The Deluge*

[1] *John Martin*, a short biography by Charles Blanc, published in a series entitled *Sujets Biblique et Poetiques*.

and *Fall of Nineveh.* And in the year of his death, 1854
a collection of fifty-nine water-colour drawings by him were
sold by the same firm. We do not know when these were
painted, but they were, in all probability early work, as we
know that his time was more absorbed later in engraving
and making plans for the improvement of London. O:
these water-colours a critic in the *Athenæum* wrote a long
and effusive appreciation, from which a few extracts may
be here given :

" These works, beautiful in execution, finished with all
the dainty minuteness of even a woman's hand, and deep
and bright in colour, present us with a new view of the
artist's character. He who revelled in vastness and sub-
limity, in gulfs lit by the white glare of the lightning's
touch—in misty seas swelling into snowy Alps of foam—in
all the darkness of Malboge and all the flames of Purgatory
—could go out and watch, it seems, with a poet's love, the
pools where the water-lilies lie asleep, the golden waves of
the ripe corn rippling into furrows of exceeding lustre, the
pale shadows that the trees cast on sunless days, and rivers
winding at their own sweet will—under the benediction of
the sun. It did us good to see the same mind exulting in
the blue chasms and frozen billows of Alpine scenery—in the
pitchy tempest terror of Belshazzar's murky hall—and then
to behold the creator of these wonders go forth to be lulled
to sleep on the soft breast of our common Mother Nature,
as if in these drawings a reaction from the wildness of his
imagination had led Mr. Martin to display his tenderest
feeling. . . .

" The best of the whole collection, for finish and tone,

were the views from the Wynd Cliff, the autumn foliage being composed of a depth of transparent and glowing colours we never saw so richly heaped together, or so finely contrasted with the purple of the retreating distance, with the cliffs of Chepstow and the waves of the Severn white in the horizon."

One is inclined to wonder whether Martin might not have succeeded in attaining a more lasting fame had he studied and produced landscapes only, and made no attempts to embody the phantasmagoria of his powerful but somewhat riotous imagination. The only instruction he seems to have received was in the school of landscape, and it might have been better for his ultimate success if he had not antagonised the critics of his day, and of days to come, by painting pictures that were, in a sense, beyond criticism, daring innovations in art, puzzling and paralysing where they failed to achieve a purely emotional effect. In England landscape has always been more appreciated than subject-painting.

The French writer already quoted observes, as the cause of John Martin's decadence in popularity, that the English have never encouraged "les ambitieux de grande peinture," their taste being more for "les peintres de portraits, de scénes familière, de paysage et de marine." And, further on, he quotes the words of Gustave Planché in 1834, who seems to echo Wilkie's dictum: "Martin is a phenomenon," for this is what he says of the English painter :

"Martin n'est pas un peintre. C'est une puissance mystérieux qui n'a de rang ni de place nulle part, qui se soucie peu de la forme de sa pensée, pour vu qu'il émeuve,

H

qu'il étonne et qu'il galvanise la pensée d'autroi. Il se complait dans une poésie sans nom, embryonnaire, inachevée confusé, qui excite l'imagination jusqu'a l'envivrement, mais qui ne laisse jamais dans l'âme du spectateur une impression complète et durable. C'est le peintre des poëtes, c'est le poëte des peintres, et pourtant il n'est ni un peintre ni un poëte."

This point of view is interesting and suggestive, in spite of its extravagant generalisation, as it draws the fine line which, I have already suggested, may lie between the genius and the perfect artist. But is it just to say that Martin's work did not leave " on the soul of the spectator " a complete and durable impression ? I think not. One may criticise adversely, but one cannot forget a Martin picture. Its impression is permanent to an extraordinary degree.

But such controversial matter is out of place here. We have followed John Martin to the zenith of his career as a painter, and will pause to consider his environment and friends.

CHAPTER VII

Friends and new acquaintances. Forgotten celebrities. *The Mummy* and *Frankenstein.* The songs of other days. Braham and his beautiful daughter, Tom Moore, and Samuel Lover. Tom Hood and his homes. William Godwin and Bunyan's grave. The Landseers, Harrison Ainsworth, Charles Dickens, George Cruikshank, and Douglas Jerrold.

ALL the forgotten world of old London is evoked by Leopold Martin's pictures of his father's ' Evenings at Home,' and the gay company that foregathered at his house in Alsopp Terrace. Some of the celebrities he prattles of have long since fallen into the dust of oblivion. Who has heard of Jane Webb, who wrote " that extraordinary work—really striking for a young woman—*The Mummy* " ? She was, says Leopold, like a daughter to his mother, who loved her as her own child. *The Mummy* brought her a husband, for Mr. J. C. Loudon, the great botanical writer, on reading the book expressed his full determination to marry the author. " He knew of no work like it ; nothing so original, nothing that was its equal except *Frankenstein.*"

" Where is dot barty now ? " and why has *Frankenstein* come down to us while *The Mummy* is unknown ? But if Miss Jane Webb is *passée* in the worst sense of the word, such names as Braham, Moore, Hood, Godwin, Caroline Norton, L. E. L. Bartolozzi, Harrison Ainsworth, and

others mentioned by Leopold, still have an old-world charm about them and are able to stir in us faint memories of a bygone day, the day of crinolines, pork-pie hats, tight trousers, and high stocks.

Of Braham Leopold writes : " When last seen at my father's he still retained a ' voice to wake the dead '—a voice to startle, delight, and charm. What a glory it was to be astounded by his bursts of *The Bay of Biscay* and *Hearts of Oak*, or the deep feeling of his *Tom Bowling!* As sung by John Braham they were an everlasting memory. To the end of all he was the wonder and delight of his friends. Few could understand that he had first been heard in public as far back as the year 1787, when he appeared at Goodman's Field Theatre under the name of Master Abrahams."

When he tries to describe Miss Braham, the singer's daughter, Leopold becomes dithyrambic. " It is difficult to describe, or attempt to describe, so remarkable a beauty," he exclaims, " and one so distinguished, at a future period, in the political world. . . . The energetic character of her mind gave her, in after times, power both to lead and command. She certainly had more genius than generally seems to fall to the share of such startling and rare beauties. . . . At once high-minded, resolute, impassioned, she was truly magnificent."

This prodigious lady, it appears, had four husbands : " First the Hon. Mr. Waldegrave : then his cousin, the Earl of Waldegrave (by marriage she became the possessor of Horace Walpole's Strawberry Hill Mansion and estate) ; thirdly, Mr. Vernon Harcourt, son of the Archbishop of

York; and, finally, Mr. Chichester Fortescue, afterwards Lord Carlingford. No woman ever attained such political influence as Miss Braham, when Countess of Waldegrave, or made her house a centre of such political intrigue or power, Lady Holland and Lady Palmerston excepted."

He gossips about Bartolozzi (son of the great engraver) and his charming daughters, Madame Vestris and Mrs. Anderson ; of Tom Moore and his warbling " melody after melody—his own Irish—making the evening charming, sweet, and memorable " ; of Samuel Lover singing *The Angel's Whisper, Rory O'Moore, The Low-backed Car*, and " other exquisite ditties." He recalls one *petit souper*, after an ' Evening at Home,' at which were present Thomas Hood, William Godwin, Allan Cunningham, John and Charles Landseer (father and brother of Edwin), S. C. Hall (husband of the Irish writer whose stories had then a great vogue), Emma Roberts, and Jane Webb ; and relates how Tom Hood " requested permission to propose a toast, as he desired particularly to wish future success to art, and to couple the toast with the name of Charles Landseer, and the ' Painters and Glaziers.' " Thereupon, he states, Landseer rose to return thanks and requested permission to couple the name of Mr. Thomas Hood with ' The Paper Stainers.' Jests which were received with great merriment.

He tells us of a visit to Hood before the poet was known to the world, and was about to try his fate with a farce at the Adelphi Theatre, entitled *York and Lancaster*, in which Matthews and Yates took the parts of rival schoolmasters. On the first night of the production Hood invited John Martin and his boy, Leopold, to " see the fun," and they went

first to tea with the Hoods at the Adelphi. They spent a most enjoyable evening, says Leopold, but the play was not a success.

Later on they paid the poet a visit at Lake House, Wanstead, " a charming cottage on an island in the lake in Wanstead Park " ; and again to his cottage at Winchmore Hill, a place with very beautiful grounds and lovely views over Surrey, Essex, and Middlesex. There they met the Reynolds, Mrs. Hood's two brothers, who afterwards became so famous as writers and publishers of sensational romance.

Leopold Martin depicts Hood as a disappointed man, convinced that he might have been either a Hogarth or a great poet if he had only been taught to draw properly, or had not followed the line of least resistance in writing comic poetry. The failure of his first volume of serious poems and the success of his humorous verse, made this almost inevitable, however, to a man with a wife and family. His wretched health would doubtless account for the melancholy moods that impressed the volatile Leopold.

Of William Godwin, Shelley's father-in-law, and a friend of John Martin's, he gives us a somewhat interesting impression.

" In person," he says, " Godwin was short and stout, with a remarkably large and curiously-developed double skull, nearly bald, the little hair remaining on the temples at the back was perfectly silvery. His eyes were deep-sunken, shrewd, keen, and lively, and retained all the fire of youth. His admiration for the acting of Edmund Kean was truly wonderful. It was at all times his boast that the

great tragedian had never performed in London when he, Godwin, had not been present. His bald head certainly never failed to mark the centre of the crowded pit. Well I remember an arrangement made by him with my father, to accompany him, not to see Kean, but to visit the burial-ground of Bunhill Fields of Finsbury, the Campo Santo of the Dissenters. Godwin's wish was to show my father how little now remained to mark what he termed the hallowed spots of the earth! When the Great Plague of 1665 broke out, Bunhill (or as it was then termed, Bonehill) was made use of as a pest field, or common place of interment. When the plague was over, this great pit, or general grave, was enclosed, and subsequently leased to several important dissenting sects, who conscientiously objected to the burial service in the Book of Common Prayer.

" William Godwin took much trouble to indicate an altar-tomb, one of the few remaining, which stands at the east end of the ground, placed there in memory of Dr. Thomas Godwin who died in 1679. This was the independent preacher who attended Oliver Cromwell on his death-bed. Cromwell had then his moments of misgiving and asked of Godwin—so told William Godwin to my father, pointing out the tomb—if the ' elect ' could never finally fall ?

" ' Nothing could be more true,' was Godwin's reply.

" ' Then I am safe,' said Cromwell, ' for I am sure that once I was in a state of grace.'

" After pointing out the forgotten grave of Dr. John Owen, Dean of Christchurch and Vice-Chancellor of Oxford when Cromwell was Chancellor—the divine who preached the first sermon before Parliament after the execution of

Charles I.—Godwin pointed out the place where John Bunyan lay and ' expressed the greatest indignation that no inscription marked the place of interment ; particularly as it is said that many had made it their desire to be buried as near as possible to the spot where his remains were deposited. He was also in high indignation at there being no memorial to the memory of George Fox, the founder of the sect of Quakers, and strongly urged my father to join him in an appeal for public subscriptions for such an object."

It must surely have surprised Leopold to hear the notorious free-thinker proposing to collect money for the graves of John Bunyan and George Fox.

The Landseers seem to have been great friends of John Martin. Edwin was two years younger than Charles, who was also an artist, and six years younger than Thomas, the engraver ; but we hear that he and John were intimates, despite some difference in years.

" My father had known him from his boyhood," says Leopold, " and he (Edwin) knew no other home but The Cottage, No. 1, St. John's Wood Road. It was a long, low house enclosed in a secluded garden. The studio, its chief room, was large, low, and dark, the floor covered with skins of lions, tigers, and deer. The windows—none of which faced the north—the usual aspect selected by artists— opened into the garden, which was quite a zoological one. There was an eagle, chained to the branch of a tree ; a fox, also chained not far off ; more than one dog, all splendid of their sort—an Alpine mastiff, a Scotch deer-hound (a present from Sir Walter Scott), a Dandy Dinmont, and other

terriers. In a loose-box might be seen a really beautiful pony of Turkish breed—quite a study—one often painted by its master, but hardly the horse such an animal painter would be expected to ride. Landseer, however, was but an indifferent horseman."

He proceeds to discuss Edwin Landseer's passion for gambling and relates how he was saved from sheer ruin by his friend, Mr. J. Bell. Although not given to melancholy, his spirits were apt to fall very low over his losses, and on one such occasion, we are told, John Martin found him so depressed that he carried him off for a walk. They met a lady in an open carriage who bowed to Martin and received in return the usual salute.

The story must be told in Leopold's own way.

" ' Good God ! ' said Edwin Landseer, ' what have you done ! Do you value your reputation ? How fortunate that you have been seen only by me ! I am too old and true a friend to mention a matter so unfortunate, and which might quite destroy your future prospects.'

" Startled, and not understanding what crime he had committed, my father answered, ' Why, I have only raised my hat to Mrs. Fonblanque, a very charming woman, in return for the honour she did me.'

" ' Yes,' returned Landseer, ' and by so doing you have risked all your future prospects and respectability in the eyes of all you have to look to. Why, her husband, Mr. Albany Fonblanque, is a *Radical !* ' "

We give John Martin credit for enough humour to accept this as chaff, but Leopold seems to take it seriously

enough and observes that, even after that, his father did not cut the lady.

He goes on to tell us that when the couple returned from their walk in the park they found the Rev. Sidney Smith (Peter Plimley) on the point of leaving his card at Landseer's door. Landseer welcomed him with effusion and the three friends entered together. He was anxious, says Leopold to make a sketch of the famous divine, but Sidney Smith had a serious dislike to sitting for his portrait. " Friend, is thy servant a dog ? " he exclaimed, and there the matter ended.

One other incident connected with Sir Edwin is given by Leopold as follows :

" I well remember Edwin Landseer bringing the Duchess of Bedford to my father's painting-room. Her Grace was delighted with a slight study (not an hour's work) of a rose with some drops of rain on it. My father intended to present it to her, but the following day Sir Edwin Landseer called to state how much the Duchess wished to place the sketch in her boudoir, and pressed my father to give it to him at once. Her Grace wrote thanking my father for parting with the sketch and enclosing a cheque for one hundred guineas. The study is now at Woburn Abbey and is the only work of that description my father ever painted."

Harrison Ainsworth was another friend of John Martin, and Leopold gives, as one of his most pleasant reminiscences, an afternoon spent with the famous novelist at his home, Kensal Manor House. From the piazza at the side of the house, he observes, was a magnificent view, extending to the Surrey hills as far as Guildford, a distance of thirty

miles. It was a one-floored house, a bungalow, we should call it to-day, and covered a good deal of ground. As usual, they went a-walking, and visited the cemetery to see the monument just erected there by Soyer, " the distinguished *chef* of the Reform Club," to his wife.

" Mr. Ainsworth stated that he had a capital joke connected with it. The wife of M. Soyer was a clever painter as well as writer, but equally distinguished as a scolding virago with a nagging, violent temper. Yet, in spite of all, he put up with her with uncomplaining fortitude, and on her death, out of respect for her talents, he determined to build a splendid monument to her memory. At a loss for an inscription he thought he might presume to request one from the Rev. Sydney Smith, as he was often at the Reform Club. ' An epitaph,' said the rev. gentleman. ' By all means ; nothing can be more simple. Give me a pen ; two words will suffice.' With quite a serious face he then wrote :

' Soyez tranquille.'

" Soyer thanked the wit, saying it was explicit and expressive."

Whether Mr. Ainsworth's " capital joke " has become a chestnut by this time or not I am unable to say, or whether the suggested *mot* was put on the tombstone. After leaving the cemetery we read how the friends wandered on to " the well-known, old-fashioned inn, The Bell, in the quiet village of Kilburn," where Mr. Ainsworth discoursed eloquently of Dick Turpin, to amuse young Leopold, and told him it was from there the famous highwayman started on his memorable ride to York,

" All this was founded, he said, on fact ; as a clear proof of which he took us up a quiet lane to a small tavern at West End, Hampstead, the direct way to the North Road. At this tavern, Mr. Ainswoth stated, Turpin took a parting drink, making himself perfectly well known, so that an *alibi* might be proved, for he had fully made up his mind that Black Bess should carry him to York in what would be thought an impossible time. This tradition and the end of poor Black Bess, he said, had made his novel (*Rook-wood*) one of the most popular of the day, and given him a name in the literary world."

In view of the fact that Dick Turpin never did ride to York, and Harrison Ainsworth had constructed his story out of a mere legend and his own vivid imagination, this is interesting. He has admitted that he had no direct evidence of the famous ride,[1] and that the only authentic evidence of such a journey taken by Turpin was from Whitechapel to Long Sutton, in Lincolnshire ; but he could not resist impressing the boy with a ' clear proof ' that satisfied his credulity—obviously for the rest of his life, since Leopold evinces no doubt of the *facts* of the story.

He gives us an intimate little sketch of Charles Dickens in 1835, or thereabouts :

"*The Sketches by Boz* then being published in the *Morning Chronicle* were the talk of all, and my father was much pleased to meet the author. Charles Dickens at this period, when but a few weeks married, was full of fun and dash. His fair hair waved long and freely over a white and un-

[1] *Life of William Harrison Ainsworth*, by S. M. Ellis.

wrinkled forehead and a clear and healthful complexion ; his eyes were large, bright, and penetrating, and he had a smile of glee for all. The cutting of the Strafford-formed face and the full upper lip were not then concealed by the thick beard and moustaches so marked a distinction at a future period. Nor had care ploughed its lines ; yet the countenance had already acquired all the idea of a great intellectual presence.

" The newly-married wife, Miss Hogarth, was a quiet, delicate, light-haired, fair-eyed lady, seemingly quite without natural power or spirit, or natural force of manner, to guide or control such a volatile character as that of Charles Dickens. In reality, however, she became remarkable for carrying out the very stringent rules required by domestic economy and regularity of life. However numerous the guests might be, either at Gadshill or Boulogne (a favourite summer abode of ' Boz ') so methodical was Dickens, that you were certain to find each morning, placed on your breakfast plate, a programme for the day—to be strictly attended to in one respect, at least, that of being punctual to the hour of dinner. The programmes were in the beautiful handwriting of Charles Dickens, not in that of his wife. Everything seemed to be under his own arrangement, and all domestic matters were his."

These programmes, by the way, do not afford a very good illustration of Dickens' volatile character ! Leopold goes on to discuss the old question of the novelist's relations with his wife, and gives his opinion of the matter for what it is worth. " We must not think," he says, " that his wife was a scolding virago, or unbeloved. It may be enough

to say that she was prosaic, while Charles Dickens was all imagination and tender melancholy, which, perhaps, at home looked like sullenness." He admits that the Dickens' home was not " without chilliness and irksomeness."

Of Douglas Jerrold and George Cruikshank he writes :

" One could not but remark the hawk-like head of Douglas Jerrold, one so full of venom that he was quite willing to sacrifice the feelings of his oldest and dearest friends for a sarcasm. The more bitter the retort, the more palatable it was to one of his type. It was not everyone, however, who detected the serpent couched beneath his smile ; for he seemed to be weighing every word, taking gauge and measurement of the intellect and temperament of every guest. In conversation his words flew forth, and his dazzling, but bitter, wit, lit up all around."

" George Cruikshank had a similar expression but it was of a more kindly nature. He was ever seemingly watching for a likely subject to sketch, when unobserved, on one of his nails—a practice he was given to. He was known invariably to arrive home from a party with a sketch of a face or head drawn on each finger-nail, which rough memorandum was again noted down previous to the usual nightly ablutions. It is generally understood that he invented, or, at any rate, introduced, the false wristband or shirt cuff, for the sake of its convenience in memorandum, sketching on it in society when unobserved. It is also understood that his washerwoman found a market for them in some private quarter and substituted new cuffs for those found so valuable.

" Among the artists congregated at George Cruikshank's was the delicate and tender painter, Frank Stone,[1] with whom Douglas Jerrold seemed to be on the most friendly terms, addressing him as ' Friend Tombstone,' a designation resulting from the unfortunate breaking up of many undertakings with which Frank Stone had become connected—chiefly art or social clubs."

We shall deal with these first literary and artistic clubs in another chapter, and close this with an account of a driving holiday taken by John Martin with his son. No date is given, but it must have been at a time when he was beginning to turn his attention to engineering schemes, for Leopold says that they went first to Long Sutton, in order to investigate the construction of the extensive, pile-built road through the marsh there—a long swamp extending for miles. The fact that they took a driving tour, because the line of coaches did not suit John Martin's plan of campaign, also indicates a degree of prosperity in his fortunes.

Leopold tells us that they paid a half-crown toll to see " the works and vast improvements suggested and approved by my father's friend, the engineer to the Sutton Trust," and then goes on to describe the journey thus :

" Our journey was then continued to the interesting old town without a thoroughfare, Lynn, with its fine old church and curious gate—the only entrance, except by river, for the town is protected by extensive sea banks. Though Lynn has much to interest the antiquary, my father's chief object in visiting the district was to see the wonders of

[1] A.R.A., father of Marcus Stone.

Lord Leicester's splendid mansion of Holkham, built on
ground reclaimed from the sea ; the wonderful work of the
well-known, fine old squire, Coke of Norfolk. The park is
the wonder, but the mansion, Holkham Hall, contains
much of interest. The collection of pictures is important,
the furniture is perfect in its quaint character, and the
sculpture is very fine. My father had often been advised
to visit the place by his friend, Sir Francis Chantrey, a great
friend of Lord Leicester's.

" After inspecting about all his lordship could well
show, we repaired to the old fishing villages of Wells and
Hunstanton, at that time miserably poor places. On
leaving Holkham we took, at the urgent request of Lord
Leicester, the road by Sneyndsham, in order to see Castle
Acre Priory. On arriving, we found, to our great vexation,
that the splendid ruin was already overrun by a large
party of tourists, fully engaging the attention of the old
people who usually acted as guides. This, however, instead
of turning out a loss, proved truly fortunate ; for, by good
luck, we found a highly-educated archæologist in the person
of a kind and wonderfully benevolent-looking lady in Quaker
costume, who was one of the party of visitors. Observing
our want of a guide, she, in the kindest possible manner,
offered to act as cicerone and furnish whatever information
she possibly could.

" This lady proved herself perfectly well-informed of
the history of the castle and locality from the earliest
period, pointing out all the architectural beauties (and they
were many), and particularly the domestic remains, such
as the buttery, the bakery, the kitchen, with its great open

space for fire ; the cellars, the gardens with fish ponds, orchards, and wells, together with nearly every remaining relic likely to interest. She then inquired whether we had seen the various places or points of interest in the district, such as Narford, Wimpole, Holkham, Houton and other well-known spots, telling my father what pleasure it would have given her to have introduced him to her brother, Mr. Daniel Gurney, at his place at Runcton, near Lynn, though she trusted at some future time to have that pleasure ; for she was sure that her brother's wife, Lady Harriet Gurney, would be greatly pleased to know my father. The lady evidently knew him herself, but how he was quite unable to say.

" On leaving the Abbey, my father thanked her for all her kindness and for the great pleasure she had rendered him ; and informed her that, if at any time she visited London, it would give him delight to render her any service, and to see her at his house. At the same time he handed her his card. Glancing at it, she cordially acknowledged the civility, intimating the pleasure she should receive in visiting him and seeing his works. . . . She also handed him a card. Imagine my father's great satisfaction on its proving to be that of the celebrated Mrs. Fry, the well-known philanthropist, the visitor of prisons and prisoners. Mrs. Fry and John Howard, with equal and true benevolent charity, each in his and her time, entered the prison houses, both at home and abroad, like angels, rendered aid and gave comfort where it was never more needed. My father felt that he had seldom been more highly and truly compli-mented than by the kind attention of Mrs. Fry.

I

"We drove on to Ely, for the sake of calling on my father's old friend, Dean Peacock and seeing what he was doing in the way of restorations. The Dean, in the most kindly and learned manner, explained all the work in progress in the beautiful cathedral. The restoration was being effected entirely at the Dean's own cost, and he showed consummate talent and great liberality in dealing with this truly interesting edifice.

"Cambridge was our next resting-place, my father looking up more old friends, equally distinguished—the Master of Trinity and Professor Sedgwick ; the former a noble-looking, portly Churchman, and the latter a sparkling, eagle-eyed man of science. Both seemed pleased to see my father and took him over the Fitzwilliam Museum. . . . Professor Sedgwick highly complimented my father . . and this great geologist expressed his approbation of the treatment of the *Restoration of the Land of the Iguanodon* given by my father to his friend, Dr. Mantell (to be used in illustrating his *Wonders of Geology*) as his idea of the country of the ichthyosaurus, the iguanodon, and other extinct marine animals."

We must now go back to somewhat earlier days and review the work John Martin was doing while he was making so many friends and meeting so many celebrities of his day.

CHAPTER VIII

The three ' Deluge ' pictures. Visit of Cuvier to Martin's studio and his approval of the phenomena in *The Deluge*. Martin's lengthy descriptions of his paintings. King William IV.'s private view of *The Fall of Nineveh*. Prince Albert's appreciation and suggestions. Other pictures between 1821-41. Foreign honours, medals, diplomas, and gifts from reigning monarchs. Visits of the Buonapartes, Lady Blessington and Count D'Orsay to his studio. The ' Deluge ' pictures, and enormous output between 1823-50.

AFTER *The Paphian Bower* and *Adam and Eve Entertaining the Angel Raphael* in 1823—large pictures exhibited at the Royal Academy and British Institution respectively—Martin painted nothing of any importance until *The Deluge* in 1826, and as this was one of the pictures that most helped to establish his fame, we must give some attention to it.[1]

It was exhibited at the British Exhibition, bearing the following characteristic inscription :

" This representation of the universal inundation of the earth comprehends that portion of time when the valleys are supposed to be completely overflowed, and the inter-mediate hills nearly overwhelmed, and the people who have escaped from drowning there are flying to the rocks and mountains for safety.

[1] It was in the possession of Sir Edward Naylor Leyland, Bart., until June 1923, when it was sold, with *The Fall of Nineveh* (and seven other paintings by Martin), by Messrs. Knight, Frank & Rutley in the great sale at Hyde Park House.

" In the six hundredth year of Noah's life, in the second month, the seventeenth day of the month, the same day were all the fountains of the deep broken up and the windows of Heaven were opened."—*Genesis* viii. 12."

In *The Observer* of February 26, 1854, obituary notice of Martin, we find this picture alluded to as follows :

" In 1826, he painted *The Deluge*, so celebrated by Sir Edward Bulwer Lytton in his *England and the English*, where he eulogises it as the greatest conception ever represented on canvas. That opinion met with the sanction of foreign artists and foreign critics, when it was afterwards exhibited at the French Exhibition, and none was warmer in approbation of his treatment of the fearful subject than the great Cuvier."

Apropos of this we have two mentions of the 'great Cuvier's' visit to Martin's studio from the pens of Leopold Martin and Ralph Thomas. As usual, Leopold's account is the more flowery. He writes :

" The visit of a most illustrious *savant* to my father's studio during his temporary absence is to me of peculiar and special interest, chiefly on account of the honour it conferred of receiving so highly distinguished a foreigner. I was alone, reading in the studio, when Dick, my father's attendant, announced ' Mrs. Lee and a gentleman.' I had previously known Mrs. Lee as a Miss Bowdiet, a writer of some note. The accompanying ' gentleman,' an elderly, portly, fine-looking man, was, Mrs. Lee informed me, very anxious, before leaving England, for an introduction to my father, and for permission to inspect his paintings. The one on the easel at the moment was the important work,

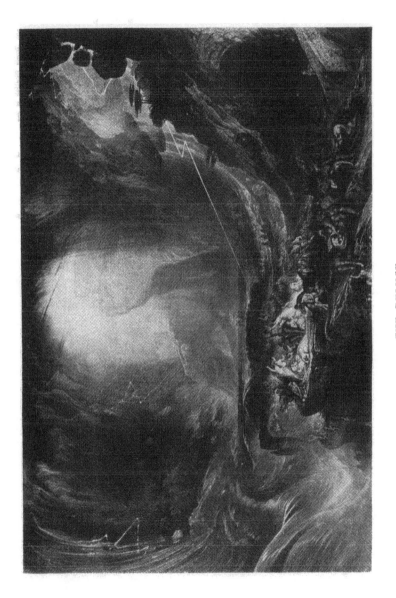

THE DELUGE.

p. 132

The Deluge. After expressing great regret and disappointment at my father's absence, the visitor placed a chair in front of the picture and continued for a lengthy period to gaze, without a word or remark, seemingly wrapped in thought.

" At length he rose, with the exclamation ' *Mon Dieu !* ' at the same time taking a small bouquet from his buttonhole, placing it on his card, and depositing both on my father's palette. He took his departure without another word. On leaving the house, however, he turned, gazed for a moment, raised his hat, made a profound bow and entered the carriage with Mrs. Lee. With some curiosity I returned to the painting-room, wondering who the visitor could be. Think of my delight ! The card was that of the Baron Cuvier."

Says Ralph Thomas, in his diary :

" February 17th, 1834.—On Monday I was looking with Martin at his picture of *The Deluge.* He said, ' Baron Cuvier came to see me when he was in London, on account of my having, in my *Deluge,* made the event the consequence of sun, moon and comet in conjunction ; the moon and comet drawing the water over the earth. This was Cuvier's opinion, he told me so, and he expressed himself highly pleased that I had entertained the same notion.' (This picture was, after much working up, exhibited at the Royal Academy in 1837.) And then, as to the age of the world, he said geology taught us that we could not calculate, but it was clear the world was millions of years old and would continue growing older for millions of years to come. And when the moon and comet came together again, their

attraction would be so great that another part of the world
would be again deluged."

Thomas adds a note that "there is something like this
in Plato."

We note that the picture, "after much working up," was
exhibited at the Academy in 1837, nine years after his *Fall
of Nineveh* had appeared, and added to his great reputation,
receiving the gold medal of the Salon and diplomas
constituting Martin a member of the Academies of
Brussels and Antwerp. With that matter, and his
knighthood by the King of the Belgians, we shall have to
deal later.

It would appear somewhat unlikely that his picture of
The Deluge should have been painted fifteen years before
The Eve of the Deluge, which was exhibited at the Academy
in 1840 and at the British Institution in 1841, if
we had not the following information given us by his
son :

" Gratified and flattered as my father may from time
to time have felt on receiving at his studio," he writes,
" foreign *savants* and others of remarkable distinction, he
never felt more highly honoured than by the visits of His
Royal Highness, Prince Albert. The Prince Consort
usually paid these visits on horseback, accompanied either
by equerry or companion. A groom was the only attendant.
Special satisfaction was received from one visit. The chief
picture in the studio at the time was *The Deluge*, then, to
some extent being repainted. I have often heard my
father say with what pleasure he received and what great
benefit he reaped from the enlightened criticisms of the

Prince. They deeply impressed him as being judicious, thoughtful, and kind, indicating a truly refined and extensive knowledge of art.

" After a lengthened inspection of *The Deluge* his Royal Highness was graciously pleased to suggest that it should make one of a series of subjects connected with the event —*The Eve of the Deluge, The Deluge,* and *The Assuaging of the Waters.* At the same time the Prince commissioned *The Eve of the Deluge* for the collection at Buckingham Palace. My father felt the high compliment and the Prince's suggestion as to the series was destined very soon to be carried out to the full extent."

A visit from the Duke and Duchess of Sutherland followed, ending in a commission for *The Assuaging of the Waters* for the Duchess's private collection.

" Thus," adds the writer, " the three connected pictures went into three different collections."

So we know why the painting, which should come second in the group of three, came first. It was painted and exhibited at the British Institution in 1826 ; repainted and exhibited again in 1837 at the Academy. It was followed by *The Eve of the Deluge* at the Academy in 1840, and again exhibited at the British Institution in 1841 ; and between these dates it was exhibited at the Paris Salon.

The Assuaging of the Waters was exhibited at the Academy the same year as *The Deluge,* 1840, and Martin wrote and published in that year a brochure explaining his conception of the three pictures. It may be remarked that in it he takes all credit for the scheme, and does not mention

Prince Albert's suggestion. Possibly the idea was his own
and the Prince merely concurred in it. After a quotation
from Genesis, he says :

" In attempting to represent this great epoch of the
world, I have found it impossible to express my conception
of the subject in one single design ; I have, therefore, in
order more fully to work out my ideas, given three scenes,
illustrating different periods of the event. ' The Eve of
the Deluge ' ; ' The Deluge ' itself, and the ' Assuaging of
the Waters after the Deluge.' "

There follows : " I have endeavoured to portray my
imaginings of the Antediluvian World, and to represent the
near conjunction of the Sun, Moon, and a Comet, as one of
the warning signs of the approaching doom.

> " The many signs and portents have proclaim'd
> A change at hand, and an o'erwhelming doom
> To perishable beings.' "

He proceeds to describe his own picture, *The Eve of the
Deluge*, quoting extracts from *Ouranoulogos*, a prose work
by " my friend, Mr. Galt," with some blank verse whose
author he does not name, and concludes :

" Upon a rock in the foreground are some Patriarchs
and the family of Noah, anxiously gathered round Methuse-
lah, who is supposed to have directed the opening of the
Scroll of his father, Enoch, whilst agitated groups of figures,
and one of the ' Giants of those days,' are hurrying to the
spot where Noah displays the scroll ; and Methuselah,
having compared the portentous signs in the Heavens
with those represented on the scroll, at once perceives the

fulfilment of the prophecy—that the end is come, and resigns his soul to God.

> " The scroll of Enoch prophesied it long
> In silent books, which, in their silence say
> More to the mind than thunder to the ear."

He gives a list of authorities for his conception below : *The Book of Enoch*, preserved by the Ethiopians ; Hebrews xi. 5, Jude xiv. 15 ; Adam Clark and *Josephus' Antiquities*, bk. i., chap. ii.

For *The Deluge* he begins again by quoting Genesis, and goes on to describe his conception of

" The time when the valleys are supposed to be completely overflowed ; and the people are vainly flying to the mountains for safety, whilst others are seen crowding upon

> ' The rocky foreground—where await
> Man, beast and bird their fearful doom.'

In the distance is the Ark illumined amidst the general gloom by the last beams of the sun and protected by the Omnipotent from the fury of the elements raging both above and below ; the only part of the great waters which remains undisturbed, indicated by the horizontal line, being at the base of the rock which sustains the Ark. To the right are the mountains bursting—or the fountains of the deep breaking open—the waters enclosing hills and plains in the vast waves, while horsemen and others plunge, in wild despair, from the rocks into the foaming deep."

More quoted poetry, and then he goes on :

" To the left falling mountains, accompanied by vivid lightnings and foaming torrents, threaten instantaneous

annihilation to the myriads of men and animals collected below in a vain attempt to escape from the rising of the waters ; nearer is an immense cavern into which the multitudes are flying in their hopeless search for safety from the falling mountains ; but they are forced back by those who have already sought shelter in the interior, and are rushing forth again to escape destruction from the subterranean waters newly breaking forth."

He concludes with a long extract from " Byron's sublime poem " and the whole of a doggerel poem by Bernard Barton, entitled " Recollection of Martin's Deluge."

Of *The Assuaging of the Waters* (said by the *Observer* to be "perhaps the most beautiful of all his productions ") he writes :

" In this picture I have chosen that period after the Deluge, when I suppose the sun to have first burst forth over the broad expanse of waters gently rippled by the breeze, which is blowing the storm clouds seaward ; in the distance . . . is the Ark in the full flood of sunlight. The direction of the land is indicated by the tops of mountains which are beginning to appear. . . . A serpent, the first tempter to sin, and therefore the original cause of the Deluge, is circled, drowned, round the branch upon which is the raven sent by Noah. . . ."

The last page is a delicate outline etching of the Deluge.

I have quoted freely from this pamphlet in order to show how vast were John Martin's conceptions, how very seriously he took his art, and how anxious he was that nothing he saw himself, by the power of his own imagination, should be missed by the public. To each of the

three pictures he appended an explanatory tag, and, indeed, few of his subject-pictures seem to be without one.

A lady whose mother lived next door to John Martin in Chelsea (whither he removed about 1848), informs me that the Prince Consort was a constant visitor to Martin's studio, and that her mother remembered seeing the painter come out in his dressing-gown to speak to the Prince, who was on horseback. But royal appreciation did not always fall to Martin's lot, as we shall see, and Leopold gives us a characteristic experience with William IV. in his reminiscences.

" Earl Grey, when Premier," he says, " once induced William IV. to show him (John Martin) some slight favour by desiring him to forward to Buckingham Palace the painting of *The Fall of Nineveh* for his Majesty's inspection, at the same time commanding him on a certain day to explain its various points of interest. . . . The picture was duly forwarded to the Palace and was placed in a good light. As commanded, my father attended. His Majesty made his appearance, shook hands, glanced at the picture and remarked that it was ' very pretty.' What a criticism ! His Majesty again shook hands and, saying no more, passed on. So ended the interview and with it my father's hopes and expectations."

Poor painter ! One can see him in the royal presence buoyed with hope and confidence, ready to pour forth all his descriptive eloquence about " the smouldering appearance of the advancing conflagration, the crashing walls, the lightning flash, the groups, the brilliant

assemblage, the doomed and devoted beauty," as Leopold puts it, only to be crushed flat under the leaden-weight of those two words—" very pretty ! "

But Leopold tells us proudly that, shortly after this interview, *The Fall of Nineveh* was sent to the Salon at Brussels by command of King Leopold I.

" But with how different a result ! At the close of the exhibition at Brussels my father received a communication from M. Van de Weet to the effect that he was commanded to express the very great regret of his Belgian Majesty that the picture of *The Fall of Nineveh* would be returned to this country, the King having hoped that it might be retained for the National Collection in Brussels. Unfortunately, by the law of Belgium, no money could be granted for the purchase of paintings by living painters other than those of native artists.

" In conveying his Majesty's deep regret, the Minister had also instructions to invest Martin with knighthood of the Order of Leopold ; likewise to present him with his Majesty's portrait or bust by the distinguished court sculptor, M. Greff ; also with the gold medal of the Salon, as well as the diploma constituting him a member of the Academies of Brussels and Antwerp. The Order of Leopold being a military decoration, it became necessary to obtain permission from the English Government to receive it. This sanction was at once obtained through my father's friend, Sir William Woods, Garter King-at-Arms at Herald's College, or College of Arms, though, unfortunately, not without the usual fees, which were anything but slight."

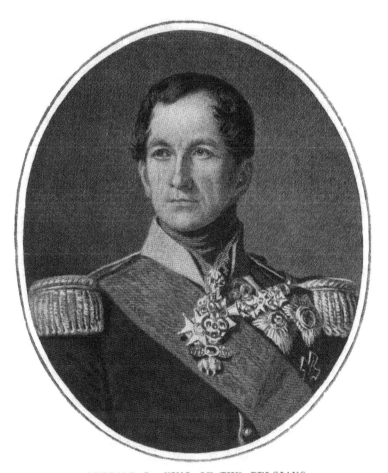

LEOFOLD I., KING OF THE BELGIANS.

p. 140.

Barren honours for our painter, with something to pay which he could, doubtless, ill afford. He was allowed no title with his knighthood ; only the right to use the letters K.L. after his name ; and who knew what K.L. meant ? It may be noted that King Leopold incurred no personal expense on Martin's account. Blandishments are cheap. He might have bought the picture. But we may be sure that John was pleased and proud at heart, none the less, when he received the Minister's letter. We may be reasonably sure, too, that his keen sense of humour was stirred.

It was, perhaps, the first of the honours he received from foreign potentates. We hear of several more medals ; from Nicholas I. of Russia, from Louis Philippe of France, from Frederick William of Prussia, who sent him also gold snuff-boxes and other gifts. Louis Philippe gave him a magnificent present of Sèvres porcelain, and the ex-King of Sardinia (Joseph Bonaparte) sent him a pair of very beautiful altar candlesticks, designed by Cellini, and given to Joseph by his brother, the great Napoleon. We may hope they were not loot !

The ex-King of Sardinia stayed for some time in London, incognito, under the title of Count Sarvilia, and Leopold tells us how he called at John Martin's studio, " accompanied by his interesting and charming daughter," to view *The Fall of Nineveh*, " for which he expressed special admiration and satisfaction." He invited the artist to dine with him at his house in Park Crescent, Regent's Park, and gave him, with a complimentary autograph letter, an engraved portrait of himself in his coronation robes. According to

our memoirist, Joseph Bonaparte was of middle size, handsome, but with more of the Orleans cast of face than of the Bonaparte. As engraved he might well have been taken for an Orleans prince.

It was when Martin was engaged upon this same picture (*Nineveh*) that he received a call from another royal personage and two celebrities of the day. Prince Louis Napoleon (afterwards Emperor of France), the Countess of Blessington, and Count D'Orsay. The Prince, says Leopold, lived then in quiet apartments at 58, Charlotte Street, Portland Place, and Lady Blessington at Gore House, Kensington, "in the garden of which Count D'Orsay occupied a small adjoining residence." These distinguished visitors, of course, expressed great delight with the paintings displayed to them, and John Martin was naïvely pleased and proud to have had two of the famous Bonapartes visit him on two different days. Leopold describes the two Frenchmen and the lady with glib felicity :

" The Count was at this time a fine-looking man, broad-chested, with a great display of blue tie and double-breasted white waistcoat. He wore light trousers with gilt chains, instead of straps, and the smallest of patent leather boots. His wristbands were turned over the cuffs of his coat. He had large whiskers, but no moustache or imperial to disguise his beautifully-turned, feminine mouth and chin. The Prince, a middle-sized, broad-shouldered, hard-looking man, was dressed in the plainest manner, with double-breasted black frock-coat, buttoned quite up, and light trousers. He was remarkable for a heavy moustache, drawn either with gum or wax into needle-points, also a wonderfully

heavy imperial, but he had no whiskers. His cheeks were quite clean shaven. The costume of the Countess was remarkable for a quantity of white lace, chiefly about the face and brow. She was still beautiful, with a splendid figure. On leaving, the Prince, when shaking hands, she said, ' I hope to see you with the Legion of Honour and as a Member of the Institute of France.' My father should have lived a few more years."

Leopold is much impressed by the fact that Lady Blessington actually ventures, before the gentlemen present, to draw aside a curtain veiling a copy of Titian's *Venus* " quite naked " ! Her ladyship did not even ask permission, he observes, " but at once called the attention both of the Prince and the Count to its wonderful perfection. This was done with every delicacy, showing a perfect appreciation of high art." The picture was, he is eager to assure us, at all times covered by a curtain !

The Fall of Nineveh seems to have attracted considerable attention and to have fluttered the critics. In *The Mirror* for May 17, 1828, we find under the ' Fine Arts Column ' a long eulogy, beginning with the usual flourish.

" Of Mr. Martin's well-earned fame as a painter it is unnecessary for us here to speak, since his efforts have proved him one of the first, if not the most, imaginative artists of his time. Indeed, the subjects which he has chosen for the display of his talent would deter all but a first-rate genius from an attempt at their embodiment." Thereupon follows the usual description—that description which Martin so loved to give—and concludes : " Mr. Martin has produced a picture of extraordinary merit, and perhaps as

frightful a scene as it is possible for any artist to embody. On one side is a sublime representation of lightning, while on the other the moon rides in sullen majesty, half eclipsed by dense clouds, and, at the back, the flames of the distant city rise in terrible splendour and throw a lurid tinge over the harbour and shipping beneath the walls." [1]

Very amusing are these old Victorian critiques of art in their strong contrast to the shibboleths of our own day. After such criticism, the 'very pretty' of King William must indeed have been a shock to the painter. It was said by a writer in the *Literary Magnet* of May, 1829, that *Nineveh* was to have been succeeded by *The Death of Sardanapalus*, a picture eighteen feet wide and fourteen feet high, containing about a million figures, some of them no more than dots. But Martin evidently thought better of this. We can, however, well imagine his execution of it.

The years following his exhibition of *The Deluge* in 1837 must have been very full and busy ones for Martin. In 1838 he sent *The Death of Moses* to the Academy, with the usual tag :

" Moses having ascended Mount Nebo, to the top of Pisgah, beholds the Promised Land. The view comprehends the camp of the Israelites, the Dead Sea, the City of Zeboim, the Brook Cedron, Bethlehem, the City of Palms, or Jericho, Bethphage, the Mount of Olives, Valley of Jehosophat, Mount of Zion. The full light of the setting

[1] One of the largest of Martin's pictures, 84 ins. by 134 ins., and considered by some critics the most wonderful in its detail.

sun falls directly on the birthplace of the Saviour and the site of the Holy City, Mount Moriah. Calvary is faintly indicated beyond ; the great west sea, or Mediterranean, forms the extreme distance."

A somewhat ambitious geographical effort for one who had never left the shores of his native land, so far as we know ! Many an English soldier to-day knows more of the regions his imagination roamed in than John Martin could have done.

In the same year *The Death of Jacob* was hung at the Academy, and in 1839 *The Last Man*, suggested by some lines of the poet Campbell, " All worldly shapes shall melt in gloom," etc., beside five landscapes.

Before 1837 it should have been stated, *Leila* (from *The Giaour*) and *Alpheus and Arethusa* were exhibited at the British Institution, with a couple of landscapes. In 1841 *The Eve of the Deluge* appeared there, a year after its exhibition at the Academy, and in 1842 *The Curfew Time*, with a line from Gray's *Elegy*. These were followed by *The Hermit* (1843) ; *Christ Stilleth the Tempest* (1844) ; *Morning in Paradise* and *Evening in Paradise* (1845) ; *The Forest of Arden*, an original design for a large picture of Moses viewing the Promised Land from Mount Nebo, and *Arthur and Oegte in the Happy Valley* (1851). And, as we have seen, his *Joshua* was also exhibited there in 1849.

In the Academy, during those years, he was even more voluminously represented. We find there *The Celestial City and River of Bliss* from *Paradise Lost* (1841) ; *Pandemonium* (from the same inspiration) ; *The Flight into*

K

Egypt (1842) ; *Canute the Great Rebuking his Courtiers* (1843) ; *The Judgment of Adam and Eve* and *The Fall of Man* (1844) ; *The Last Man* (1850) ; *The Destruction of Sodom and Gomorrah* (1852) ; and no less than forty-seven landscapes.

Two of his pictures, *Christ Stilleth the Tempest* and *The Eve of the Deluge*, were exhibited both at the Royal Academy and the British Institution, and *The Last Man* was shown at the Academy in 1839 and 1850. They may not, however, have been the same picture, as they bear different quotations, the first being, " All worldly shapes shall melt in gloom," while the second runs :

> " I saw the last of human mould
> That shall creation's death behold,
> As Adam saw her prime."

Both derived from the poet Campbell.

We have taken Martin now up to his sixty-third year, so far as the exhibition of his principal pictures at the Academy and British Institution are concerned. There were many others, of which we find note here and there at different galleries in England, the most important being *The Destruction of Pharaoh's Host, The Crucifixion* (for the plate of which we are told he afterwards received from Collins a thousand guineas), and *The Coronation of Queen Victoria*, which was exhibited at Buckingham Palace and bought by Mr. Scarisbrick, with *Nineveh* and *The Deluge*, for two thousand guineas. Martin confidently expected that the Coronation would earn for him a title he coveted, that of Historical Painter to the Queen of England, but he was not so honoured by the Crown, and the refusal to the

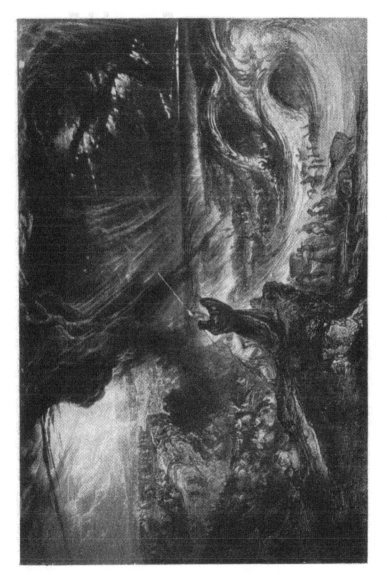

THE DESTRUCTION OF PHARAOH'S HOST.

(One of John Martin's illustrations to the Bible.)

p. 146.

request, made for him by Lord Grey, nearly broke his heart. We have a pathetic picture of him at the time (1838) from the pen of Mr. Thomas, when Martin was almost distraught with debt and anxiety, causing his wife and children great anxiety. But of this more hereafter. His financial losses, due to a too generous and confiding faith in his fellow-men, and sometimes to over-confidence in his own powers, must be left, with his three last pictures, for a later chapter.

CHAPTER IX

Martin becomes an engraver. His substantial printing establish-
ment at Allsop Terrace. Two thousand guineas for twelve
illustrations to Milton's *Paradise Lost*. Accounts with print-
sellers in London and other large cities. Sales in the United
States, China and Japan. Illustrations to the *Bible* and *Pil-
grim's Progress*. Isabella Martin, her Father's secretary.
Anecdote of Wilkie.

THE number of pictures painted by John Martin in those
middle years of his life seems to us the more amazing when
we come to consider his achievements as an engraver.
That he was not the only painter who engraved his own
work we know. J. M. W. Turner studied the process of
mezzotint, etched the leading themes of his *Liber Studiorum*
on the plate and supervised the engravings, sometimes even
working upon them himself. But Martin actually became
an engraver ; not only graving on the copper and steel
plates, but setting up a press and producing the pictures
from his own workshop. In his letter to the *Illustrated
London News*, already quoted (1849), he says, speaking of
his work on and after 1821 :

" Most important of all was my acquiring the art of
engraving and producing the ' Illustrations of Milton,'
designed on the plates (and for which I received 2,000
guineas) ; The ' Belshazzar's Feast '—the first large steel plate

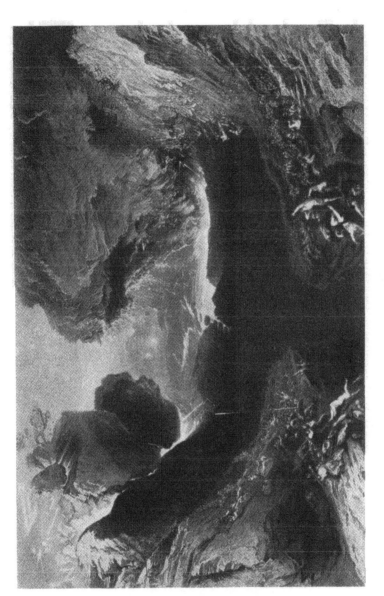

THE GREAT DAY OF HIS WRATH

p. 148.

ever engraved in mezzotint, the 'Joshua' and the 'Deluge,' between the years 1823 and 1828."

Further on he states that, after devoting a certain portion of his life to engraving, he was compelled to abandon it, owing to the imperfect laws of copyright.

"My property being so constantly and variously infringed that it became ruinous to contend with those who robbed me, I was therefore driven from the market by inferior copies of my own works, to the manifest injury of my credit and pecuniary resources."

Judging from an infamous print I have of *The Day of His Wrath* (one of the famed 'Judgment' pictures, without any imprint of engraver's or printer's name), he must indeed have had cause for bitter complaint.

He does not tell us how he acquired the art of engraving, but he must have studied it in the years 1821-3, and probably his first production, *Belshazzar's Feast*, engraved on copper, was a pretty rough piece of work. But its success was so great that he determined upon engraving his other large pictures, and, being dissatisfied with the slowness of printers, decided to set up a press of his own. Of this we have some interesting matter from Leopold.

"Notwithstanding," he says, "the amount of practical skill and knowledge gained by my father in the production, or engraving in mezzotint, first on copper and then on steel, of the plate of *Belshazzar's Feast*, it quite failed to impress him with any desire to become an engraver, and it was accident alone that made him one by compulsion. . . .

"Such had been the popularity of his painting of *Joshua*

Commanding the Sun to Stand Still that, following the
advice of his many friends, he decided on the publication
of a large engraving. Of little moment as such a decision
may seem, it really marked an important era in my father's
art career. His original idea was not, as in the case of
Belshazzar's Feast, to execute the work himself, but to
procure the services of some well-known engraver. The
commission consequently was given to Charles Turner,
distinguished for his engravings from the work of his great
namesake, J. M. W. Turner, and others. The contemplated
engraving was to be in mezzotint ; the plate of a size not
less than thirty by twenty-two inches, and the cost was
not to exceed £500. Such an arrangement was expected
to result in a work of importance. This, at any rate, was
the feeling of my father and his advisers.

" But Charles Turner, though so distinguished in his
art, quite failed to enter into the feeling of the poetry of
the painting. He seemed to have no heart in the work.
Month after month passed, payment after payment was
made in advance, but with little or no result. Deeply dis-
appointed that one so distinguished should fail in really
good work, my father felt compelled to call to his assistance
the co-operation of an old and mutual friend, Mr. William
Brochendon, who undertook to negotiate with Mr. Turner.
The result was the utter destruction of the plate, and all
the work, as it then stood, was cancelled. Such instalments
of money already advanced went as payment for work
executed and stood as the loss of my father.

" The one way out of the difficulty, the only one in my
father's eyes, was for himself to make up for lost time and

attempt a new engraving on steel. On so deciding, he had kind aid from his friend Mr. Thomas Lupton, who offered every mechanical assistance in his power. A large steel plate was procured from Harris & Co., the mezzotint ground was laid, the etching or outline was made, and, in the course of four months, my father completed what proved to be, perhaps, one of his most successful engravings. Thus by compulsion he became an engraver, for he could meet with none who fell into the spirit of his painting."

Allowing for a certain colour, which we must always allow the garrulous and effusive Leopold, there is doubtless truth in this narrative, and it certainly gives a plausible reason for John Martin's plunge into the engraver's art. Charles Turner obviously did not care for Martin's subjects, and perhaps cared less for his method of painting them. The sum of £500 may have tempted him to undertake work that he found it distasteful to accomplish. It is no new story.

In mezzotint, we are told, unlike line engraving, the plate has first a series of chalk lines drawn upon it, about three-quarters of an inch apart. Between these lines a tool called a 'cradle' is employed, rocked over the surface till it presents the appearance of a file. Then new parallel chalk lines are drawn across the plate, and a similar series of lines worked across, cutting the former ones at right angles. After that the plate is worked again in the same way, from corner to corner, at an angle of forty-five degrees. The operation is repeated in graduated angles from sixty to a hundred times until the entire surface of the plate is

reduced to a 'burr' of infinitesimal size, which gives an impression on paper of a rich, velvety black.

When the plate is thus prepared the subject is wrought on it by scraping away the 'bur' in the lighter tones with a tool known as a scraper, and, in the high lights, polishing it quite smooth with a 'burnisher.' Its special quality is, we are told, to give richness and delicate gradations of tone to the values of a picture, and the engraver is able to work on it in much the same way as a painter on his picture.[1] This fact would naturally appeal to Martin, and as he evidently enjoyed going over his best-loved pictures several times, we may imagine that he found much pleasure in engraving them.

Leopold has told us that his father built " a substantial private printing establishment and convenient painting-room with an outlet into a back lane " on to his house in Allsop's Terrace, attached by a long gallery supported by iron pillars ; and this must have been some time in 1822 or 1823. It was not, says Leopold, " till the formation of a regular printing establishment under his immediate supervision that my father became fully aware of the importance and really great art required to understand fully the quality of various inks and to obtain a perfect knowledge how to work them, as well as how to use thick and thin oils. Workmen of the present day are little aware of the great debt due to John Martin for the present perfection in the art of printing, and for mezzotint engraved plates. The printing room under my father's studio was

[1] Arthur Hayden, *Chats on Old Prints.*

as nearly perfect as art could make it. He had fly-wheels and screw presses of the latest construction ; ink grinders, glass and iron ; closets for paper ; French, India and English drawers for canvas blankets, inks, whiting, leather, shavings, etc. ; out-door cupboards for charcoal and ashes—in fact, every appliance necessary for what my father was converting into a fine art. For with him the working of the various inks was really a high art, besides effecting a great saving of labour and valuable time to the engraver."

" At the outset he would pull a plain proof of the plate, using ordinary ink ; then work or mix the various inks. First, he made a stiff mixture in ink and oil ; secondly, one with oil and less ink ; and, thirdly, a thin mixture both of ink and oil. Lastly, he worked up various degrees of whiting and oil, with the slightest dash of burnt umber, just to give a warm tint to the cold white. In working, or inking, the plate the thick ink (No. 1) went to the darkest tints, No. 2 to the medium ones, No. 3 to the lighter shades ; the inks consisting chiefly of whiting being the most difficult to work and the most artistic. Separate dabbers were required for each description of ink. The greatest attention was needed in the use of the canvas when wiping off, so as to blend or harmonise the various inks, especially those of whiting. The blending or harmonising was really a task of great skill, to be acquired only by instruction from the engraver. *Joshua Commanding the Sun to Stand Still*, *Belshazzar's Feast*, and *The Deluge* were all engraved by the hand of John Martin."

Those who happen to possess these prints may be interested to know that they were engraved by the painter

himself, a fact which should give them a peculiar value as
curiosities in art some day, if not to-day. Leopold goes on
to tell us something of his father's workmen :

 "He found it a great difficulty to get time for the
artistic supervision and necessary instruction of workmen.
All the chief houses had been called into requisition—
Chalfred and Dawes, Lahee, McQueen and S. H. Hawkins
—but hardly any could, or would, supply hands. Formerly
the masters themselves performed such work for my father.
Mr. Hawkins would never permit anyone else to attempt
it ; he worked off every impression. Few copies, however,
could be worked off a plate in one day—not more than
eight or ten perfect impressions. Hence the great diffi-
culty in obtaining really good hands. The work did not
pay if taken by the piece ; only by the week. Indeed, of
such importance did the workmen look upon it, that one
really good hand in the employ of Mr. Lahee, named Wood,
who got but 30s. a week, demanded as much as £5 from
my father. A really clever man is worth nearly any amount
of pay. He can make himself a necessity to the mezzotint
engraver, not only by his skill in printing, but by doing the
work so as to preserve the plate as much as possible—a very
important matter when so few really fine impressions can
be obtained, especially from copper plates. My father
only uses steel. *The Fall of Nineveh* was the largest steel
plate produced up to the date of its publication. A special
paper had to be manufactured for it."

 We may take a few grains of salt with all this, but it
is nevertheless interesting as showing something of the
growing defiance of skilled labour nearly a hundred years ago.

Leopold Martin claims that his father was not only an experimenter in the art of engraving, but that the art was indebted to him for certain improvements. Writing of " the glorious blaze of light " in prints of *Belshazzar's Feast*, he declares that it was chiefly the effect of the combination of certain materials in the ink he used, and the result of his own experiments. Burnt oil, a quantity of whiting, and little Frankfort black, ground well together, were the ingredients, or chief ingredients, according to Leopold, who appears to have learnt something of engraving and printing from his father.

We may certainly believe him when he informs us that the illustrations of Milton were the first series of engravings executed by John Martin, and here we enter upon another phase of this extraordinary man's life. He became an illustrator, and a famous one. An engraving of his Marcus Curtius, made by the celebrated Henry Le Quex for the Annual, *Forget-me-not*, was so fine and so much appreciated that we are told the proofs sold for more than the annual itself, and the public demand was so great that 10,000 copies were sold separately. Mr. Ackermann sent one of the last impressions to Martin, in order that he might see what a first-class engraving could be ; from which we may assume that John was then trying his hand with the graver's tools. The Milton illustrations were chiefly designed by him on the plates, and very impressive they are. The *edition de luxe* I have seen (very large—I should say imperial quarto) gives one an exalted idea of Martin's genius, and, indeed, his Milton pictures are said to show him at his very best.

His engravings altogether did not lie open to the gibes
of captious critics who objected to his colours. True, the
critics fell foul of his figures as well, but in a small picture
the lack of dignity, of which they complained, was far less
conspicuous.

It is a matter for regret that no enterprising publisher
of his day commissioned a set of plates for Dante's *Inferno*,
which would have been a subject after Martin's own heart,
and one that he could, surely, have illustrated as no other
artist ever could.

The order for his Milton illustrations came from an
American publisher in London (Bond Street) named William
Prowitt, according to Leopold. They were twelve in number
and he received for them, as Martin tells us himself, the
sum of two thousand guineas. Leopold says that he had
fifteen hundred guineas more for a set of duplicate plates
of a smaller size.

He also informs us that the sale of his father's engravings
were even greater in the United States, China, and Japan
than in his own country. " Outside London, Manchester
and Liverpool were the chief markets," he observes, " but
more copies may be found in the folios of collectors in New
York, Boston, and Washington. In China and Japan they
may be seen in all houses of men of rank and education.
The plates have often been retouched and re-engraved,
but not by my father. The originals are therefore valuable,
the rest are worth little more than the paper on which they
are printed—at least in the eyes of collectors or
connoisseurs."

His Milton illustrations were succeeded by a set of

plates for the Bible, also designed on the plates, a commission from Ackermann, the dealer, who had first ground him down when he was almost starving. He did not recognise Martin as the poor youth who had sold him a number of drawings for a guinea or so, and John was too proud to tell him. The artist must have chuckled over the large sums paid him by Ackermann in royalties on these and other engraved pictures. But they were not the first sold to Ackermann since that first sordid transaction of his boyhood ; for we read in the Reminiscences that " Mr. Ackermann reminded my father that he might claim the honour of being his first publisher—the one to publish in the year 1816 a series of etchings on copper, illustrations of English forest trees." We can imagine the conversation ; the bland dealer rubbing his hand and fawning upon John, who would gravely listen, with a twinkle in his humorous eyes, and make no comment to this effusion.

Apropos of engraving, Leopold tells us an anecdote about Sir David Wilkie which may be new. He had, says the writer, a very strong aversion from seeing any of his work reproduced in wood engraving, in spite of his high opinion of the great engravers of his day, Bewick, Thomson, Williams, and others; and could never be induced either to draw on the block himself or let anyone else do his pictures.

Allan Cunningham, however, his great friend, managed to persuade him to promise a frontispiece for his poem, *The Maid of Elvar*. Cunningham was delighted, knowing

the value of such an illustration, and provided the artist with a well-prepared block, the proper pencils, and other necessary materials for a wood engraving.

Days passed, weeks rolled into months, but no drawing came to hand. Cunningham pleaded, Sir David protested he had no time. At last, however, the block was sent. But on it was—not a pencil drawing, such as John Thomson could cut, but a highly-finished painting in oil-colour of a Highlander with his pipes !

The picture was, nevertheless, eventually engraved on steel by one of the Findons, and formed the title-page to *The Maid of Elvar*.

Martin supplied a good many such small pictures. Beside his illustrations of Milton and the Bible there is an edition of *The Pilgrim's Progress*, published in 1830 by John Murray, Albermarle Street, and John Major, Fleet Street, which has two copper-plate pictures by him as frontispieces to Parts I. and II., *The Valley of the Shadow of Death* and *The Celestial City*—both engraved by W. R. Smith. Southey contributed a Life of Bunyan to this edition, which is somewhat rare.

I have been fortunate in obtaining the loan of a most interesting account-book belonging to John Martin through the kindness of Mr. Hardcastle, of Newcastle, who acquired it at a sale some years ago. It contains the painter's royalty accounts with leading print-sellers in London and elsewhere during the years 1828-41, and was kept by his eldest daughter, Isabella Mary, with masterly precision. Her beautiful clear handwriting would be like copperplate

were it not for a definite character of its own that shows the woman she was. John Martin, we know, leaned upon her all his life, found in her not only a devoted daughter, but a perfect secretary and amanuensis. Her many great qualities have been illuminated by her family down to this generation, and she was, apparently, loved and adored by her brothers and sisters.

We find, from her accounts with Ackermann (Strand), Moon, Boys & Graves (Pall Mall), Molton (Pall Mall), Agnew and Zanetti (Manchester), Grundy and Fox (Manchester), Linnecar (Liverpool), Freeman (Norwich), Lambe (Gracechurch Street), and others, that John Martin made a considerable sum by his royalties on engravings alone, as well by their sales outright. Ackermann paid him (between 1828 and 1836) £3,000 8s. 8¼d. ; the Moon firm (between 1826 and 1834), £2,105 19s. 4d. And altogether he seems to have been paid £18,430 9s. 4½d. during the years in which these accounts were rendered. In another part of the account-book (which is a strong volume bound in white vellum) we find a " List of chance subscribers to Mr. Martin's print of Belshazzar, 1826-36," which shows that the sale of this one engraving brought him £1,806 8s. 6d. Think of the number of these pictures that must have been sold ! Where are they all now ?

On one page we find :

Received by cash for proofs, etc., of Belshazzar and Joshua from Nov. 24th, 1826, to November 30th, 1827. the sum of...................... £691 18 0

On another :

1828	13 as 12 prints Belshazzar	73/6	44	2	0
June 6th.	do. Joshua	63/-	37	16	0
Aug. 1st.	do. Belshazzar	73/6	44	2	0
	do. Joshua	63/-	37	16	0

		£163	16	0
25 per cent.	40	19	0	
	£122	17	0	
5 per cent.	6	2	10	

Paid J. M. M. £116 14 2

Every separate account bears, at its left-hand corner, the word and initials, "Paid J. M. M."

We learn from this book that an unlettered proof of *The Deluge* cost 210s. (ten guineas), whereas the lettered ditto was worth 105s. ; that *Belshazzar's Feast* was priced, in 1828, at ten shillings more than *Joshua*, and the prices of both went up in 1831-3. *The Fall of Nineveh* apparently remained stationary at five guineas. But, on the whole, it seems clear that Martin's prices improved as time went on, up to 1843, when he appears, from the following letter (kindly copied for me by Mr. C. B. Stevenson, Curator of the Laing Art Gallery, Newcastle) to have a supply exceeding the demand.

"London, 30, Allsop Terrace New Road,
May 22nd, 1843.

" MR. LINNECAR.

" DEAR SIR,

"It is some years since I heard anything from you, or have had occasion to write on business as I have

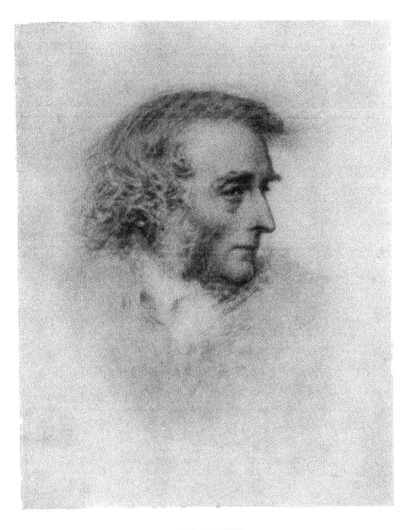

JOHN MARTIN.
From the drawing in chalk by his son, Charles Martin. (*Laing Art Gallery.*)

p. 160

not been publishing anything new. Last year, however, as you may possibly know, a Mr. Gilberts of Sheffield published my latest plate, the '*Eve of the Deluge*,' from the picture in Prince Albert's collection—but I never heard whether it was seen or circulated in Liverpool. If it has not fallen under your notice the size and prices are as follows: $25\frac{1}{2}$ inches by $15\frac{1}{2}$ price unlettered proofs—3 gns —lettered 2 gns—prints 1 gn. Now of this plate I effected a very large exchange with the proprietor with the view of exporting largely to America, but I own from the present state of the market I am afraid to proceed farther, until I have better probability of success, and as I do not wish to keep so much dead stock on hand, I am looking about me to clear out some of it. If the plate has not been seen in Liverpool I should think its small size and low price would alone be likely to attract, and if you think so also, and are willing to enter upon the speculation, I will offer the most liberal terms. My wish is to dispose of a certain number out and out and thus get rid of them altogether. The number I think to be the smallest I could sell in this way would be 25 prints for £12 cash ; the impressions are all good and on fine paper. I have a few unlettered and lettered proofs but this I cannot sell at less than 50 per cent.

" Whatever may be your views let me know by return of post.

" And in the meantime I remain, Dear Sir,

<div style="text-align:center">" Yours very truly,</div>

<div style="text-align:center">" (*Sgd.*) JOHN MARTIN.</div>

" Mr. G. Linnecar,

Liverpool."

L

It is a business-like letter, and if not composed by Isabella (as it probably was), shows the practical side of our great painter, that side which will be shown in further correspondence of his on a different subject later.

Whether *The Eve of the Deluge* was a less popular picture than some of his others, or whether a ' slump ' had occurred in his engravings through over-production, when the above letter was written, we cannot say. But it is certain that between 1826 and 1840 Martin must have made at least £21,000 by his engravings alone, including the Milton illustrations, and probably a great deal more, if it be true that he received £1,500 from the American firm for smaller drawings of the Milton pictures. But of this we have no positive evidence at present.

CHAPTER X

The Annuals and John Martin's connection with them. His amazing output of work during the years 1821-8. Friendship of th Martins and Tenniels. Marriage of Leopold with John Tenniel's sister. The Pot Luck Club. Martin called a 'Radical Revolutionary.' Story of Hogg and young Mrs. Burns. Martin's walks in the country with Serjeant Thomas. Change of address between 1824 and 1828.

THE year 1822 (or 1823) saw the birth of the Annual in England, that elegant compilation of poetry, prose, and picture which conquered Victorian society and was the parent of our later Christmas annuals. It was not, however, intended to cater for the general public, as our modern productions are, being rather an appeal to more cultured taste and well-filled pockets, for only the affluent could afford to indulge in a copy. At first its price was 12s., which afterwards rose to a guinea ; but as the years went on and its popularity increased, the competition of publishers forced the price down to half that sum and even less.

The first Annual, *Forget-me-not*, published by Ackermann (upon a German model), was an ambitious production ; its literary contributors were among the best of their day, and it must have had a certain quality sadly lacking in most of its descendants.

It reached high-water mark in 1828 when Harrison

Ainsworth, with Charles Heath, the engraver, produced *The Keepsake*. This was a most expensive production, costing £12,000 [1] and selling at a guinea. Ainsworth himself was represented in it, Sir Walter Scott, and others as renowned in their time, if to-day forgotten. But the Annual's deterioration was steady after the thirties, if we may judge from the specimens I have recently seen ; and anyone who wished to study mid-Victorian literature at its worst could not do better than dip into some of these feeble volumes.

Here is the table of contents to one, edited by Emmeline Stuart Wortley, published in 1837. It is called *The Keepsake*, and contains the following choice morsels :

> *Thursday Morning*, or the Bachelor's House, by the Lady Dacre.
>
> *I am come but your Spirits to Raise*, by Lady E. Stuart Wortley.
>
> *Francesca Foscari*, by the Countess of Blessington.
>
> *The Sea ! The Sea !* A Tale, by Lord Nugent.
>
> *Polish National Hymn*, by the Lady Charlotte St. Maur.
>
> *The Orphan of Palestine*, by Lord William Lennox.

It will be seen that lords and ladies are 'plentiful as tabby cats' in its pages, and that its patrician editor did not disdain to trade upon their titles for the purpose of attracting a snobbish public. It was, of course, the palmy day of 'ladies and gentlemen,' who were not then to be found behind counters or serving machines in workshops ; and we find in another Annual (*Friendship's Offering, a Literary Album and Annual Remembrancer*, 1829) that

[1] S. M. Ellis, *Life of William Harrison Ainsworth.*

distinctions were sharply drawn. For, side by side with *Love and Sorrow*, by the late Henry Neale, Esq., and *Leaving Scotland*, by W. Kennedy, Esq., stands John Clare, the ploughman-poet of Northamptonshire, plain and unadorned even by a ' mister ' !

It is astonishing to read what fudge these persons of quality could write, and still more astonishing to think that a public could be found to swallow, without nausea, their effusions. Perhaps the decent fare offered by the first Annuals lured the public to buy without tasting those that came after ; but it is only too evident that, as time went on, the Annual became a pleasant meadow for the aspiring amateur to sport in. Every ambitious scribbler who could afford it started to edit an Annual and contribute to its pages any old manuscript that the professional press had refused. This theory alone can account for Lady E. Stuart Wortley's *Keepsake*, which, among other gems from her pen, gives publicity to doggerel beginning as follows :

> " How d'ye do—how d'ye do, my dear Jane,
> I have volumes to tell you indeed,
> I'm enchanted to see you again ;
> What a life we young ladies do lead !

> " To be sure, since your poor father's death,
> You've been locked up and blocked up at home,
> Like a sword left to rust in its sheath,
> Like a plant left to pine in its gloom."

There are twenty-four stanzas of this inspired poesy, some better and some worse than the foregoing, but these will serve to show the quality of Lady Emmeline's genius and give some idea of the matter provided by the later

Annuals, whose aim was, according to one editor, " to increase the sources of innocent amusement . . . while conveying some fine moral or religious sentiment." They soon began to be adapted to religious aims, with temperance, missionary, or other definite objectives, and we find among the hosts of titles *Forget-me-not, Keepsake, Book of Beauty, Book of Gems, Literary Souvenir, Iris, Elegant Extracts*, and the like. In *The Christian Keepsake* and *Missionary Annual* the pious editor starts his preface thus :

" The cultivation of taste for the fine arts has ever been a source of pleasure and improvement to the virtuous and intelligent patrons of society ; and the extent to which this taste now prevails has secured for the Annuals, which blend with literary excellence embellishments of a high order, very general approbation. . . . It has been considered that a volume more decidedly religious would be peculiarly acceptable to a large portion of readers, and, to supply this desideration, *The Christian Keepsake and Missionary Annual* is now offered to the public."

But even in the religious Annuals it is easy to recognise the personal yearning for publication of their reverend editors protruding from the ' Table of Contents.' In *The Iris : a Literary and Religious Offering*, of 1831, the Rev. Thomas Dale starts off with an unblushing travesty of the *Ode to the Nativity*, and sprinkles his other lucubrations plenteously through the volume, obviously resolved to be no mute inglorious Milton while it is possible to publish an Annual and shine upon its pages !

Curiously enough, in *The Keepsake* of 1837 we find poems over the names of Alfred Tennyson and Edward Fitzgerald. But it seems almost impossible that one of the greatest of our poets could ever have written lines so void of poetry or sense as the following :

> " The Sabbaths of eternity—
> One Sabbath deep and wide :
> A light upon the shining sea,
> The bridegroom with his bride."

Long after the verse, stories and essays of the Annuals had descended to this fatuous level, their " embellishments " continued to be of a high order. The accompanying pictures are generally good, even in the cheap successors to the original Annuals, and we come across, here and there, exquisite steel engravings from the hands of such well-known men as Le Keux, H. Robinson, J. T. Willmore, C. Heath, E. Goodall, etc.

Martin was among the first, and was often his own engraver. So on this account, apart from its interest as a souvenir of other times, a *Keepsake*, a *Forget-me-not*, an *Iris*, an *Amulet*, or any other of these elegant Victorian productions may be a valuable possession.

Leopold Martin gives the story of the Annual's inception.

" It was in the year 1828, as far as my memory serves," [1] he writes, " that my father's old friend, Mr. R. Ackermann of 96, Strand—the first who opened an art gallery in London, and certainly the originator of them in all great towns in England [2]—also introduced quite a new speculation in

[1] It was in 1822-3. [2] Can this be substantiated ?

publishing. It was in the form of an elegant Annual, with the title of *Forget-me-not*, and consisted of a compilation of short stories and original poems by authors of high standing, together with a series of engravings from the hands of the most celebrated line engravers, either from original designs, or from well-known pictures by the chief artists of the day. The publication of the work proved so novel that it formed quite an era in the literary world. Such was the success of Mr. Ackermann's *Forget-me-not* that it was followed by at least ten or twelve of like description, all under the editorship of distinguished authors, or the superintendence of persons equally well known, such as Mrs. S. C. Hall, Mr. Thomas Pringle, Mr. E. B. Lytton Bulwer, Mr. A. A. Watts and others, including Lady Blessington and Mr. Thomas Heath, the distinguished engraver."

He then tells us about Henry le Keux's wonderful engraving of his father's sepia drawing of Marcus Curtius and further informs us that the same engraver also reproduced his painting of *The Crucifixion* as an illustration for Mrs. Hall's *Amulet*, issued the following year ; and that his first picture, *Sadak*, reappeared in a more expensive Annual, *The Keepsake*.[1]

It has been remarked that John Martin's work showed to great advantage in these little pictures, where " the smallness of the scale and the absence of colour enables us to appreciate the grandeur of his conceptions without being too strongly reminded of his defects " (*Dictionary of*

[1] The price of *Forget-me-not* was 12s., *The Keepsake* a guinea.

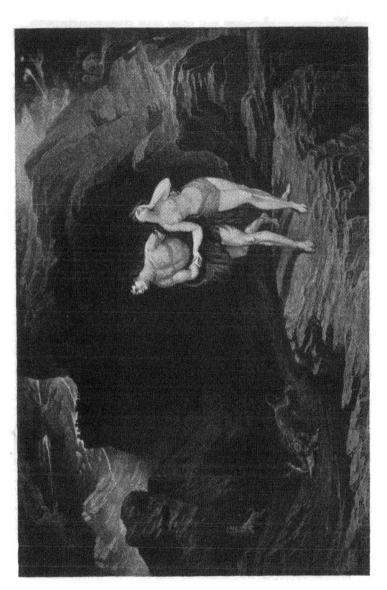

ADAM AND EVE EXPELLED FROM PARADISE.

(One of John Martin's illustrations to "Paradise Lost.")

p. 168.

National Biography), and Charles Lamb, writing to Bernard Barton, the Quaker poet, on receipt of his *New Year's Eve and Other Poems*, to which Martin had engraved the frontispiece, says : " Martin's frontispiece is a very fine thing." It is not easy to trace how many of these small pictures he drew or engraved, but from allusions in the reminiscences of Leopold Martin and Ralph Thomas, we may conclude that he was represented, not only in many of the Annuals but in frontispieces to books of the day by authors over whom the cobwebs have grown.

Was there anything on earth that John Martin did not essay to paint or draw ? How he found time to paint his great subject-pictures, his scores of landscapes, and to draw and engrave illustrations to volumes of poetry and works on geology, as well as the *Bible, Paradise Lost,* and *The Pilgrim's Progress* in those years of his prime must remain a mystery. Surely his days must have been twice as long as those of the average man ; and when we read a letter to him from Joseph Toynbee, offering to call and discuss a certain important matter with him at 7 a.m., it is possible to realise how little time is wasted by those who have devoted their lives to great aims.

And, besides his art, Martin had other great aims which devoured not only his time but the money gained by his genius and labour. These have to be dealt with in a later chapter, though they were occupying much of his thought at this period of his vital and extraordinary activity, when he was at the zenith of his fame and money flowed into his coffers. The carking shadow of debt that threw its gloom over his path a little later on, had not yet begun to haunt

him. Like many another artist, John Martin could not keep money. Anyone could wheedle it from him, and his huge circle of friends assisted him in spending it. Some of these friends were as great and as disinterested as Martin himself, and it would be pleasant to linger over Leopold's pen-pictures of them. Of Samuel Rogers, "whose break-fast equipage was a wonder of refinement and perfect-ion ; the china being of old Chelsea, Battersea, Derby, or Worcester, the silver either Queen Anne or still older English."

Of John Jackson, R.A., who "had no particular artist's window but many which were all darkened by thick blinds, an advantage to a portrait painter."

Of Thomas Alcock, the distinguished surgeon of St. Thomas's Hospital, who "had devoted much study to the beautiful art of modelling in wax, chiefly that of anatomical subjects," with a minute description of his process in repro-ducing a cast of the face.

Of Allan Cunningham, whose brother, Peter, married Martin's second daughter, Zenobia ; of John Hunt, Luke Clennan, Sir Charles Wheatstone, William Etty, "a short, thick-set, slip-shod, slovenly person, strongly marked with small-pox, whose conversation was generally confined to the one subject of art, which made him, to artists only, a charming companion," and many others, too many by half to set down here.

It is only necessary to mention that Leopold married the sister of one of these famous personages—Sir John Tenniel. The Martins and Tenniels were early friends, and the children of both families played together. We have

Leopold's word for it that John Tenniel received his first commission through John Martin, who introduced him to John Murray, the publisher. It was for a hundred illustrations to *Æsop's Fables*. The following paragraph may be of interest :

" Few who are in the habit of seeing Mr. John Tenniel's well-dressed and well-mounted figure in the Row in Hyde Park can be aware that the moustachioed, whiskered, and ruddy-complexioned, handsome face, really bears an unobservable blemish, if it may be so called, for it is really ' unobservable.' It was the result of a melancholy and truly unfortunate accident. While at practice, when quite young, with his father, an accomplished small swordsman, the button unhappily came off the point of the father's foil and, both being without masks, touched the eye of John Tenniel. The father never knew what frightful injury the touch had done. The secret was religiously kept by the son and everyone else ; yet the stricken eye was blinded for ever ! Who would think that the mass of beautiful and artistic work produced by John Tenniel resulted from a single eye ? "

It was a circle of light that John Martin moved in then, the light cast by a galaxy of starry names. Other biographies have shown their splendour. John Forster in his Life of Charles Dickens, S. M. Ellis in his Life of Harrison Ainsworth, Lewis Melville, in his Life of Thackeray, etc., and the only strange thing is that, in these exhaustive memoirs the name of Martin does not appear. We read of Cruikshank, of Macrone, of Maclise, of Leech, of Landseer, of Wilkie and dozens more, but not a word of Martin ! It

would almost seem like a conspiracy of silence. For Martin
was friendly with all these men, and most of them met at
his weekly, gatherings.

It is possible that the literary and art clubs, now so
numerous in London, originated, as Leopold Martin suggests,
from the Evenings at Home held in John Martin's house.
Before the Athenæum Club was started in 1824 no meeting-
place existed for the association of men known in literature,
science and art, except in private houses. The few clubs,
such as the Army, Navy, or United Services were each
confined to a particular class, and were not only exclusive
but expensive. The little coteries formed at the Mermaid
in the sixteenth century and Button's Coffee House in
Addison's day can hardly be accounted clubs, although the
idea doubtless originated in Shakespeare's time and the
word ' club ' was used as we use the word ' bill ' now.
" After paying my club," Pepys writes in 1660, when he
leaves the Mitre or other tavern. It is amusing to read
what our garrulous Leopold has to say about the first
literary club in Victorian London :

" Feeling the want (of a club) a very serious one, Mr.
William Jerdan, editor of the *Literary Gazette*, combined
with Mr. Andrews, the well-known bookseller and publisher
of Bond Street, Mr. Alaric A. Watts, Mr. John Britton (' little
Britton '), the distinguished archæologist and author, Mr.
Murphy, father of Mrs. Jameson, so well known by her
works on painting, and some others, to get one. In the
first instance, they proposed the formation of a friendly
association to be termed ' the Pot Luck Club,' the members
to meet once a week at each other's houses and partake

of whatever plain repast accident might have placed on the table—pot luck, in short. It was the feeling that such meetings would be, at least, genial, friendly, and pleasant, and likely to be popular.

" It fell to the lot of Mr. William Jerdan to hold the first ' pot-luck ' meeting. The abode of Mr. Jerdan was an important one—Grove House, Brompton. He himself was a *bon vivant*, and the dinner, though perhaps in his usual style, was luxurious and costly, not like the ' pot-luck ' of most of the members of the club. The following meeting fell to the lot of Mr. Andrews, a regular ' dinner-giver,' and he made his even more *recherché* than Mr. Jerdan's. The wines were of the best and of the greatest cost ; in fact, everything was epicurean to a degree. Mr. Britton, my father, Mr. Murphy, and other members took fright. Could this be what was intended ? Was this ' pot-luck ' ? The next meeting was put off ; most members were only too glad to do the same, and abandon what might ultimately result in serious inconvenience. The Pot-Luck Club no longer existed ; it was dead, to all intents and purposes— killed by its own members."

A not uncommon experience, and one bearing its own moral. Leopold continues :

" Soon afterwards my father was invited to join a few friends with the intention of forming a committee to organise a new club, to be termed ' the Literary Union.' . . . Thomas Campbell, the poet, was elected chairman ; Cyrus Reading, also an author, secretary. The Committee included Mr. C. W. Dilke, founder of the *Athenæum*,[1] a journal renowned for the lofty tone of its articles and the asperity of its

criticism. The name of Mr. Dilke sounded a note of terror
in the imaginations of all humble authorlings, for it had
become a synonym of merciless, critical excoriation. My
father and Mr. C. W. Dilke, junior, afterwards Sir C. W.
Dilke, Bart., with some others, composed the working
committee.

"A house was taken in Waterloo Place, and, for a time,
all went well. The Literary Union obtained a certain
class of members, but it could not be expected to vie with
the Athenæum, into which club first one and then another
obtained admission. My father retired from the Athenæum.
He had been elected by the committee a member ; they
having the power to elect a limited number of persons
yearly who had attained distinction in literature, art, or
science. The number was limited to nine. To be elected
was a marked honour. All other members were chosen by
ballot. After a few years the Literary Union was reformed
under the title of 'The Clarence Club,' when it became more
noted for its free luncheons of 'biscuits and bitter,' and for
its cuisine, than for its members, who consisted of all
sorts and conditions of men. It no longer exists as a
club."

It is probable that the Pot-Luck Club was identical
with, or grew out of a gathering that Ralph Thomas calls
'The Club,' which met every fortnight (in 1832) at the
houses of its members. It was the custom of this club, he
tells us, for each member to draw a paper from a hat, and
whoever drew the lowest number had to open a discussion,

¹ C W. Dilke acquired the *Athenæum* in 1830.

choosing his own subject. Martin often took part in these discussions, and always spoke well, but he never would stand up and make a speech.

" Sir Thomas Lawrence," he once said, " proposed my health at a dinner at the Freemasons' Tavern, but I felt tongue-tied. I had neither strength, courage, nor presence of mind to utter a word." On another occasion, when he and Thomas were in the Lobby of the House of Commons together, Martin said : " Much as I love to hear speeches and esteem speech-making, I never could speak in my life and never shall be able to put a dozen sentences together in public."

It was not that he had nothing to say—far from it. Everything points to his having been a great talker and a keen debater. When roused, he evidently forgot himself and his nervousness. Ralph Thomas gives a somewhat amusing account of his behaviour at a dinner given on the anniversary of Robert Burns' birthday. It was in 1832, and they met at the Freemasons' Tavern—Martin, Burns (son), Allan Cunningham and others. Thomas spent the next evening with Martin at his house, and the latter regaled him with a description of what had taken place the night before.

" There was no unity of feeling in the affair," he said. " The speeches displeased me, and I could not help hissing. I was so disgusted with their Tory sentiment ; they were out of place in commemorating the memory of Robert Burns. When I hissed some person cried out, ' Knock that fellow down.' I looked for the utterer and scowled on Mr. Logan, who had turned savagely at me. I said to

him, smilingly, knowing him, ' How do you do, Mr. Logan,'
and kept on hissing, while the Tory boasts were persisted
in.

" It is a disgrace to Scotsmen to have so neglected Burns
while he lived, and the sentiments uttered that night were
at variance with all Burns's feelings, writings, and actions.
They excited me.

" Allan Cunningham said : ' Burns was not so badly
off with £70 a year, Martin, as you suppose ; and the sale
of his poems, especially the second edition, brought him
a considerable sum.' I replied : ' His father was steward
to a gentleman and had only £20 a year. It was too little
to support a wife and family. Burns's independent spirit
always kept him down. He was too noble for his age and
country. Scotland owed him much, for he had caused
thousands of persons to like the Scotch for his sake. He
had gained a world's admiration by his independent writings,
but he lost the support of the rich, and men must be pre-
pared to suffer if they indulge in the luxury of independent
expression.' "

It would be interesting to know what were the ' Tory
sentiments ' that set Martin hissing (as he did, be it remem-
bered, after Queen Caroline's death, when *God Save the
King* was sung, the King being our unspeakable George IV.).
They were probably sentiments that the Tories of our day
would hiss at as heartily. But Martin was regarded as a
revolutionary in those days. He was, says Thomas :

" A Deist in religion, a radical reformer in politics, an
independent and unselfish in art, and conscientiously honest
in all things. I need hardly add that he found opposition

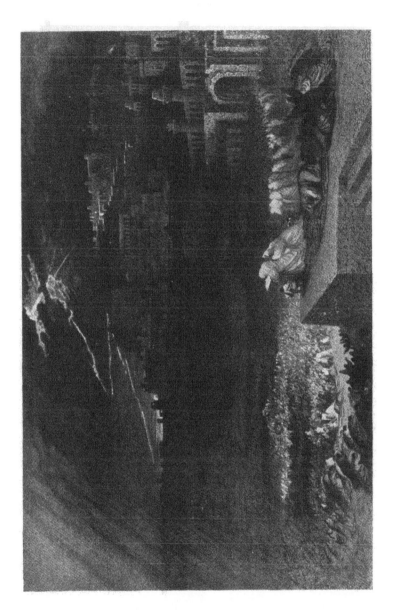

THE REPENTANCE OF NINEVEH.

p 176.

general and distaste to his principles and opinions very frequent. But he seldom proffered his opinions or sought discussion even of his hobby horses."

He was a ' radical reformer ' in good company, at all events. Charles Dickens must have been a man after his own heart. Both had known the upward fight and struggle, and were unable to forget their early sufferings.

One other entry from Ralph Thomas's diary of 1832 affords a quaint picture of Martin's circle at the time.

" Last night," he says, " I took tea with Stebbing, after which we went to Martin's. There we found Hogg, the Ettrick Shepherd, Mrs. Burns and Captain Burns, the youngest son of the poet, Allan Cunningham and wife, Godwin, Pringle—and about a score more. I take Hogg to be about fifty-three, very strong and healthy, the heartiest old cock I ever met. He sang two songs of his own (I believe) which were encored. He sang ' Paddy O'Rafferty ' with much power ; his voice has a mellow, rich sound, sharp by turns with sweet upper notes, and he has a taste which gives his singing uncommon life. I never heard a song sung with more spirit, and when he came to one part he would slap the shoulder of Mrs. Burns, who sat beside him, hug and cuddle her with his right arm in so hearty a manner that, after the first shock, we were all much amused. Mrs. Burns, with the best possible good nature, laughed at it as much as any of us. And this friendly familiarity each time seemed to strike new fire and feeling into his old mountain flesh.

" I was delighted by him, for, with uncommon politeness, he addressed me by name—drank to our better

M

acquaintance, and promised to come and see me. I am
sorry to add he forgot to keep his promise.

" Burns is a modest, unassuming man. Pringle says
he resembles his mother. His features are regular, but
Hogg and Cunningham, especially when they laugh, splutter
and display a huge quantity of gums and jaws. Allan
(Cunningham) sang ' Barring o' the Door Well ' ; C. Land-
seer sang ' Olden Time ' ; Martin regaled us with ' The
Gypsies ' and another song, in his favourite minor key, and
Burns gave us ' The Castle of Montgomery ' and others, all
his father's. I had asked Martin to sing the ' Castle of
Montgomery,' knowing how sweetly he sang it, and thinking
it would specially please all the Scotsmen, but Hogg said
no one should sing Burns's songs but his own son while he
was present. Burns sang softly and sweetly, but not to
advantage after Hogg. . . . Then we had a chat, supper,
and speeches till a very late hour. I walked home with
Stebbing and he told me his early history."

Queer, contradictory old days of Victoria, when speech
and manners were so formally precise, the proprieties so
easily outraged, yet men indulged in orgies of emotional
sentiment as they indulged in vinous convivialities, without
stint or shame ! These quaint journals bring them before
us very vividly. We hear John Martin hissing at the Free-
masons' Tavern, or singing " The Gypsies " in his own house,
or taking huge walks with Ralph Thomas and regaling
himself on bull's eyes and brandy-balls between his pæans
of enthusiasm for the landscape around him.

" These trips," writes Thomas, " were as mentally
charming to us as they were physically beneficial. We

mingled mutual instruction with each springing delight, and nature reciprocated our rational joy. As Martin arrested my steps or speech to point out various lovely ' forms and shows ' of nature in her grandeur and sublimity, while he was wrapt in idolisation, I would apply some apt passage of a cherished author, which would appear to electrify him, and his steadfast eye would be fixed upon mine till I had concluded, when he would bound on like a startled hart. Sometimes his joy would find vent in song, and at other times he would quote some favourite passage, either of Milton, Gray, or Collins. . . .

" This commingling of nature and art was to me an inexhaustible feast. But love cannot live on flowers, and on these occasions we smoked squibs and ate lollipops. I call to vouch (for this) every old woman keeping a small window for the show of sweetmeats within ten miles of Allsop Terrace, boxing the compass in the direction of green fields. What customers John Martin and I have been to them for brandy-balls, toffy, and bull's-eyes ! We cleared their bottles and kept the supplies fresh for younger children of the vicinity."

" Younger children " is good. How young they felt may be gauged by it, and by the next sentence :

" After reciting the divinest passages of some of our mighty men of mind, Martin would say : ' After that a bull's-eye,' or, ' That deserves a brandy-ball.' "

A year later Thomas writes :

" I spent the evening with Martin. We walked home with Graeff and Constable, the landscape painter, from the Western Literary Institution, after Moscati's lecture

on Improvisation. Took bread and cheese and grog with Constable at his house in Charlotte Street. After showing us some of his pictures, he told us he had worked in a mill as a miller, after he was a man, and up to that time he had never touched a brush. . . .

" Stebbing had made a foolish speech about Martin and the Royal Academy the week before, at his Club night, which Constable talked about and told us how he had answered. He said : ' I showed them that if there was any blame anywhere, it was with you, Martin, for not complying with the rules of the Society. But that you need not mind being left out of the Academy ; they could do you no good. I said that John Martin looked at the Royal Academy from the Plains of Nineveh, from the Destruction of Babylon, etc.,' and added, ' I am content to look at the Academy from a gate, and the highest spot I ever aspired to was a windmill ! ' He went on comparing himself with Martin, speaking of himself and his work with earnest humility, and of Martin with the highest eulogium. There were several men, he said, that he should like to see in the Academy, but Martin had gone beyond the point at which it would have benefited him. His pictures were sold at prices higher than if he had placed them in the Academy Exhibition, and he was as universally known as any member. In conclusion he observed : ' I felt the wish for a change in the rules and regulations while I was working my way up ; but I was not, I confess, bold enough, or independent enough, or rich enough, to make the necessary resistance to effect any reform.' "

" Constable was a very prudent man," observed Thomas, in conclusion.

Another entry of the same time (1833) tells of a walk home with Atherstone, who showed him an article he had written on Martin in the *Edinburgh Review* for June, 1829, for which he had not been paid till that year. He, Atherstone, had applied many times for the money unsuccessfully, but hearing that Jeffrey [1] was in London he called upon him, and next day received a cheque for £20. This fact, so casually mentioned, throws a vivid light on the estimation in which John Martin was held at that date. One of the leading reviews pays a critic £20 for an article on him !

The statements of Ralph Thomas are generally to be trusted. He leaves a blank space in his diary whenever he is not sure of his facts. For instance, in July, 1832, he quotes John Martin as saying :

" The Emperor of Russia, when here, held up both hands, with expressions of delight and amazement while looking at —— "

The name of the picture is evidently forgotten and the diarist does not hazard a guess. But whatever the painting, the fact stated may well be true, since we know that John received a diamond ring from Nicholas I.

We find that Martin changed his address again between 1824 and 1828. His *Design for the Seventh Plague of Egypt* was sent to the Academy from 19, Charles Street, Berner Street, in 1824 ; while *The Fall of Nineveh* in 1828 went

[1] Francis Jeffrey, critic of the *Edinburgh Review*.

from 30, Allsop Terrace. *The Dictionary of National Biography* says that his address was Charles Street in 1837, but that must be an error, since we find *The Deluge* noticed in the Academy list of that date as coming from the other address. What happened we have no means of discovering. John may have let his house, or, in the hour of his prosperity, have taken for a time another house in the West End, away from his printing works. His occupation of the Charles Street house may have been longer than four years, as his pictures would be sent from the studio in the ordinary way, and bear its address. But as I find no mention of Charles Street in either of the memoirs before me, I conclude that he was not there long. Leopold, indeed, tells us that " after thirty years' residence in Allsop Terrace, my father removed to the only other house he ever occupied " ; but Leopold's memory is not always to be implicitly relied upon. It is possible that John Martin took the West End house only while the extensive alterations of his house in Marylebone were in course of progress.

In 1833 we find him giving an exhibition of his own pictures in the Lowther Arcade, as the following letter to William Jerdan shows. William Jerdan, it will be remembered, was a writer and critic of importance in Martin's day. As editor of the *Literary Gazette* for over thirty years, he wielded a powerful influence on contemporary art and literature, and he wrote also for the quarterlies. His autobiography, in four volumes, covers most of the period with which we are dealing. He was the intimate friend of Dickens, Ainsworth, and many other celebrities, including John Martin.

Here is the letter. It contains an allusion to another matter, which shall be dealt with further on.

> " 30, Allsop Terrace, New Road.
> " *Monday, March 11th*, 1833.
>
> " MY DEAR JERDAN,
>
> " I have been so much gratified with your articles on the National Gallery that I cannot refrain from writing to express how perfectly I agree with you in all your notions. I know nothing of Mr. Wilkins, but the poor man seems to be so egregiously vain that it is evident nothing can be done with him, or one might feel tempted to destroy him with his own weapon—' *the pure Greek.*' I sincerely trust, however, that the eyes of the Public are *now* sufficiently opened ; and that, in spite of the Royal Academy support, they will not allow the creation of another incongruous building to rival the (according to Mr. Wilkins) *universally admired London University.* As you mentioned that you intend to open a few remarks on a National Gallery, I was on the point of sending a few prints for your approbation, when I saw an article, by a lover of the Fine Arts, in the *Times* of this morning, which so exactly expresses my sentiments, that any person who had heard me speak on the subject would imagine that I was the writer. If you have not seen the article let me request you to look at it ; for the remarks on the necessity of having the Gallery in a fine *airy* situation, are most just ; it is, indeed, impossible to *preserve* pictures in a proper state unless the air is good. The objections made by some to the situation of the Regent's Park for the Royal Academy, because it is out of the way,

will scarcely hold good, when we consider the immense number of persons who annually visit the Zoological Gardens, as there are more visit them in three months than visit the R.A. in the whole season—and every individual pays 1s. Besides the R.A. is an established exhibition and the people *would* go out of the way to it.

" I am going full tilt against our self-styled patrons of the Fine Arts, who endeavour to ruin us independents ; and as they will not give me an opportunity of showing my works decently at *their* exhibition I have determined on setting up for myself, and am on the eve of showing all my works at present in my possession in the Lowther Arcade. My rooms are not very convenient, being some-what too small, but I trust that you will honour me with a visit.

" On Friday evening next (15th) my friend Mr. Donald-son will give a lecture at the Royal Institution on my ' plan for correcting the drainage of London by preventing the sewage from being thrown into the river, for preserving the manure, *etc.*, and I mention it to request that you will, if possible, favour me by attending it, as it is a subject of great public advantage ; and I think will not prove un-interesting, especially at the present time. I have con-siderable support in high quarters, but am very desirous of its being made public. If you should feel inclined to give any description of the plan, I have enclosed a copy of my paper containing the details, as it might be of some service. Mr. Donaldson most likely will describe it differently ; but will not deviate from the points or the order of arrange-ment. If you go to the R.I. and have not enough tickets

for yourself and friends, let me know, and I will send you as many as you require.

" So much of your time is occupied, I ought to apologise for the length of this communication, and do so most sincerely. With compliments to all your circle I remain,

" Yours most truly,

" JOHN MARTIN.

" William Jerdan, Esq."

It is possible that this was not John Martin's first exhibition of his own pictures in London for, as we have seen, *The Fall of Nineveh* was on view at the Western Exchange in Old Bond Street on May 17, 1828. There is other evidence to show that this was a private venture.

CHAPTER XI

John Martin at the height of his popularity. Frith's tribute to
his personal appearance. The ' Radical Hat.' Contemporary
appreciation of Martin's work. Gift of Sèvres China from
King Louis Philippe.

FROM letters such as the foregoing and others of this period
we gather that John Martin was then at the zenith of his
career and full of hope for success in certain schemes he was
hatching, of which more hereafter. He seems to have been
extremely popular and his personal attractions must have
been great. Frith writes of him in his autobiography as
" handsome John Martin," and adds that he was " certainly
one of the most beautiful human beings I ever beheld." A
miniature of him in early life by Charles Muss, and an oil
painting of later date, in the possession of Colonel Bonomi,
bear out this statement.

He was still living in Allsop Terrace, surrounded by a
number of more or less celebrated persons—Leigh Hunt,
Lord Erskine, William Beckford, Charles Dickens, and
others. Leopold gives an account of the district and
improves the occasion, after his wont, with a little political
gossip of the day.

" Not far from my father's residence, a splendid mansion
named Harley House had been erected by a friend of ours,

Miss Day, but it was, later on, occupied by the mad Duke of Brunswick. Miss Day was the daughter of Mr. Day, of the well-known firm of blacking manufacturers, Day & Martin. At this period the manufacture of blacking was confined to three great firms—Day & Martin, Henry Hunt, and Henry Warren—and all were in an extensive way of business. A cousin of my father had married a Miss Hunt, one Watkin Martin.

" Such a connection may excuse an anecdote as a family reminiscence. Mr. Hunt's family for ages had been extensive landed proprietors, but had become somewhat reduced in circumstances. The present members engaged in business and became Radical representatives. On the occasion of a great debate in the House of Commons on the land question, Mr. Hunt gave Sir Robert Peel the sharpest retort perhaps ever received by him in reply to an attack. Mr. Hunt had been liberal in speech, as usual, and Sir Robert, in reply, charged him with being unacquainted with the subject, which was one only for a land-owner and not likely to be understood by a mere tradesman. Mr. Hunt said, in reply, that what Sir Robert had stated was to some extent true. It was a fact that he, Mr. Hunt, was a ' tradesman,' and perhaps uninformed, but that he was the first of his race who had been reduced to ' trade,' whereas Sir Robert's family had been all tradesmen and manufacturers, and he was the first gentleman of his line ! Sir Robert was taken aback and spoke no more that evening.

" At this period Henry Hunt, Sir Francis Burdette, and Joseph Hume were the Chief Radical members of the House of Commons. They all three wore drab or white

beaver hats ; hence the term ' Radical Hat ' as applied to the old-fashioned white beaver."

Martin seems to have been bombarded with requests for illustrations to books at this time. We have long since ceased to admire the religious poetry of Queen Victoria's early days. Even *Festus*, perhaps the most quoted poem in our language after Shakespeare's, is almost unknown to this generation, and it is difficult for us, in our generation, to realise how this kind of poetry had laid hold of our immediate ancestors. A considerable number of writers indulged in flights of pious verse, on the lines of Milton and Bailey ; Byron did not disdain to take Cain for the protagonist in a tragic drama ; biblical subjects were, in short, the order of the day. And I have no doubt that a great many of these poems were illustrated by John Martin, though we know of only a few.

I have before me a long letter from one of these minor poets, whose work is forgotten to-day, although it had, apparently, some vogue in his lifetime. It is interesting to see the stimulus and inspiration he derived from John Martin. The letter is sent from Bath, but bears no date ; so that it is impossible to tell whether he or Lord Byron was the first to present Cain as a subject for poetic drama.

> " 20, Northampton Street,
> " Bath.

" MY DEAR SIR,

" It is with a feeling of the greatest pleasure that I beg your acceptance of a work which is, properly speaking, a first part to *Cain*, and which ought in point of time to

have been written first. I hope you will like it as well, if not better ; one advantage, at least, it has over the former work is, that it is totally freed from all ruggedness of versification. I have placed the second edition of *Cain* in the hands of Colburn, who has promised to exert himself and dispose of it speedily, and the third, which I am sanguine of, will be carefully corrected throughout, and several additions made, and all the notes omitted. Not being on the spot to correct the proofs, numerous errors crept in which represented me to be more careless than I really was For instance—one among many—the two last lines on the ode to yourself I wrote :

> " Shall thy name, though thou be fled,
> Live—till memory's self be dead."

As it stands now, the rhymes are, I believe, repeated twice over. I do hope that I shall be enabled to offer you a corrected edition of the third, during the winter, the appearance of which will give me the greatest possible pleasure ; and Colburn & Co. are very confident about it.

" I consider such little attentions as these as tributes which are due to you, for you have long been acknowledged as the great Poet Painter of the day, without the shadow of a rival. I will not go so far as to say that I have at any time copied from your fine conceptions, but I have had them always before my eyes (as I have those of Milton and Byron) and have been mindful of their style, and what I have thought of them I have, however feebly, declared. There is a passage, for instance, in ' The Revolt ' which I should, perhaps, have never conceived, had I not caught it from

your style—I mean the attitude and gesture of Moloch immediately previous to the Ascent.

"You will be glad to hear that both works are likely to become popular in Germany, the former, I am assured, is now under translation. The last time I heard of you was from Coleridge, who told me that you were employed in illustrating the Bible. I thought you would eventually undertake this, for it is the fountain head, and higher you cannot go.

"One thing I feel certain of, that whatever you are doing you can hardly add to your reputation, and if I envy you (which I most certainly do) it is in a generous desire to become eventually as distinguished in my own work, if that were possible. Let me express now my earnest hopes that this may find you in excellent health, and I pray you to believe me, my Dear Sir,

"Yrs. most faithfully and sincerely,

"EDMUND READE."

Another letter from a contemporary writer is also not without interest, since it suggests that John Martin was illustrating Shakespeare for some publisher, and also drawing pictures for a publisher in Dresden. I have not, however, been able to discover any trace of these.

"1, Pump Court, Temple.
"Feb. 2.

"MY DEAR SIR,

"My only excuse for troubling you with another copy of this book is the note at p. 218, where I have taken

the liberty of making an allusion to yourself. I have not yet heard of the arrival of your illustrations in Dresden, though I have not the least doubt that Retzsch will acknowledge them ere long. You will be glad to hear that you have made a good bargain for the continuation of the Shakespeare Outlines in this country. I rather think the *Midsummer Night's Dream* will be the next. Believe me to remain, with the highest respect, faithfully yours,

<div align="right">" A. HAYWARD."</div>

Three letters from Martin Tupper in 1852 give a thumbnail sketch of the author of *Proverbial Philosophy* in the full tide of his fame. The first, which is obviously hurried and confused, invites the artist to draw half a dozen illustrations for a book, quoting some of the subjects required— Rest, Ambition, Cheerfulness, etc.—and ends, " hoping it may please you, and you have time to give my poor old book the benefit of your magic skill," but does not mention the title of the book. The other two seem to refer to drawings sent by Martin to Tupper.

<div align="right">" Albury, Guildford.</div>
<div align="right">" June 19, 1852.</div>

" MY DEAR SIR,

" See what a good thing it is to give to a good man : one is sure to receive the true Homeric ἐκατόμβοι, ἐννεαβοιων, and I only hope that you may have made the Plate still more valuable by your autograph in the corner. I write to tell Hatchard's people to take all care of it until I call ; for I could not have it rumpled and crumpled by travel.

" All thanks.

" Some day when you have a mind to it, and time—and fine weather—let me show you some of the beauties of fair Albury ; your painter's eye (it is your 'poet's eye in a fine,' etc., etc.—' *ut pictura poesis*,' you know) will revel in our landscapes. And you can bring Peter Cunningham with you—if he'll come.

" A day ticket will enable you to spend many hours here ; and if you are a walker, I can find you good scenic sport. Only, if and when at any time you propose to come, please let me know beforehand that I may be sure to be at home to welcome you ; and to send a carriage for you to the station—as per definite advice.

" About my old book, and the original object of my voyage to Battersea, if anything comes of it by way of illustration—well, and better than well :—if otherwise— still well and better than well, seeing it has given me the pleasure of your acquaintance.

" Believe me to be—with the highest admiration of your genius, very truly yours,

" MARTIN J. TUPPER.

" John Martin, Esq., K.L." etc., etc.

On July 10 :

" MY DEAR SIR,

　" As your valued ' Plate ' has not reached *Hatchards*, and as, e'er now, I have found a parcel left me at *Hatchetts* by mistake—I write to tell you how it is that I have not yet had the courtesy to acknowledge it. Further-

more I take this opportunity of inquiring how far it may possibly suit you to favour me with some two or three, at any rate, of your glorious designs for my book, or with the whole half dozen I suggested to you in my last letter.

" I long to see your splendid triad of pictures all together in some well-lighted Exhibition room ; surely you have beaten even yourself in this gigantic effort of genius. Truly yours,

" Martin Tupper.

" John Martin, Esq., K.L." etc., etc.

These effusive letters, with their many commas and dashes, their enormous signature and the enigmatic " etc. etc." with which they end, do not seem to express the prim and formal writer of trite aphorism, but Tupper had obviously another side from that he offered to the public, and must have been a homely and genial fellow. As there is no work of Tupper's illustrated by Martin, I suppose they did not come to terms. There can be no doubt that he supplied some drawings, but they did not appear in print.

William Howitt was another of the writers who evinced some desire to bask in the reflected glory of John Martin by obtaining some of his illustrations to a book ; though, again, the book is not specified. There is no date to this letter, a matter for some surprise, as Howitt counted himself a historian, and historians are expected to be precise. The author of a terrific onslaught upon the House of Lords (*The Aristocracy of England*) under the pseudonym of ' John Hampden, Junior,' however, was no slavish

N

myrmidon to fact, and so small a detail as a date might well seem beneath his notice. He wrote :

"DEAR SIR,

"I beg your acceptance of a copy of the work I once proposed to you to illustrate. The book is doing very well and has been highly complimented by people of taste and imagination. The Story of Victor " (or is it Nichor ?) " is one I should have particularly liked to have seen illustrated by your pencil, had I not concluded to print the work without any embellishments. Mrs. Howitt begs me to present her compliment to Mrs. Martin and yourself. Yours truly,

"W. HOWITT."

A letter from the Duc de Broglie to John Martin and his reply concerning the gift of Royal Sèvres china from Louis Philippe, may fitly close this chapter of correspondence :

"Paris, *le* 31 *juillet*, 1835.

" Ministère des
Affaires Etrangères.
" Protocole.

"Le Roi a reçu, Monsieur, les six magnifiques estampes dont vous lui avez fait hommage, et a bien voulu les agréer avec une distinction particulière. Sa Majesté m'a chargé de vous envoyer, en Son nom, et comme une faibile marque de la satisfaction que Lui ont fait éprouver vos beaux ouvrages, quelques pièces de porcelaine de Sa manufacture royale de Sèvres. Ces pièces vous parviendront par l'entremise de Son ambassadeur à Londres.

FACSIMILE LETTER FROM THE DUC DE BROGLIE TO JOHN MARTIN.

p. 194.

" Le bel usage que vous savez faire de vos talents vous a acquis Monsieur, une haute renommée ; et je m'estime heureux d'avoir, en accomplissant auprès de vous les ordres du Roi, l'occasion de payer à ces talents le tribut d'admiration qu'ils méritent.

" Recevez, je vous prie, Monsieur, les assurances de ma considération la plus distinguée.

<div align="right">DE BROGLIE.</div>

" Monsieur John Martin, peintre,
 " à Londres."

<div align="right">" London, 50, Allsop Terrace.
" September 17th, 1835.</div>

" SIR,

 " I beg leave to acknowledge the receipt of your letter of the 31st July, announcing the gracious intention of His Majesty the King of the French to mark his approbation of my works by presenting me with some pieces of porcelain from the Royal Manufacture of Sèvres. I cannot sufficiently express the gratification and pride I experienced on the signification of this high honour, and hasten to inform you that this splendid and truly beautiful present has just arrived. I have endeavoured, however inadequately, to express my gratitude in a letter to His Majesty, which I have taken the liberty of forwarding by means of His Excellency le Général Sebastiani, and with every assurance of my profound respect,

 " I have the honor to be, Sir,

 " Your most obedient and very humble Servant,

<div align="right">" JOHN MARTIN.</div>

" Monsieur le Duc de Broglie."

CHAPTER XII

Martin's schemes for the improvement of London. His published plans and maps for the disposal of sewage, for a pure water supply, for the Thames Embankment. Approval of Thomas Sopwith, the famous engineer. Letters from distinguished persons in sympathy with his suggestions. The formation of a company to carry them out. The usual obstructions. Mr. Facing-both-ways and his kind.

IN his letter to the *Illustrated London News*, already quoted, Martin says :

" In consequence of the strong interest I had always felt in the improvement of the condition of the people, and the sanitary state of the country, I turned my attention to engineering subjects and two-thirds of my time, and a large portion of my pecuniary means have, since 1827, been devoted to the objects I have at heart ; though even here I have been obstructed and injured by the inefficiency of the patent laws, and, indeed, total absence of real protection for original designs in engineering and mechanics.

" My attention was first occupied in endeavouring to procure an improved supply of pure water to London, diverting the sewage from the river and rendering it available as manure ; and, in 1827-28, I published plans for the purpose. In 1829 I published further plans for accomplishing the same objects by different means ; namely, a weir across the Thames, and for draining the marshy lands, etc. In 1832, 1834, 1838, 1842, 1843, 1845 and 1847 I published

and republished additional particulars—being so bent upon my object that I was determined never to abandon it ; and though I have reaped no other advantage, I have, at least, the satisfaction of knowing that the agitation thus kept up constantly, solely by myself, has resulted in a vast alteration in the quantity and quality of water supplied by the companies, and the establishment of a Board of Health which will, in all probability, eventually carry out most of the objects I have been so long urging."

He tells us also here of his other schemes for improvement :

" Among the other proposals I have advanced is my railway connecting the river and docks with all the railways that converge from London, and apparently approved by the Railway Termini commissioners, as the line they intimate coincides with that submitted by me and published in their report—the principle of rail adopted by the Great Western line ; the lighthouse for the Sands, appropriated by Mr. Walker in his Maplin Sand lighthouse ; the flat anchor and wire cable ; mode of ventilating coal mines ; floating harbour and fires ; iron ships and various other inventions of comparatively minor importance, but all conducing to the great ends of improving the health of the country, increasing the produce of the land and furnishing employment for the people in remunerative works."

It would be impossible, in the space at command, to dwell at any length upon all John Martin's inventions and suggestions, several of which have materialised since his death, though no credit has been allowed to him. A volume might be written on this subject alone, and if written

by an expert, might prove of great interest to generations yet to come. For example, one of his ideas was an underground railway, with a great central terminus, and this was, I believe, planned out and laid before the House of Commons, only to be turned down as quite impracticable !

But as I am dealing with John Martin as a personality and an artist, not as an engineer or a reformer, I can but touch lightly on this side of his extraordinarily complex character. His accusation against those who, he said, appropriated his ideas without acknowledgment would fill many pages, and there can be no doubt that he was badly treated. But what inventor ever reaps the full reward of his inventions, and is not a prey to the sharp commercial adventurer ? John Martin was no exception to this rule, but in his case he did not even have the satisfaction of seeing his ideas adopted in his lifetime, or of knowing himself, as he desired to be, a public benefactor.

We have noted that all the Martins were besieged by ideas, wise or wild, according to their different temperament. William and Jonathan were full of theories and conceptions, as well as John, and, like him, arraigned nefarious persons who stole their ideas. But John had, in addition to the conceptive brain, a power of reasoning and concentration lacking in his brothers, and we have now to consider one of his ideas for the improvement of London that was of considerable value and importance— his scheme for a fresh-water supply and sanitary organisation, with a suggestion for the Thames Embankment.

Of course it is now almost impossible to discover how far this scheme was purely original and how far it has been

carried out in the form he projected. Any definite statement might be met by the claim that others were, at the same period, working on the same problems ; minds more technically capable of producing practical schemes. But that he was one of the first, if not *the* first, to agitate on the subject, and that he found influential supporters, is a fact beyond doubt. And I think it equally beyond doubt that his untiring energy and perseverance, his strong personality and character for absolute integrity of purpose, were chiefly instrumental in the materialisation of schemes that must have been, as we say, 'in the air' at that time.

Dr. Benjamin Richardson, in his able biography of Thomas Sopwith, compiled from the great engineer's private diary and notes, says of John Martin :

" Mr. Sopwith had unbounded admiration of the marvellous John Martin, the painter, whose works as an artist were, he thought, even surpassed by his suggestions as an engineer, by his plans for improved sanitation and by his hopes of securing a healthy world."

And he quotes from Mr. Sopwith's diary (May 10th, 1836) as follows :

" Afterwards went to the Institution of Civil Engineers to hear Mr. John Martin, the great painter, explain his plans for improving the river Thames."

Dr. Richardson adds : " With the suggestions made by Martin he (Sopwith) was very greatly impressed, and I have heard him say that the whole plan indicated an advance of the most remarkable order—an anticipation, indeed, of the improvement that has been made in what is now called

the Thames Embankment, and including other projects
not less important and still unfulfilled."

Perhaps we cannot have a stronger testimony to John
Martin's originality and engineering genius than this. But
that he believed himself to be gifted in that direction, and
was sometimes tempted to wish he had followed the more
practical and useful profession, one may learn from Leopold :

" ' Oh, my boy, if I had only been an engineer ! Hun-
dreds (of pounds) with me would then have been thousands.
And instead of benefiting myself and a few only, I should
have added to the comfort and prosperity and health of
mankind in general.' Such was the oft-repeated cry of
my father, not only to me but to many of his associates.
Great as his mark might be as a painter, his constant idea
seemed to be that he had mistaken his vocation, and was
fully under the impression that he ought to have followed
that of an engineer. He felt certain that his mark might
have been still more important. Be this as it may, it is
quite clear that engineering pursuits were more congenial
to his inclinations."

Diffused interests are pitfalls to genius or talent. They
may here account for the distinct falling off visible, accord-
ing to critics, in Martin's later work. But it is impossible
to believe that his son was right in saying that ' engineering
pursuits ' were more congenial to him than painting. He
had suffered cruel disappointments at the time when he
began to devote himself seriously to these plans for the
improvement of London, and was, no doubt, asking himself,
as the years crept on, what was the value of a purely personal
success compared with that of an impersonal benefit to

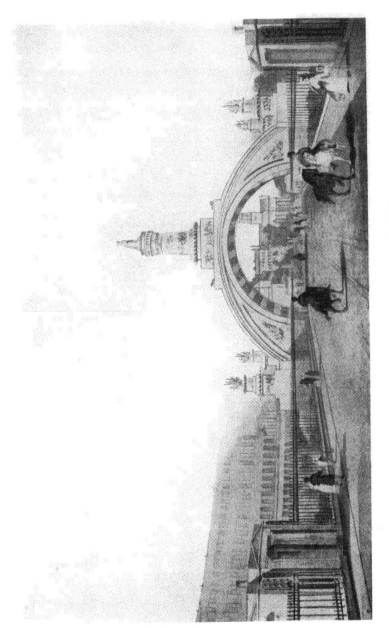

DESIGN FOR THE THAMES EMBANKMENT.

(In the possession of Colonel Bonomi.)

his race and country. But that he ever had a greater love for any other pursuit than he had for art, one can never believe. She must have been his first and last love, however pitilessly the years may have robbed his hand of its cunning, or altruistic ambition had weakened the first fine directness of his aim.

Leopold tells us that his first published plan for the supply of pure water to the Metropolis and its environs was " a beautifully illustrated quarto volume," but it is really a pamphlet. It was published in 1827-8 and went into a second edition, the second being probably a revised and improved one.

" For years previous and up to the period of his death," writes Leopold, " his whole heart was centred in his grand plan, the Embankment of the River Thames, the great feature of which combined a great intercepting sewer, recovery of land and, above all, the construction of a noble terrace, walk and roadway. The various published plans for these vast improvements extend over a period of many years. With the sanction of the Government, under the superintendence of the Board of Works, this noble work has now been carried out."

This was written in 1889. It continues :

" Unfortunately life closed before my father's suggestions and plans were more than in part completed ; but without doubt John Martin was the original projector of the noble Embankment of the Thames—a magnificent metropolitan improvement, to the plans of which he had devoted such large sums of money, much valuable time, and deep study. Yet both the Government and the Board of Works ignored

him and his name, and, without scruple, adopted his plan in nearly every particular. He was a painter, not an engineer ! But at least a tablet in recognition of his lifelong efforts might be placed in the wall of the Embankment, marking his claim as original designer. His family look upon it not only as a matter of justice, but as their right, that the claims of John Martin should have some public recognition. They are in possession of documents bearing the signature of nearly every man of distinction at the period, approving and offering support to efforts in any way leading to the completion of works of such grand sanitary, public, and artistic design, which would be, not only the glory of London, but the wonder of the age."

It does not seem a very extravagant demand for the family of John Martin to make—just that recognition of his lifelong efforts—but it has not been granted !

This is not the place to discuss his claim to be originator of the Thames Embankment ; but one would like to know what counter-claims have been made, and, if Martin did not originate the idea, who it was that forestalled him.

Certain of the documents to which Leopold alludes lie before me, kindly entrusted to my hands by the Baroness de Cosson, John Martin's only surviving grand-daughter, by his youngest daughter, Jessie. They are most interesting and would fill a good-sized volume, including the following printed and MS. matter.

1. A manuscript prospectus of the Sewage Manure Company.

2. A plan, on tracing-paper, of the proposed sewer in Westminster.

3. Large engraved map, entitled " Plan of the London connecting railway and railway transit along both banks of the Thames, with an open walk from Hungerford to the Tower and from Vauxhall to Deptford. Metropolitan Improvement Plan by John Martin, September, 1845."

4. Small plan ot the Great Metropolitan connecting railway and public walk, by John Martin, September, 1845.

5. Address by John Martin to the shareholders of the Metropolitan Sewage Manure Company, May 11th, 1850.

6. Manuscript list of Martin's Metropolitan Improvement Plans.

7. Printed form of thanks from the Royal Society of London to John Martin for " Documents and Drawings relative to the Thames and Metropolitan Improvement, dated June 15th, 1849."

8. Another from the same society for " Outline of a comprehensive," etc., etc., etc.

9. Manuscript on " The Importance of Preserving Open Grounds in the vicinity of large Towns."

10. Engraving of Plate 5th, Sea Lights, signed John Martin, 1829.

11. Manuscript agreement for engraving *The Last Judgment* picture, dated June 7th, 1851.

12. Similar agreement with regard to *The End of the World* and *The Plains of Heaven*, dated June 23rd, 1852.

13. " Means of Safely Making and Storing Gunpowder, and at the same time of establishing an efficient system of National Defences." Four-page manuscript signed John Martin.

14. An appeal to " The shareholders of the Metropolitan

Sewage Manure Company," protesting against certain unjust charges, declaring that errors of management alone called for complaint and demanding a committee of investigation. Printed May 11th, 1850.

15. " Statement of dates corroborative of Mr. Martin's Memorial." Manuscript dated 1849 and signed John Martin, in Isabella's handwriting. (See Appendix.)

And several others, among them an interesting survey, in Martin's writing, of the history of Hyde Park, showing some patient research work and applied to the necessity of open spaces about London.

To these may be added forty-seven letters, some rough drafts of his own in Martin's handwriting or that of his daughter Isabella, and others from such well-known men as John Bright, Michael Faraday, Joseph Toynbee, William Howett, Martin Tupper, Prince Albert (through his secretary), the Duke of Northumberland, the Duke of Beaufort, Lord Grey, Lord Lincoln, Lord Robert Grosvenor, Sir Francis Beaufort, Sir John Swinburne, Charles Barry, Dr. Hodgkin, Dr. Elliotson, and others whose names are unfamiliar to-day. Many of them are merely polite acknowledgment of letters or plans ; some are making appointments for meetings, among which the following is interesting (I have already alluded to it in Chapter X.), the handwriting is very tiny and precise.

" 12, Argyll Place, St. James's.

" *March* 5*th*, '49.

" MY DEAR SIR,

" It will afford me much pleasure to see your

water-works. On account of my numerous engagements
I find it difficult to get so far as Chelsea unless I go early
in the morning, when I could reach you on horseback at a
quarter past seven o'clock; if that hour is not too early I
will be with you on Tuesday, if it is fine.

> "Yours, dear Sir, very faithfully,
> "JOSEPH TOYNBEE.

"John Martin, Esq."

Another from the same hand accepts an invitation to
tea at 'half-past seven o'clock'; presumably in the
morning.

Faraday seems to have been on more friendly terms
since he begins his three letters, "My dear Martin." They
are dated 1846, 1851, and 1852, and as the subject of the
second deals entirely with the respective gravity of air
and hydrogen its reference is problematical. John may
have written to him about sewage, or lighthouses, or safety-
lamps! But the first letter was probably concern-
ing his plans for the drainage of London. It runs as
follows :

> "Royal Institution,
> "*November 9th*, 1846.

"MY DEAR MARTIN,

> "I have received and thank you heartily for the
reports. I have read them. I give you joy of the develop-
ment of your most important subject and proposition, and
congratulate you upon the progress which its practical
application is making. I trust that you will find, in this

case, that your labour will be followed by that pleasure, honour, and profit which is its just reward.

"Yours very truly,

"M. FARADAY."

That he received much appreciation and commendation of his schemes, especially the greatest scheme for the drainage of London and beautifying of the Embankment, these letters amply show. But they show also that Mr. Facing-both-ways was too often his enemy. It is amusing to us to read the glib admiring phrase continually followed by the facile excuse ; but it could not have been amusing to the earnest reformer and inventor himself. This is the kind of thing we find over and over again :

"*Private.*

"DEAR MARTIN,

"I approve highly of your circular. It is simple, efficient, and unpretending, and providing that you afford no obstruction to the flow of the sewage, cannot, I think, as it at present appears to me, meet with any opposition on the part of the Commissiners of Sewers, whose name I think you had better, perhaps, introduce by a few words such as these, in the 8th paragraph : 'We have no doubt that the Court of Sewers will promote a work so much in furtherance of their important and useful labours, and that the Commissioners of Metropolitan Improvements will approve such an undertaking. And as it interferes with no private interest and secures an important national advantage,' etc., etc., etc. . . .

" Upon consideration of the matter of my relative position in the Court of Sewers, I feel that I cannot take any part in your project, but may more disinterestedly promote its useful purposes for the public good by not being connected with it in any way personally.

"Believe me, dear Martin,

"Very faithfully yours,

"THOS. L. DONALDSON."

(Date illegible.)

It is not difficult to imagine how our honest and direct John Martin would receive such a Tartuffian epistle, with its pitiful blend of blarney and compromise. And perhaps it shows more clearly than any explanation one could offer, the kind of thing Martin found himself up against in his eager attempts to better the conditions of the Londoner.

A letter from the Duke of Beaufort on the same subject will have a familiar ring in the minds of many impatient reformers of to-day, though far more direct and straight-forward. It is written in his own hand.

" DEAR SIR,

"Whenever the Bill you refer to comes before the House of Lords you may rely on my giving it my best consideration. I do not think it possible that the Standing Orders can be reversed in this instance, as there is still so much Business remaining of those Bills which have complied with the Standing Orders that some, even of these, must stand over till next Session, and I conceive *The Metropolitan*

Sewage Manure Bill to be of too much importance to be hurried over at so late a Period of the Session. No doubt it may effect very great improvements, but it is a measure not to be carried without mature Consideration, as so many Interests will be materially affected by it.

> " I remain, dear Sir, very truly yours,
>
> " BEAUFORT."

" Oh, these material interests," one can imagine Martin exclaiming. " Who can make headway against them ? "

It would appear, from two letters written to him in 1846 and 1848 by Dr. Hodgkin, that a company was formed by his friends and supporters for the purpose of carrying out his plans for the sanitary improvement of London. Dr. Hodgkin, a member of the Society of Friends,[1] was probably a man of some public standing. He writes in 1846 :

" MY DEAR FRIEND,

" I am sorry that thy letter has remained so long unanswered, and must plead in excuse the circumstance of my having been much occupied and frequently called into the country. . . . Having made this explanation, which will, I hope, clear me in thy eyes of having had any part in the past transactions which have given thee pain, I will now state what is my view of the case, as far as I

[1] Thomas Hodgkin (1798-1866), M. D. Edinburgh, 1823, curator and pathologist, Guy's Hospital, 1825. Member of London University Senate. Published several works, and a glandular disease was named after him (*Dic. Nat. Biog.*).

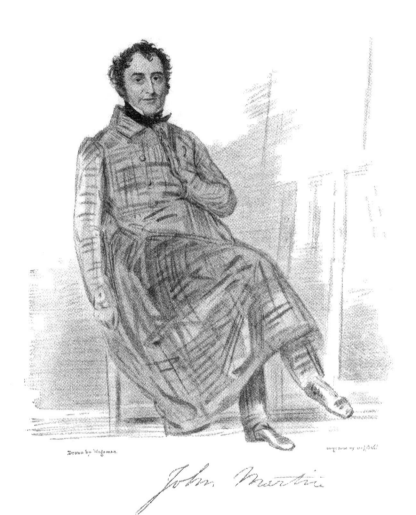

Drawn by Wageman. Engraved by J. J. Hall.

John Martin

JOHN MARTIN IN HIS STUDIO.

(*From a pencil sketch by Wageman in " Arnold's Magazine of the Fine Arts."*)

p 208.

am able to form a judgment respecting it. Thou wilt probably recollect that, when the subject of compensation to thee, as projector, was agitated, many months ago, I expressed the opinion, and wish, that thou shouldst receive an ample recompense. I originally joined the undertaking both to promote what I regarded as an important work and to aid thy laudable and persevering efforts. As to the mode of making this compensation, I believe I have hitherto given no opinion to any of my colleagues, but I may now say that I think it may be both more availing to thee and more just to the shareholders to make thy remuneration proceed from the profits of the concern. We may at once fix the proportion what thy portion shall bear to the profits, but to take thy remuneration from the price of the shares, which as yet the whole business is a speculation, will, ˙ fear, be fatal to the undertaking on the outset, and bring us all into great discredit.

" I say this with the sincerest friendship to thee, whom I should be glad to see deriving an ample income from thy project. And so far from having any selfish motive for the opinion I have expressed, I am ready to move that if the projector's bonus is to be taken from the price of the shares, the shares of the provisional committee men and the stipulated bonus to them, which I never asked, should be applied to that object. We shall then be above all reproach from the public and have given a substantial proof that we regard the project as a national benefit. I repeat, however, that I think the bonus ought to be the result of the profit of the undertaking.

" Thine sincerely,

" THOMAS HODGKIN."

O

We knew that John Martin was harassed by debts about this time, and had spent a great deal of money in advancing his scheme ; but it does not appear that his pressing for a substantial recognition of his labours met with any response. Two years later we read, in Dr. Hodgkin's other letter, that the company is beset by difficulties, and there is every reason to believe that it came to grief and accomplished nothing. " I have not been able to be a regular attendant at the meetings of the directors," he writes, " but I believe it is quite the feeling of the Board to do thee justice." He speaks of opposition from without and lack of co-operation within the company, and of a desire to do justice to the whole body of shareholders. But nothing more definite, and a letter from R. Grosvenor the following year (1849) demonstrates the same kind of deadlock.

" I sincerely regret," he writes, " to learn from your letter of the 20th that your exertions for the public good in forming plans for the improvement of the Sewage, so far from being rewarded, have hitherto proved serious inroads on your finances, and are likely to reduce you to still greater difficulties, if some compensation should not be very speedily made by those who have the power, sub-stantially, to recognise the claims of distinguished merit. You ask my advice as to the propriety of your handing a Memorial to Her Majesty's Government, and whether it should be addressed to the Ministers collectively, or to one individual. I am of opinion that your best mode of pro-ceeding would be to memorialise Lord John Russell in your own name ; perhaps, however, it would be advisable to

efer in the application to those friends who have an interest
n your plans."

Two years later we have another glimpse of the
subject from his daughter, Isabella, who writes of the
Court of Sewers (July 6th, 1850) :

" MY DEAR FATHER,

" This day's paper contains a short report of the
proceedings of the Court of Sewers yesterday, and although
there is no statement of progress in the general drainage
plan, a slight summary of what passed may not be un-
interesting to you, as a proposal for improving the drainage
of an important district was advanced by Mr. Frank Forster.
You may remember the loud outcries of the inhabitants of
Holloway and Hackney, at having had to pay sewer rates,
while no sewage arrangements were in progress which could
relieve them. It appears that, at present, the drainage of
the district runs into the Hackney Brook and thence to
the Sea. The Committee propose to construct a sewer from
Stamford Bridge to Lorraine Place, Holloway, a distance
of three miles, to receive the sewage of Holloway and part
of Hackney, which will still ultimately find its way to the
Sea at a point, as I understand from the map, in the very
centre of the East London Water Works ! This sewer is
not to be less than 13 feet below the surfaces and the *average*
height is to be 7 feet ; and it is to have a regular inclination
of 8 feet to the mile, the level of the invert at the lower
end being 51 feet above ordinance datum. The cost of
the whole, in the best description brick, £7,900. This
proposal seems to me to coincide with your suggestion of

intercepting the drainage of the uplands, and from the point of Stamford Bridge the sewer might eventually be easily directed to the depôt on Stamford Hill, leaving the sea so far unpolluted.

"The remaining business of the Court consisted in orders for little portions of sewers to the amount, in the aggregate, of £11,000 ; the contents of nine of these additional sewers will discharge into the Thames for the present. This confirms the conclusion that the Commrs. will form intercepting sewers near the river.

"In reply to some observations addressed to the chairman—he distinctly stated that the works at those sewers about London and Blackfriars Bridge are only temporary, and would be discontinued when the general plan is decided."

There follow details of the funeral of Sir Robert Peel, and other items of London news, and the better concludes with the words :

"Do not destroy this as I have no other memoranda of the business of the Court of Sewers.
 "Your most affectionate daughter,
 "ISABELLA MARY MARTIN."

It must have been a blow, two years later, to receive the following special note :

"DEAR SIR,
 "I am very much pained to be obliged to acquaint you that the Directors of the Metropolitan Sewage Manure

Company do not think that it will be possible for them, in the present condition of the Company, to engage in the extended scheme you propose for their consideration. The dead weight of the past miscarriage of the Company upon their shoulders precludes the hope of reaching the distant hills of Hounslow with the fertilising showers of London Sewage, vainly to be attempted by means of calls and new subscriptions from a reluctant proprietary, exasperated by frequent disappointments and struggling to escape their present liabilities at the smallest costs.

" You will, therefore, be so good as to excuse my entering into any details on this occasion, and believe me, dear Sir, your very obedient servant,

" OLIVER HARGREAVE."

On the opposite page there is a rough copy of a letter in Martin's writing :

" DEAR SIR,

" Certainly nothing was farther from my thoughts than that the Met. Sew. Co. in its present crippled state, could engage in *any* extended scheme of works whatever, and my object in opening a communication with our friend, Dr. Hodgkin, was simply to consult as to how far it might be practicable to recover from past misdeeds, and to accomplish some suggestions as to the means of connecting the existing company with the general System of Metropolitan Drainage.

" Although as much in the dark as the other shareholders respecting the measure of the Directors, yet the

results make me fully aware that the company cannot do anything without a radical change ; and that, unfortunately, owing to internal divisions, injudicious and ill-directed experiments and continued misrepresentations, both the company and the object had suffered material injury ; but I own that I did not think the case entirely irremediable. As, however, the company seems literally to be defunct and past resuscitation, of course further attempt on my part would be futile. But I have, at least, the satisfaction of knowing that it has no power of obstructing the progress of those who may be disposed to move."

A note in Serjeant Thomas's diary gives an amusing sidelight on Martin's obsession :

" Nov. 2nd, 1840.—Yesterday I took tea with Martin. Having read all day we walked in Hyde Park, but I left by six, having been bored to a dead headache by the old story of Patent Rope Cable, Stink keys and Sewers, etc. I am so fond of the company of Martin that I can't help going, but if he gets upon that, all is over with me. He couldn't sleep last night and he thought of something new as to sewerage backing, etc. Everything he does, too, is borrowed or stolen from him, so his time is absolutely lost upon those subjects ; but to oppose or dissent is to anger and offend him, so I am obliged to be a listener in torture."

This from his most loyal and devoted friend, is a very strong testimony to the state of John Martin's mind during those years of struggle. But that no amount of such ' torture ' could make Ralph Thomas swerve in his fidelity

and admiration is plain from a later entry (January 1st, 1844), when he says of Martin :

" He has genius and untiring energy. His eye and cheek light up with the fire of feeling as he warms with his subject, and he is eloquent even without art or study, eloquent by nature. I feel I always learn something good from him, both matter and manner. And I felt to-day, as I did the first day I was introduced to him, that it is one long gratification and reward, worth all my struggle, to have known and to be the friend of such a man."

Eloquence is wasted on sewage, and even John could not make it interesting to his friend. But sewage could not part them! To the last Ralph Thomas sits at Martin's feet and looks up at him with adoring eyes.

CHAPTER XIII

Dark days for the Martin family. John, materially injured by the bad state of the copyright laws, finds that the £20,000 brought him by engravings has all melted away. He is in debt and distress. His schemes for improving London have failed. Letters to the Queen and Ministers ignored. His nephew, Richard, commits suicide in his house. The Coronation picture revives his fortunes. He resolves upon trying a branch of art new to him, a life-size historical picture, of which we hear no more. Quite free from debt and making money again in 1843.

FOR some years, between 1828 and 1838, Martin passed through a time of sore distress and difficulty. He made a great deal of money, which seems to have slipped through his hands too quickly, and the unsatisfactory state of the copyright laws put him at the mercy of pirates, who not only appropriated thus sums that should have been his, but injured his reputation by flooding the market with bad prints of his work.

Having sold his fifty plates illustrating the Bible to Mr. Bull, the publisher, for £2,000, and his plate of *The Crucifixion* to Moon and Boys, print-sellers, for £1,000, he had begun to regard engraving as a source of income upon which he could reasonably count ; but this source was tapped by a number of fraudulent publishers and print-sellers against whom, it appeared, he had little redress. It is on record that he brought one action against a man named Brooks, of Bond Street, at the Court of Common Pleas, and won it.

But beyond having to pay the costs of the trial and being bound over not to print or sell any more of John Martin's copyright engravings, the pirate seems to have got off without any payment to Martin ; and we are told that other printers, unintimidated, went on gaily selling his pictures for their own entire benefit.

Martin's generosity to his family and friends has been noted before. He lent money freely to anyone who asked him for it, and was fleeced of large sums by unprincipled men who traded on his good-heartedness. He was not a borrower himself, having the independent man's dislike of incurring obligations which could only weigh on him, and he is reported to have spoken very bitterly of those so-styled friends who borrowed from him continually and forgot to pay him back. His brothers always sponged on him, as we have seen, and his weekly entertainments must have run away with a good deal of money, as he was a true North Countryman in his lavish hospitality. Add to all these dranis upon his purse the large sum he expended on his schemes for the improvement of London, and it is easy enough to know why he fell into low water.

" I feel myself," he told Serjeant Thomas in 1837, " a ruined, crushed man. I shall sink now ; there are no more bright days in store for me. My eyes have been opened to the state of my affairs and I am a pauper. I am dishonoured. I know not what will become of us. I have never attended to money matters and this is the consequence. I have earned £20,000 in a few years and I am now not with a penny. I have been plundered and deceived."

He spoke very bitterly of one Burns, a solicitor, to whom he lent £500, and of his brother Richard, who both dishonoured the bills they gave him.

" All my time, labour, and anxiety have been thrown away ; all my property and hope of support, my security from dependence, as I looked upon it, all must go—and to raise £500 and other sums for the debts of others ! Oh, is it not heartless ? I did it as a friend. My brother, too, and other relations bringing me down to disgraceful ruin at a time when I hoped all my projects were ripening into practical operation."

Ralph Thomas tells us how he walked with Martin round Kensington Gardens and Park " for about five hours," listening to his lamentations on the evil days that had befallen him, a sad chronicle of debt, doubt, and disappointment. For in addition to his pecuniary embarrassments, Martin had received no answer to an application he had made (under persuasion of his friends and admirers) for the post of Historical Painter to Queen Victoria, and his Thames plans had failed to materialise. Of the latter Thomas writes :

" His Thames plan is to him as lost. Dr. G. has, with Burns, the attorney, manœuvred the matter, to Martin's inextinguishable distaste and abhorrence, having made a job for himself out of it already, and injured the concern permanently ; also having called himself (in a paper which he got Martin to sign) ' the Maturer of the plan,' and having as such given himself advantages which were repulsive and destructive to the whole concern. Martin is disgusted with G.—not less so with the solicitor, and he has with-

drawn ; after infinite worry, labour, expense, and loss of time."

We know what it must have cost Martin to relinquish his beloved scheme ; and the ignoring of his testimonials by the Queen and her advisers would also be a bitter pill to swallow.

" He has such a proud and independent mind," says Thomas, " that he has scarcely ever asked a favour in his life, and requires to be worked up before he will do so. . . . He feels, therefore, this coldness and neglect as cruel stings to his pride."

His wife told Serjeant Thomas that this was, indeed, the first cause of his deep depression. But when Thomas rallied him upon it, asking, " Can you let so small a matter dash your spirit ? " Martin replied that he could bear fifty such disappointments calmly and patiently, " and add to them the carpings of critics and the false stories heaped about me by friends of the Academy " ; but what galled him was that those he had trusted and believed his true friends had been false to him. It was this, and the position of debt and insolvency in which he found himself, that had plunged him into the Slough of Despond.

" He has a strong spirit," writes Thomas, " an earnest, active mind, as full of generosity as genius ; but is a mere child in the business of life. All his mind and energies being engrossed in his profession, and in his hobby projects, he has left all his money matters to others."

And again, in January, 1838 : " Mrs. Martin came to see me respecting getting some more money on pictures. She says they are sorely distressed and talks about calling

their creditors together. . . . I do not know what they will do. They have got £500 from Tilt for the Bible plates,[1] but they now want £600 to redeem the pictures, plates, etc., which Phillips the auctioneer, holds."

And later he writes : " Mrs. Martin called about getting up a raffle or, as she calls it, a lottery, of some of his old pictures. I spoke to him about it, and it is against his feeling, but, he fears, inevitable. They propose to raise £1,500 by two-guinea shares. He seems now disposed to give up working altogether, he does nothing but mourn and despair. His plates and pictures being in Phillips's hands, he fears he shall lose his Nineveh plates and all, and is beyond all consolation. . . . He is no longer the same man. Haggard looks and distempered mind have seized him. He blames his family for not saving him from all this misery and poverty."

Again in March, 1838 : " Mrs. Martin came here on Monday. Oh, what a state of anxiety and distress she is in ! Martin, she fears, may go out of his mind, and she is afraid to speak to him. As to herself, she says his conduct will lead her to do what he will be surprised at, for she cannot endure much longer such distress and anxiety. He is sullen and will not speak to her or anybody."

It was in August of the same year that Jonathan's son became insane and committed suicide in John Martin's home, which must have put a terrible climax on the misery of the household. If anything could have driven the unhappy man out of his mind, that event was calculated to

[1] I am unable to explain this statement, unless Martin engraved a smaller set of plates for another Bible.

do so. But, apparently, he had rallied from his state of despair and was working again before it happened. It is more than probable that poor Richard succumbed under the weight of general depression in the family upon which he was quartered ; but his uncle was made of different stuff and possessed within him the recuperative power to shake off the incubus.

His fortunes began to mend towards the close of the year 1838, and in 1839 he was inspired to paint a picture which led to a resuscitation of his fame and name—*The Coronation*.

" The painting of this picture," says Thomas, " was a fortunate circumstance for Martin, and he has availed himself of all the advantages it suggested. . . . It struck him that to introduce portraits into this work would give it interest. Nothing daunted by his want of experience or reputation in this line of art, but feeling he could do that, or anything else if he tried, he set about writing to all the distinguished personages that attended this interesting ceremony, hoping to induce them to sit to him. And his hope was realised.

" He succeeded beyond his most sanguine expectation. They came, they sat, they were painted. And when they came they saw the works hanging on the walls, or in his gallery, and admired them. One bought one, another bought another. Prince Albert, Earl Grey, Lord Howick, the Duke of Sutherland, one after the other sat, and Martin sold ! Earl Grey charmed Martin one day. He mistook the light streaming across a picture for an effect of the real sun shining across the gallery, and asked him to draw the

blind. He could scarcely believe they were rays of paint. The delusion was admired and talked of."

It was renewed life to Martin, this picture, and he was up working at it every morning at five o'clock, sticking to it all day. In his splendid faith that he " could do anything he tried to do " he adventured with all the vital energy of youth and made a fresh start in life at the very moment when it had seemed that he must sink under waves of despair.

There were dark hours occasionally, even while he was working on this picture. His family was still depressed, debts still harassed him. " I offered to lend him some money," says Thomas, " which he again obstinately refused to take." [1] But when, later in the year, his picture of the Coronation was in Buckingham Palace and he received sums amounting to £800 from Earl Grey and the Duke of Sutherland for pictures, besides other money from engravings, his spirits, and the family spirits, rose, and his friend writes exultantly (October 26th, 1839) : " He is now going on in glory, and working indefatigably."

He must indeed have worked like ten men to achieve all he did between 1840 and 1852, when *The Destruction of Sodom and Gomorrah* appeared at the Academy. We find him represented in both the most important art galleries of London by an enormous number of landscapes, as well as by subject-pictures. And during most of the time he was also expending abundant energy in agitating for the improvement of London. His passion for art could not

[1] He did, however, on one occasion consent to accept a loan from his faithful friend.

extinguish his interest in science, engineering, invention, and reform. Nor must it be forgotten that he was working, in the first years of the fifties, on those last ambitious pictures, *The Last Judgment, The Great Day of His Wrath,* and *The Plains of Heaven,* powerful conceptions that would have taxed all the powers of a younger man to execute. And he was then over sixty years of age.

In 1843 we find him starting on another venture, chronicled by Ralph Thomas as follows :

" He is determined to try a picture for the House of Commons, and has set about a labour which would have intimidated most men, especially men who had earned reputation and feared to lose it. He determined to paint King Canute challenging punishment for himself on a charge of murder, a subject worthy of John Cross who painted the incomparable *Richard, Cœur de Lion,* now in the House of Lords. . . .

" This is another style quite new to him, foreign to all his previous studies. His great success was in architectural perspective ; besides which he has, in late years, wonderfully succeeded in pure landscape, now in oil, now in water-colour. And now he's working at the highest flight of the art, an historical life-size figure-picture. Nothing daunted by the difficulty of the work and the novelty of the labour, he has bought bones and figures and set to work with heart and soul to study anatomy. The attempt is noble and to fail is no disgrace. All students of the figure learn, by many years' labour, the difficulty of accomplishing this task creditably, and if Martin has not become a Frost or a Le Jeune in correctness, he draws the figure tolerably well and

has much improved himself. He has made a small cartoon and a life-size one."

It is not every artist who, after achieving a world-wide fame, sets himself the arduous work of a student ; and that a man of such abounding self-confidence as Martin should do so is certainly remarkable. Perhaps the drawing of his figures in *The Coronation* had been called in question, for we know that adverse criticism is a fine stimulus to effort. At all events, I think it might be shown that John's anatomical studies helped him in his last pictures, especially *The Great Day of His Wrath*, wherein the nude bodies of men and women are shown in their ghastly peril, falling into gulfs of darkness amid the hurtling rocks and raging seas.

Serjeant Thomas tells us that Martin was partial to Canute, and we know that his picture of that monarch commanding the waves to stop at his feet received the silver medal of the Liverpool Academy. But we hear no more of the larger picture, and, obviously, it was not accepted by the House of Commons. So Martin once more suffered one of his many disappointments. But we learn that he was never again in financial difficulties, for Serjeant Thomas writes the same year (1843) :

" Martin says he is better off now than ever in his life ; he only owes four or five hundred pounds, and he has a deal of property by him, and immediate power over such a sum, and more."

His daughters were making good marriages and his sons prospering in their careers. We may conclude that the clouds had rolled over the Martin household, and that

irritable and irascible as he must inevitably have been at times, under the unrelaxing strain of his strenuous mental and physical work, John Martin was normally his own genial self ; taking his long walks, sucking brandy-balls, and descanting on everything under the sun ; entertaining many friends, and, doubtless, often boring them with dissertations on sewage and other dull matters. In the next chapter we will discuss some of those friends.

CHAPTER XIV

Some of John Martin's friends and acquaintances, Luke Clennell, Sir Charles Wheatstone, J. K. Brunel, George Stephenson and others. A trial trip on one of the first engines. Letters to Prince Albert and others. Martin's religious views. His further inventions; lighthouses, fireproof ships, etc. Exhibitions of science and machinery. The Old Panoptican. *Household Words* and Martin's Pamphlets.

ONE of John Martin's friends, a North-countryman like himself, hailing from Newcastle-upon-Tyne, was Luke Clennell, whose picture, *The Charge of the Light Brigade,* was once so famous. Leopold tells us that " so highly was the picture appreciated that an unusual permission was granted by Government to erect a temporary wooden building, facing Hyde Park, in which it could be publicly exhibited." Clennell was a pupil of the Bewicks, and so skilled a wood-engraver that his instructors gave him permission to attach his name to blocks issued by them, a distinction permitted to few of their pupils. He and Martin were friends in their boyhood, and the success of the latter in London tempted Clennell to try his fortunes there. He achieved a certain distinction but over-taxed his brain and died in an asylum. The Waterloo picture was the last he ever painted.

Another friend of Martin's was Sir Charles Wheatstone, to whom we are indebted for the concertina. In 1836

Wheatstone " constructed an electro-magnetic apparatus by which signals were conveyed through nearly four miles of wires, and he was knighted, with W. F. Cooke, the following year for their invention of the magnetic telegraph. A few years later Wheatstone's alphabetical printing telegraph was patented. Ten or eleven years earlier he had invented the concertina and the Wheatstone concertinas are known as the best in the world to-day. Both Leopold Martin and Ralph Thomas give us particulars of his friendship with John Martin.

" When Charles Wheatstone was comparatively unknown in the world of science," writes the former, " he became a constant and valued friend of my father. This was long before the electric telegraph investigations and experiments were complete, or the wonderful results thought of. Some time after this early friendship, Mr. Wheatstone had been appointed professor at King's College, an appointment that was hardly popular—as he failed as a lecturer. His utterance was so rapid that it was nearly impossible to follow him. . . .

" I well remember accompanying my father to Somerset House to witness some of the professor's experiments with the first electric telegraph wire. He had a wire embedded in the bottom of the river Thames, passing from the College on the Middlesex side to the Shot Tower, near Waterloo Bridge on the Surrey side, thus connecting the two counties. Messages were passed without any difficulty and with perfect success. Thus encouraged, Mr. Wheatstone made the invention the subject of constant study.

" It was about this time I accompanied him, with my

father, to the India Rubber Cable factory of Messrs. Enderby at East Greenwich. Mr. Enderby explained a new application of sulphur to liquid india-rubber in coating wire for use in his contemplated submarine cable. Mr. Wheatstone, at this period, was seldom seen at my father's without some novel, ingenious model or invention, such as an instrument for measuring the velocity of light, or for electric currents, or for improved construction in harmoniums, or in mouth or finger instruments of more or less importance. . . . Sir Charles Wheatstone was small in feature, child-like to a degree, short-sighted, and with wonderfully rapid utterance, yet seemingly quite unable to keep pace with an overflowing mind. To the close of my father's life he remained a fast friend."

Martin appears also to have been well acquainted with George Stephenson and other scientific men, including J. K. Brunel, the engineer of the Great Western Railway. In 1841, his son tells us, Martin received an invitation from the latter to accompany him on an experimental trip, in which to test the power and capability of a broad-gauge engine as to the speed to be attained. As yet no experiments had been made by authority. The arrangements on this occasion, for a positive test, were most complete.

" A most experienced engine-driver was to take charge of the engine, one of the most powerful the company had constructed. On the morning appointed my father's friend, Mr. Wheatstone, accompanied him to meet Mr. Brunel at the Paddington Station. They were attended by time-keeping clerks and a very old office assistant. The party drove on the engine—there were no carriages—to the

Southall Station, at which point the experiments were to commence. The first object was to try to discover the time in which full speed could be obtained, and in how short a distance the engine could be pulled up and brought to a stand. But the chief object Mr. Brunel had in view was to ascertain the highest rate of speed.

" The engine was provided with a thick plate glass in front, to protect those upon it from the strong current of air With Mr. Brunel's eye on the steam pressure gauge and hand on the safety valve, we were off, and in half a mile we were running at ' top speed,' the time-keepers busily at work. To the great satisfaction of Mr. Brunel and the astonishment of all, it was discovered that the distance of nine miles from the Station at Slough had been run in six minutes, or at the rate of ninety miles an hour— a very different result from that which Mr. Stephenson's early calculations would have led one to expect.[1]

" The morning spent with Mr. Brunel," Leopold concludes, " was a truly memorable one for all parties ; especially so to my father, who, from the first—as far back as the opening of the Liverpool and Manchester Railway in 1830—was of the opinion that the speed of trains was practically unlimited."

John Martin was, according to the same authority, deeply interested in " the important question relating to transverse or longitudinal sleepers, and the speed to be obtained on the broad, narrow, or intermediate gauge." [2]

[1] We may venture to doubt Leopold's accuracy here.

[2] Leopold claims that a certain laminated beam, or girder, and a longitudinal sleeper, still in use, were invented by his father.

He was present at a meeting of a Committee of the House
of Commons at which the elder Stephenson had stated, in
evidence, his opinion that eventually a speed of twelve miles
an hour would be obtained for ordinary trains ! It was
the same meeting at which Stephenson made his famous
retort about ' the coo.'

And on another occasion he gave evidence with George
Stephenson in an inquiry into accidents in coal-mines, when
the question of safety-lamps *versus* improved ventilation
was discussed. George Stephenson believed that the careful
use of the safety-lamp was of much more importance than
any improved system of ventilation which John Martin
advocated. Stephenson, "with the appearance of a working
man out in his Sunday best—blue coat, buff waistcoat,
drab trousers and such a white tie, wound two or three
times round his neck !—gave evidence in plain, matter-of-
fact style," says Leopold, " and, being an engineer, of course
carried the day against a mere painter."

In spite of the fact that John Martin, in his later years,
broke away from the strictly orthodox theology in which
he had been reared, he had, we are told, many good friends
among Churchmen and other professed Christians. Dr.
Dibden, rector of St. Mary's, Bryanstone Square, was one ;
an ardent book-lover and collector of choice editions (as
Martin himself was, in a lesser way). And very staunch
friends, too, were Dr. Howley and Dr. Harcourt, the Arch-
bishops of Canterbury and York, Dean Ireland, Dean
Milman, and Dean Buckland, with the Bishops of London,
Norwich, Durham, and Chichester, if Leopold Martin may
be believed. He and Ralph Thomas both devoted con-

siderable attention to the religious opinions of the painter, and both give assurance of his "inward and spiritual grace," though Serjeant Thomas is uneasy at his rationalistic speculations. Says Leopold :

" He was a man of piety and strong religious impressions. . . . His character, as known to the world and in private life, was that of a deeply spiritual worshipper of the Bible " ; and he goes on to tell how his father, while taking sketches for his coronation picture in Westminster Abbey, was suddenly so overcome by a " glorious anthem breaking from organ and choir," that he fell on his knees and could work no more that day. A Bible and the poems of Milton lay always near his easel, and these two works were his constant companions. He was never at a loss, his son declares, for a quotation from one or the other.

Perhaps this assurance is hardly necessary. The inspiration of the bulk of John Martin's work is too obvious. Nevertheless he seems to have held, for his day, advanced and liberal opinions on religious matters. " Martin," says Thomas, "is a thorough Deist and believes that all that is good flows from a God. But he entirely disbelieves that anything not good, merciful, or great can come from such a source. . . . He railed at the Jews for imputing atrocious acts to Him. If they committed a massacre for interest or vengeance they said it was God that commanded them. If any man was rash, vindictive, or inhuman, all his acts of wickedness perpetrated for the purposes of his craft, were attributed to the direction of God ! "

According to Martin, David was " a cruel monster," and he denied that he could have been a man " after God's own

heart." " David took the merit of this title to himself,"
he said, " just as Henry VIII. called himself ' Defender of
the Faith ! ' " And in his opinion it was wicked to say
that God commanded the inhuman crime of the sacrifice
of Isaac by his father. He denounced Jacob as a thief
and refused to believe that God loved him better than
Esau ; that He would " countenance frauds in violation of
humanity, honesty, and morality." Moses, he declared,
was a wicked murderer and robber ; he ought to have taken
the Jews through the wilderness in a few days. It was
cruelty to keep them there, and treachery to borrow on
false pretences, and to keep the jewels which the Egyptians
lent them.

Further sceptical statements shocked his friend ex-
tremely, so that he " could hardly sit quiet as he listened."
He found it very amazing that Martin could believe in an
Omnipotent Power and yet deny the divine authority of the
Old Testament ; also that he could accept the new theory
that the world was many millions of years older than the
Bible stated, and that it was first " peopled with inferior
animals, then a grade superior, and finally with man."

" This I thought ridiculous enough," the good fellow
continues, " but he said he got it all from geology ; for
there were no bones to be found of man, though there were
the bones of all sorts of other animals." And he concludes
with charming simplicity : " I was almost glad to hear
him silly over something. If he does not think that man
was created and placed upon earth by a Creator, then I
pity him."

In these days the religious controversies of our Victorian

forbears seem a little childish ; but the Serjeant-at-law's horror at the great painter's free-thinking has a certain significance. " This is indeed, I feel, an awful subject to dwell upon—to approach even," he says, " but when I said this to Martin, he asked me—' Why ? Man is endowed with a power of reason and everything is placed before him to reason by and with, as facts and arguments. Should veneration for his early education make him fear to approach his beliefs or religious tenets ? Why should man use one kind of logic for religion and a different kind for general affairs ? ' "

Thus argue our schoolboys to-day. But we realise that in John Martin's day courage was required, not only to utter such heterodox opinions, but to form them. He had been trained to fear hell-fire like his ancestors. But, in everything fearless, John had ' faced the spectres of his mind ' and triumphed over them before he arrived at middle years.

Nevertheless, like the sceptics of our own day, he speculated in spiritualistic theories, and Serjeant Thomas tells us of a walk he had with Martin during which the latter told him of an arrangement he had made with Boniface Musso whereby the one who died first should communicate with the other. After Musso's death Martin invoked his shade to arise and manifest itself by some sign, such as the candle burning blue or the door opening and shutting three times ; but no such sign was vouchsafed him, though he repeated the invocation often in solitude, at midnight, in his closet, in the fields, and on a foggy, misty moor. He told Thomas that he always put out his left hand in these

invocations, "wishing to save the one he painted with, lest the foul spirit might wither the one he put forth to take his departed friend's hand." By which we may learn that Martin seriously believed in the possible material-isation of spirits at one time, and prepared himself for revela-tion. But his old friend Musso never manifested himself.

Two other friends of his, according to Leopold, were Ralph Watson and Thomas Brickwood, unforgotten names of men who harboured progressive ideals in his day and were pioneers of educational reform. With them Martin was associated in several attempts to organise exhibitions of scientific inventions in mid-Victorian years. The first was that of the Adelaide Gallery, near Charing Cross, with the object of displaying machinery in working action. It was constructed in the form of an extensive gallery, down the centre of which was a canal for the exhibition of models of every description of propelling power. But it failed to interest the public, and its chief promoter, Mr. Ralph Watson, " kind-hearted philanthropist and wealthy man," cut his throat in despair at the failure.

Fortunately, John Martin had put no money into this venture, but he entered undaunted upon a fresh one, known as the Panoptican (I have heard my mother speak of it), which also came to naught and resulted in a serious loss. The third attempt was successful. It was called the Polytechnic, and was instituted for the advancement of practical science and other branches of industry. " To a certain extent," says Leopold, " it carried out the objects Mr. Ralph Watson and my father had at heart."

All this should be interesting to Londoners, as evidence

of John Martin's continuous efforts to improve and benefit that city. All the while that he was conceiving stupendous subjects to paint, he was also conceiving equally stupendous schemes of material reform, to say nothing of his minor suggestions and inventions, which must have occupied a good deal of time. He seems to have been interested in almost every conceivable subject, and to have advanced ideas on many of them. For instance, we find him advocating ' fire-proof ships ' to replace our ' hearts of oak,' and the Channel Tunnel. He must have written hundreds of letters on these subjects, of which I venture to quote four

The first, written in August, 1830, is addressed to the Duke of Buckingham and Chandos, one of his patrons, and is an appeal to King William IV. It is written in fine, delicate handwriting (not his own or Isabella's), and signed by himself. The postscript is particularly interesting, as it is probably Martin's first appeal for royal support. We learn that he memorialised Queen Victoria later.

" MY LORD DUKE,
 " I beg respectfully to offer to your Grace my heartfelt thanks for your kindness in procuring for me the honour of laying my picture before His Majesty. If I again venture to intrude upon your goodness, it is now less as soliciting a favour for myself than as entreating the aid of your powerful influence towards the promotion of plans, which, if carried into effect, will, I feel confident, greatly contribute to the practical good, and to the health, the comfort, and the ornament of this Metropolis. The plans which I have the honour to present I would entreat your

Grace to lay before His Majesty as soon as may suit your Grace's convenience. To the whole of these I do not expect that His Majesty can have leisure to attend : but he may perhaps condescend to command them to be submitted to the consideration of competent persons. Two of them, however, the plan, namely, for lighting the Eastern Coast, and thus preventing the numerous shipwrecks about the Goodwins and other sands—and, secondly, the plan for supplying London with pure and plentiful water from the river Coln—may without much loss of time, be readily understood by His Majesty, and their great public importance will, I hope, justify me in soliciting his brief personal consideration of them.

" There are, among the rest, two inventions ; an ' elastic chain cable,' and an ' elastic iron ship,' which, from His Majesty's knowledge of, and interest in, naval affairs, might perhaps interest him—but I cannot venture to hope for his attention to so many things. In respect to the plan for lighting the sands, I could only entreat that one of the proposed lights should be erected, by way of proving the possibility of completing the whole. Should it fail, there would be but a slight loss of money ; should it succeed, it may show the way of saving annually many thousands of lives and millions of property.

" Hoping that your Grace may deem a subject of such importance to supply an ample excuse for my again intruding upon your valuable time, I have the honor to be, my Lord Duke,

" Your Grace's most obedient
" JOHN MARTIN.

" To His Grace, the Duke of Buckingham and Chandos, K.G."

" P.S.—With renewed thanks to your Grace for your condescension in enabling me to lay before His Majesty my picture, and I beg very respectfully to add that it is my ambition to be deemed worthy of competing for the honour of being appointed Historical Painter to their Most Gracious Majesties. I may, I trust, be excused for saying that I received the same honour from Her Royal Highness the Princess Charlotte and the Prince Leopold. When I add to this that I have been honoured by the notice and by the gifts, of their Majesties of Russia, Prussia, and France, and that the Academy of Edinburgh has, wholly unsolicited by me, or even by my friends, elected me honorary member of that Institution, it may, perhaps, gratify your Grace to find that, in the approbation which you were pleased to bestow upon me some years back, when I was less known, you had not wrongly anticipated that other judgments would confirm your own."

We have seen how His Majesty King William IV. treated the picture and the artist, and how abortive the appeal proved to be. But the Duke of Buckingham was always a good friend to John Martin, and bought many of his pictures, including the one now in the Tate Gallery. He offered eight hundred guineas for *Belshazzar's Feast*.

The next letters I shall quote are dated twenty years later, two years before John Martin's death. One is from Francis Beaufort, of the Admiralty, and the other Martin's reply, a rough copy by himself.

" Admy., *Jan. 7th,* '52.
" DEAR SIR,
 " I laid your note to me of the 10th before their
lordships and they immediately sent for the plans of the
fire-proof ship that you ' submitted to them some years
ago.' It has not yet been found in the proper office and I
would therefore request you to send me the date of that
communication in order to simplify the search.
 " Yours very truly,
 " F. BEAUFORT."

Martin replies :

" MY DEAR SIR FRANCIS,
 " I find that I had the honour of showing the plans
relating to my Floating Harbour Lighthouse, Fire-proof
Ship, etc., to the Earl of Haddington on April 20th, 1842,
and that his lordship, having been interested in one part
of the design, some considerable correspondence on the
subject subsequently took place. It may be as well to
observe that the plan, as it stands, is partly altered and
improved ; and that I shall be most proud to show the
drawings and models I have by me to the Honourable
Lords of the Admiralty, or to any officer they may depute
to call and report for them.
 " I beg to remain, etc.,
 " JOHN MARTIN.
" Admiral Sir F. Beaufort."

The fourth letter is a copy of one addressed to " His

Royal Highness Prince Albert, a roughly-written and much-corrected copy in Martin's own handwriting :

<div align="right">" <i>Dec.</i>, 1852.</div>

" SIR,

" It may be within the recollection of your Royal Highness that some time ago I humbly submitted to Her Majesty a Memorial on the subject of the imperfect operation of the Copyright and Patent Laws, and of the injuries I had consequently sustained from the piracy of several inventions submitted to the Government and the public from time to time during the last 25 years.

" I respectfully now beg leave to refer again to this subject, owing to some recent signal instances in further confirmation of the grounds of my complaint, and which strongly mark the injurious working of the system, not only in its effect upon the interests of the public, but in its injustice to the individual. In the years 1829 and 1842 I published and submitted to the Trinity Board a design for a Lighthouse for the (Goodwin ?) Sands, and the plan gave rise to a long correspondence, resulting in a promise from the Chairman at a Meeting of the Board on June 14th, 1842, to apply to me when next they fixed a Lighthouse on the Sands. The complaint which I now presume to intrude on your Highness is that, notwithstanding this promise and the evidence in existence, the Trinity Board have since erected several Lighthouses on the principle I proposed and yet both deny me compensation and evade the recognition of my claim to the invention.

" The next case to which I venture to refer, relates to

the Board of Admiralty, who, on being informed that I had designed certain improvements in ship-building, and to the construction of Fire-proof ships, forwarded to me an intimation that the Surveyor of the Navy would call to inspect my plans. My experience at the Trinity House, however, induced me, in my reply, to express my reliance on the honour of the Board to recognise my right in the invention, should they eventually adopt that plan ; but this provisional guarantee was instantly declined, and the plans have therefore never been inspected. On a more recent occasion the Corporation of Liverpool expressed their cordial wish to see my plans, but positively declined to give a provisional, or any, guarantee not to appropriate them.

" It is scarcely for me to pronounce upon the merit of my own plans, but if they have been found worth appropriating, as in the case of the Lighthouse, my right to the invention should, in common justice, be duly acknowledged ; and, at all events, your Royal Highness may judge of the probable loss to the public from the fact that the estimate of an experienced practical engineer for a Lighthouse constructed on my principle is only £700, whereas the pirated ones cost £7,000, irrespective of the important circumstance that my structure can be placed in deeper water than is practicable with the other. As regards the other inventions I have not risked showing them, so that whatever meritorious ideas they may contain are quite lost to the public.

" I have ventured to submit the foregoing statement to the consideration of your Royal Highness, as a member

of the Trinity Board, in the hope that by directing your attention to the operation of the system, the evils complained of may eventually be remedied, and that, so far as I am personally concerned, my injuries may through your Royal Highness's intervention, be recommended for redress.

> " With the greatest respect,
> " Your Royal Highness's most dutiful and
> " most obedient humble servant,
> " JOHN MARTIN."

To this we have not the reply, but the following note of acknowledgment from Colonel Phipps in 1850 indicates the kind of answer he probably received :

> " Osborne,
> " *August 5th*, 1850.

" SIR,

" I have received the commands of His Royal Highness the Prince Albert to acknowledge the receipt of your letter of the 28th ulto, together with the papers which accompanied it. His Royal Highness is not aware of any means by which he can assist you in the object you may have in view from the statement you have forwarded. It would be contrary to the invariable practice of His Royal Highness to interfere in the claims made upon the Government upon the score of public service of individuals which should be decided upon according to their own merits. With respect to the Laws of Patent and Copyright, they are

Q

subjects which could only be advantageously considered by the Members of Her Majesty's Government.

"I have the honour to be, etc., etc.,

"C. B. PHIPPS."

That after receiving this curt reply, John Martin should have again written to Prince Albert shows his extraordinary tenacity. He certainly never knew when he was beaten !

A very long letter addressed to "the Honourable the Chairman and the Elder Brothers of the Trinity Board," dated March, 1852, lies also before me, in which he complains most bitterly of the treatment he has received, and there can be little doubt that he had cause for complaint. In it he offers to prove that the design used for certain lighthouses was his invention, adopted some years after it had been rejected by the Board, and that he had made improvements on it since, which, had he been consulted, would have been beneficial. It concludes : "I have no hesitation now in appealing to your Honourable Board to do me the justice which is my due by awarding me compensation for the use of an invention which has proved to be so entirely beneficial." The technical details given in this letter show how much time and thought he must have sacrificed to the subject.

The following letter from the office of *Household Words* is interesting and shows that Martin left no stone unturned that could possibly serve public ends.

" No. 16, Wellington Street,
" North Strand.
" *August 17th,* 1850.
" My dear Sir,
" Some delay has arisen in answering your communication (which Mr. Charles Dickens has desired me to apologise for) in consequence of an unusual press of business upon us lately.

" Your pamphlets on sewerage and water supply have been placed in the hands of the gentleman who has charge of these subjects for *Household Words,* and, no doubt, allusion will be made to them as opportunity offers. The memorial in manuscript has been carefully perused and notes taken from it of such passages as are of general public application. As it may be possible you have no copy of it, I enclose it.

" Believe me, etc., etc.,
" W. H. Wills."

I will conclude with a letter from the Duke of Northumberland concerning the design submitted by Martin to the Lifeboat Committee :

" Lyon,
" *Nov. 26th,* 1851.
" Sir,
" I am exceedingly sorry that the model which was sent in to the Lifeboat Committee was in an incomplete state, and therefore could not be judged so favourably as it deserved. The Lifeboat Committee sat for several months in examining and trying the models ; but when they had

adjudged the Prize and delivered their Report, their duties ceased. As I did not consider myself a competent judge to decide the question, I left that decision entirely to the efficient officers who were kind enough to take on themselves that onerous duty, and every letter that was addressed to me on the subject I forwarded to the Chairman of that Committee. But that Committee has now ceased to exist and there is no longer a tribunal to refer to.

" I can only regret that I cannot suggest a remedy in your case.

<div style="text-align:right">" Your obedt. servant,</div>

<div style="text-align:right">" NOKTHUMBERLAND.</div>

' John Martin, Esq."

CHAPTER XV

John Martin's death in the Isle of Man, 1854. His three last pictures, known as the 'Judgment' pictures, left to a cousin, Mrs. Wilson. Their exhibition all over the world. Press Opinions. Obituary notice in the *Observer*. Agreement with Thomas Maclean for the engraving rights ; afterwards cancelled.

THE three last pictures painted by John Martin were *The Last Judgment, The Great Day of His Wrath,* and *The Plains of Heaven,* the last two being called originally *The End of the World* and *All Things Made New.* He was working on *The Plains of Heaven* up to the time when he departed for Douglas, in the Isle of Man, where he had a paralytic seizure on December 17th, 1854.

It is everywhere conceded that these were not equal, either in design or execution, to his greatest pictures ; even Leopold observes that they do not do his father justice. But we know that they were not finished when the artist was called away, and they were, at least, sufficiently striking to inspire an almost frenzied enthusiasm wherever they were shown.

Leopold tells us that they were painted solely for the purpose of being engraved ; but this we may doubt. Although he had entered into an agreement with Maclean, the publisher, for the right to engrave these pictures, and to exhibit them for advertising purposes, it is difficult to

believe he would have expended so much time and passionate energy in painting pictures whose colours would not be seen. Had it been the case he would merely have drawn them, or engraved them himself.

Before me lie copies of documents, dated respectively June 7th, 1851, and June 23rd, 1852, the agreement between " John Martin of Lindsay House Chelsea in the county of Middlesex Professor of Historical Painting of the one part and Thomas Maclean of No. 26 Haymarket in the said county of Middlesex Publisher and Print-seller of the other part," in which the latter promises " at his own costs and charges to cause or procure to be engraved and executed by such artist as the said John Martin shall in writing approve, a perfect and correct engraving or lithograph of the before mentioned pictures."

The terms are then stated :

" The copyright of the said engravings shall be the property of the said John Martin and Thomas Maclean in the following proportions, that is to say *one third* of such copyright shall be the property of the said John Martin and the remaining two thirds shall be the property of the said Thomas Maclean, who is to have the right of exhibiting the pictures at his own expense at such places and during such periods as the said parties shall agree for the purpose of obtaining subscribers to the said engravings " ; but their exhibition for money is only to be by permission of the painter, who is to receive the same terms as agreed upon with regard to the engravings—one-third of the profits, the publisher bearing all incidental expense. He also engages to advance John Martin one hundred pounds on

each twelve hundred pounds' worth of each of the engravings which shall be ordered or subscribed for, in anticipation of the said one third part of the net receipts. Yet John Martin is in no case to be personally liable to repay any advance made under this clause.

There are other clauses by which John Martin is to be protected against injury, either to his pocket or his fame ; one, notably, which stipulates that, after a certain number of impressions shall have been taken off the plates, they shall, from time to time, be deposited in a box in the presence of both parties, " who shall with their respective seals seal up the same, or the said box shall contain two locks, each with different wards, the key of one such lock to be kept by the said John Martin and the key of the other to be kept by the said Thomas Maclean—the box to be deposited with some third person—and opened but in the presence of each of the said parties or their agents."

There can be no doubt that, whatever were their technical defects, these three last pictures of John Martin's made a wide sensation. They were exhibited all over the world for about thirty years (in America, 1857), and afterwards shown in a good light at the Alexandra Palace. Since 1900 they have been hung in the staircase of the Doré Gallery, and I suppose it was when that gallery was closed that they went into storage.

"Some fifteen years ago," writes Mr. Thomas Hunt Martin, " I was invited to exhibit them in Canada, at the great biennial exposition there," but he does not say why they did not go. It was probably a question of expense.

He believes that the late Sir Charles Holroyd (Director

of the National Gallery) was much inclined to purchase these pictures for the nation at one time. But they lie at present in a warehouse and have certainly not been seen by anyone for twenty years or more. Will no one ever resuscitate them and let us see what it was that so dazzled our forbears ?

Leopold tells us that the inspiration for *The Last Judgment* and *The Day of His Wrath* were found by his father in the " Black Country," as he passed through it at night. " The glow of the furnaces, the red blaze of light, the liquid fire," he writes, " seemed to his mind truly sublime and awful. He could not imagine anything more terrible, even in the regions of everlasting punishment. All he had done, or attempted in ideal painting, fell far short, very far short, of the fearful sublimity of effect when the furnaces could be seen in full blaze in the depth of night." Milton's infernal regions were linked in his mind with Wolverhampton !

But *The Plains of Heaven*, the third of the triad, was a vastly different picture. Lord Lytton called it " the divine intoxication of a soul lapped in majestic and unearthly dreams." It was as purely imaginative as the other pictures, but over this, his last work, there is to be found a beauty and poetry lacking in the other two.

Shortly after his arrival at Harold Towers, Douglas, John Martin was stricken with paralysis, and his old friend, Dr. John Elliotson,[1] went at once to the Isle of Man to see

[1] Appointed Professor of the Practice of Medicine to the London University in 1831. Harvian Orator, 1848. Practised Hypnotism and was first to use the stethescope. Author of several medical works.

him. Isabella was there (she may have gone with her father, or have been summoned there later), and we find this letter to her from the physician dated February 1st in the following year (1854). It throws some light on a statement that has appeared here and there to the effect that Martin hastened his own end by a rigid abstinence, imposed upon himself by some theory he had conceived. Being speechless, he was unable to say why he refused the nourishment prescribed for him. Dr. Elliotson evidently refers to this strange obstinacy of his friend.

" MY DEAR MISS MARTIN,

" Your father must be much stronger than he is before an attempt can be made, with propriety, to bring him home. Should he gain strength he may, of course, be brought home. Your letter interests me greatly. Your father is a glorious man. One that I admire beyond my power of expression. Do entreat him to yield to advice in everything ; and do remember me in the very kindest manner to him.

" Yours sincerely, my dear Miss Martin,

" JOHN ELLIOTSON."

Leopold tells us that his father never spoke again ; and a note in the *Observer* of February 12th, 1854, under the heading of " John Martin," states that :

" The last accounts received of the state of this eminent artist leave but little hope of his ever resuming his interesting labours. When we first announced to the public the unfortunate attack of paralysis that deprived him of

speech and the use of his right hand, hopes were entertained of a favourable change, but months have passed away and he is still unable to be removed home from the Isle of Man ; and, to add to the calamity and danger, he has so far lost the use of his legs that he cannot, without assistance, walk across his room. It is true that his sight, his hearing, and mental faculties remain unimpaired as ever, but to a man so full of strength, activity, and energy as he has ever been, the change is equally sad and fearful. He had many commissions on hand, but we fear that his brilliant career of genius and industry is closed. Should any change take place we shall not fail to give early intimation of it."

Twelve days later the painter's obituary notice appeared in the same paper, and above it the editor prints Isabella Martin's simple letter to an old friend of her father's (probably Dr. Elliotson) announcing the event.

" My dear father was taken from us on the 17th inst. at half-past six a.m. His end was most tranquil and beautiful. He passed away without effort or apparent pain and was conscious to within an hour of his death. He seemed perfectly aware that he was dying but to have no fear of death."

" We have scarcely," the editor adds, " recovered from the excitement caused in the arts by the death of Mallord Turner, and the publication of Haydon's inward thoughts and daily adventures, when a genius whose originality of conception has astonished all Europe is snatched from us in the full strength and maturity of his powers " ; and

KIRK BRADDAN CHURCH, ISLE OF MAN.
Burial Place of John Martin.

then follows a column's biographical sketch of the painter's career, in the course of which we read :

" About a fortnight after his seizure he ceased to take food, except in the very smallest quantities, giving his attendants the impression that, in so doing, he was acting on some principle which he had accepted in his own mind, though he had no longer the power to explain the why and wherefore. Nothing would induce him to change this system of rigid abstinence, and the consequence was that nature received an insufficient sustenance from without and he gradually sank in strength and spirits. . . . The mind of the artist kept its tone and his hand its power to the last. He was working on pictures illustrative of the Last Judgment to within a few weeks of his death. . . . On these large works he had been employed for the past four years— on them he may be said to have spent the last efforts of his genius. He was painting on the *Plains of Heaven* within an hour of starting for the little island where he breathed his last. Of course all these works are left un-finished."

The writer concludes his sketch with the words :

" Such is our record of the last of three great geniuses —Hogarth, Flaxman, and Martin—who have convinced the world that, in the fine arts, as in poetry, Englishmen are capable of all that is great and beautiful. John Martin was painter to King Leopold and other sovereigns on the Continent ; yet there is no picture of this great painter in our National Gallery now that the public can contemplate and admire."

That appeared on February 26th, 1854. It holds good

to-day ; for though there is one of John Martin's pictures, *The Destruction of Herculaneum and Pompeii* in the Tate Gallery, it is neither shown nor mentioned in the catalogue. And, in any case, it is not one of Martin's best pictures and cannot fairly represent him.

In an Isle of Man paper, *Mona's Herald* (date unknown), there appeared an article signed G. H. W. (G. H. Wood), on " The Death of John Martin, Esq., K.L., beginning :

" A mighty spirit—a son of genius—has passed away from this earth. Martin, the greatest of British Artists, is no more. . . . Any eulogium on his transcendent genius would be superfluous. His works praise him and are appreciated throughout the civilised world. He was a man of noble-minded independence of soul, generous and confiding in his friendships—in his manners dignified yet courteous and affable ; gifted with eloquence and captivating powers of conversation. His annual visits to our Druid Isle and ardent admiration of its wild and picturesque scenery may well be a subject of honest pride to Manxmen . . . and henceforth the deathless name of Martin, associated with that of our lonely Isle—like the great Napoleon's linked with St. Helena—will invest it with an interest and celebrity which will endure to the end of time ; and we may truly predict that strangers from all parts of Europe, landing on these shores, will, like pilgrims journeying to some far-famed distant shrine, visit the grave of Martin."

Alas for the prophecies of the devout ! I wonder how many of the holiday-makers who throng the Isle of Man every year have even heard the name of John Martin !

The article ends with a string of rhymed couplets in

praise of the painter, written in the same hyperbolical strain :

> " 'Twas his on bright imagination's wings
> To speed his flight 'bove all sublimer things,
> Beyond the bounds of time and space to soar
> Where never mortal held his flight before "

and so forth. This magniloquent elegy was reprinted the following year in a four-page sheet advertising the exhibition of these pictures in London, after they had been shown in the provinces. Here is the announcement :

JUNE, 1855
ON VIEW IN THE GREAT HALL OF COMMERCE,
52, Threadneedle Street
THE MOST SUBLIME AND EXTRAORDINARY PICTURES IN
THE WORLD
The Day of Judgment, The Plains of Heaven
and
The Great Day of His Wrath
Valued at eight thousand guineas
Painted by the
Late JOHN MARTIN, K.L.,
(Historical Painter to the King of the Belgians)
Painter of *Belshazzar's Feast, The Fall of Babylon, The Deluge*, etc., etc."

Following the rhapsody of G.H.W. comes a selection of equally fervid quotations from the local press of the towns in which the pictures were exhibited—Oxford, Birmingham, Leicester, Bristol, Chester, and others.

" An opportunity is here afforded the public," says the

Oxford Journal, " of viewing three of the most magnificent paintings which have, perhaps, ever been submitted to the notice of lovers of the fine arts . . . these superb works of art are the production of the late distinguished Mr. John Martin, whose *Belshazzar's Feast, The Deluge, The Destroying Angel* and others have already secured him an unrivalled and lasting fame."

The *Birmingham Mercury* follows with :

" Among the many mighty spirits that England has produced, none have surpassed the transcendent genius of John Martin. Not only has he immortalised himself by the perfection to which he has attained as an artist, but he has gained an everlasting renown by the grandeur and sublimity of his poetic conceptions."

Here the writer gives a graphic description of the pictures, the closing paragraphs of which I may perhaps be forgiven for quoting, since the record gives the vivid impression made upon a lay mind by the painting.

" Beneath the whelming crowd of worlds . . . may be seen myriads of demon shapes writhing in unutterable woe, as they are swept towards the dark fathomless gulf which yawns before them. A degree of anguish is portrayed upon their countenances which none but a master mind could have conceived. Down they rush into the bottomless pit amid the wreck of a tottering, crumbling, and sinking universe. But, turning from this fearful convulsion, we behold all the lovely and enchanting scenes of spirit-land, or, as the Poet-Painter termed it, an ideal picture of the Plains of Heaven.

" This plain, as seen through a glass, seems illimitable

THE PLAINS OF HEAVEN.

p. 264

ınd infinite ; it is bounded in the far distant horizon by a
 faint, shadowy stretch of the new Jerusalem—not a mere
earthy structure, but a vast ideal city, immaterial and
undefined.

" Such is but an inadequate description of three of the
grandest pictures that have ever been produced. With an
imagination soaring far into the Unknown, and giving such
an embodiment to his wild and luxuriant dreams, Martin
has reached a pinnacle to which none but the most daring
may aspire, and has raised himself to an equality with the
Dantes, the Miltons, the Goethes, and Baileys of all ages
and climes."

The *Birmingham Journal* follows suit :

" In the millennium of art, which, possibly, the next
generation may see, when it will be recognised as the duty
of the State to purchase, for national use, the great produc-
tion of sculptor and painter, a collection of John Martin's
works may probably be made. Scattered, as they now
are, over the chief private galleries of Europe, we would
advise our readers not to miss this opportunity of seeing
together three of the finest pictures of the most original
genius of our time. . . . He saw all things through his
own medium. . . . He cut for himself a lonely and dangerous
path, in which he had no predecessor."

The *Bristol Mirror* says of *The Plains of Heaven :*

" In this picture there are several touches of beauty
quite equal, if not superior, to Claude or Turner."

Here the time of exhibition had to be extended, owing
to the crowd of visitors ; as we learn from the *Bristol
Gazette :*

" Hundreds of persons are daily paying the rooms a
visit, and the excitement is as strong as ever ; everyone
being delighted with a sight of these sublime works."

From the *Leicester Mercury* we read that " there are
now on view at the Town Hall three magnificent works of
art . . . the productions of that extraordinary genius,
the late Mr. John Martin, whose mighty talents have earned
for him the title of Prince of Painters." And from another
Leicester journalist we have the confession that " they are
the most extraordinary and sublime works we have ever
seen—a vast poem, wonderfully conceived."

Without giving the provincial journalist too much credit
for critical acumen in the matter of art, we may reasonably
suppose that the men chosen to write these articles in the
leading papers of our larger towns had some understanding
of their subject. In the art galleries of Birmingham,
Bristol, Leicester, etc., good pictures were exhibited from
time to time. But that no such pictures as these of John
Martin's had been seen in them is sufficiently obvious. The
impression of remarkable genius made by them on these
unbiassed critics is plain. Whatever technical flaws were
visible to the initiated in art, there was no doubt in the
mind of the ordinary man that they had been painted by
one who must be an immortal.

At the end of the circular we find the advertisement of
engravings of the pictures at the following prices :

	Artist Proofs	£12 12
The Day of Judgment {	Proofs before Letters ..	£10 10	
	Letter proofs	£6 6
	Prints	..	£4 4

The other two pictures being priced at ten, seven, four and three guineas respectively. Orders were to be sent to Messrs. Leggatt, Hayward, and Leggatt, of 79, Cornhill, London.

There is no information forthcoming as to why the engravings were the property of Messrs Leggatt, and not Mr. Thomas Maclean, according to the agreement quoted. That agreement must have been cancelled, if it were ever signed. Perhaps John Martin's death prevented his signing it.

We have no means of ascertaining the amount of money realised by the sale of these engravings, but it must have been considerable. Thousands and tens of thousands of the prints must have been sold, not only in England but abroad. What has become of them all? I remember seeing them here and there in old-fashioned houses, but not lately. Yet they must lie somewhere, for people do not often destroy pictures. And in addition to these legitimate engravings there must have been many thousands of pirated copies, such as the dreadful print of *The Day of His Wrath* in my possession. Where are they?

R

CHAPTER XVI

The family of John Martin. Connections with Sir John Tenniel,
Sir Frederick Bridge, Allan Cunningham, Joseph Bonomi and
Henry Fielding. Charles Martin, the portrait painter. John
Martin's home at Chelsea. The fresco on the wall. Sale of
stained glass windows painted by him. His grave at Kirk
Braddan, Isle of Man.

JOHN MARTIN left three sons and three daughters, five of
whom were married. His wife survived him by only four
years, dying in December, 1858. Isabella Mary, his eldest
daughter, never married, although, I am told, she inherited
her father's good looks, and her portrait appeared in a
'Book of Beauty' as one of the beauties of London. If
this portrait is the one I have seen, now in the possession
of Colonel Bonomi, I can believe this, though it is the kind
of beauty that has lost its appeal to-day. From all accounts
she must have been an exceptional character—as clever,
good, and lovable as she was handsome. Leopold declares
that she was unmarried, "not from lack of opportunity,
but from absolute love for her father, to whom she was
devoted." He calls her a "great-hearted, loving, and
affectionate sister and daughter," and all her life shows
her possessed by the spirit of self-sacrifice ; for after her
mother's death she went to live with her youngest sister,
Jessie, and at that sister's death took entire charge of her
children.

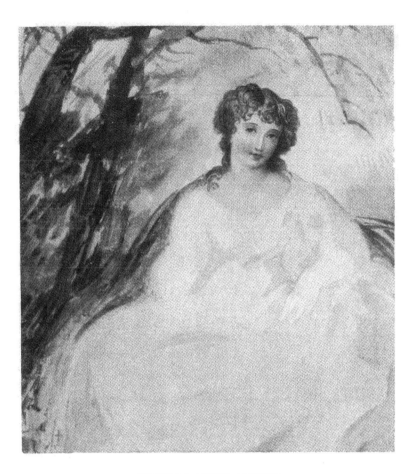

ISABELLA MARY MARTIN.
John Martin's Eldest Daughter.

p. 258

Madame de Cosson, her niece, writes of her thus : " I
wish I could tell you how splendid, and how clever, my Aunt
Isabella was, and what a devoted mother to us all ; how
she helped my father when he was Curator of Sir John
Soane's Museum. She managed all the business part of
this, as well as helping my father with his literary work."
Isabella died in 1879.

Zenobia, second daughter of John Martin, married in
1842, Peter Cunningham, son of the famous Allan Cunning-
ham and himself a man of letters well known in his time.
His son, Mr. W. A. Cunningham, informs me that he was
for years on the staff of the *Illustrated London News*, con-
tributing a weekly article headed " Town and Table Talk
on Literature and Art," and was succeeded by George
Augustus Sala. He was a friend of Charles Dickens, who
presented him with a complete edition of his works. I
believe Zenobia was considered a handsome woman ; all
the Martins must have been good-looking, unless report
errs. She had three children, one of whom is my cor-
respondent.

The youngest daughter, Jessie, married the renowned
antiquarian and Egyptologist, Joseph Bonomi, whose
brother Ignatius married Henry Fielding's daughter. Joseph
Bonomi was Curator at the Soane Museum for many years,
assisted, as we have seen, by his sister-in-law, Isabella.
Jessie married very young ; her life was short and tragic,
for she lost her first four children in one week from whooping-
cough, and after bearing four more, died when the last
was born, at the age of thirty-four. Her sixth child, Cecilia,
married the Baron de Cosson, who is an expert on old

armour, and said to possess one of the finest collections in Europe. Her eldest son has lately retired from the Egyptian Service,. in which he has held important Government posts.

Her brother, Colonel Joseph Ignatius Bonomi, C.B.E., late King's Own Royal Lancaster Regiment, commanded a training battalion of that regiment during the first three years of the war, and was in charge of an American rest camp for the last year. He is in possession of a drawing by John Martin of the Thames Embankment as visualised by the artist in his scheme,[1] and four water-colour landscapes ; as well as the Sèvres china presented by King Louis Philippe and the cabinet John Martin made to hold all his medals and gifts of honour. Colonel Bonomi has also the miniature and oil-painting of his grandfather to which I have referred, the original etching of *Belshazzar's Feast*, and other treasures.

John Martin's eldest son, Alfred, married, but I cannot give the name of his wife, as the family appears to have forgotten it. He had sons and grandsons, but I have not been able to learn anything about them or come into touch with them. Alfred held a good appointment in the Irish post office.[2]

The second son, Leopold Charles, from whose memoir I have quoted so much here, was the godson of Leopold I., King of the Belgians, and married the sister of Sir John

[1] It is inscribed : " Design for Embankment submitted to the House of Commons, 1838. Dedicated to Alderman Sir Matthew Wood, Bart., M.P., and the Honourable Members for the Committee for the Improvement of London, Aug. 1, 1835."

[2] Leopold says he was General Superintendent of Income Tax in Ireland and held this post at the time of his death in 1872.

Tenniel in 1844 (I think, but exact dates have not been kept). He was the author of several books on costume, coins, etc., and held, he says, for thirty-six years an appointment under the Crown, the gift of Lord Melbourne, when Prime Minister. Leopold had six children, of whom three daughters are still living. The eldest, John, who married a Miss Bridge, a connection of Sir Frederick Bridge. Marian, who married Dr. King, of Ambleside ; Eva, who married another King ; and Julia, the youngest (unmarried) are living ; Hyde, Isabella, and Annie (who married Mr. W. H. Rylands) are dead. I am told that Annie inherited her grandfather's gift, and painted beautifully.

The third son, Charles, was an artist of some distinction, a well-known portrait-painter in his day. He married Mary Anne Wilson, daughter of Mr. and Mrs. Thomas Wilson, of Harold Towers, Douglas, and lived for some years in that town, but went to America later and made his name there by painting many famous persons—Washington Irving, N. P. Willis, Longfellow, and others, including the widow of Alexander Hamilton, Secretary of State to George Washington, an interesting woman. In England he painted Lord Lyndhurst, Dickens, Bulwer Lytton, Disraeli, etc., and contributed a number of portrait sketches to the early numbers of the *Illustrated London News*. An excellent likeness of Harrison Ainsworth by him appeared in the *Pictorial Times* of July, 1844, with an account of the novelist by Hugh Cunningham ; and Charles also executed a very fine portrait in chalk of his father on his death-bed, which hangs now in the Newcastle Corporation Art Gallery. It was exhibited at the Royal Academy. Mr. Thomas Hunt

Martin is the only son and only child of Charles Martin. He went several times to America with his father.

Death came so suddenly to John Martin that he died without making a will ; or, at all events, his will has not been entered at Somerset House. But his grandson, Mr. Thomas Hunt Martin, assures me that the three last ' Judgment ' pictures were left by the artist to Mrs. Wilson, whose daughter, Mary Anne, married Charles Martin. Perhaps the pictures were a gift. John Martin was staying at Harold Towers when his last illness put an end to work, and he may have presented those pictures to his hostess in gratitude and compunction for the trouble he was causing. Mr. T. H. Martin had, he tells me, a certain interest in them, which he afterwards disposed of. When they had been shown in Europe and America for thirty years, he says, they had to be stored, and their enormous size made the charges so heavy that he could not afford to pay his share. He believes they are now stored in a cellar off Tottenham Court Road.

We hear that John Martin was painting on *The Plains of Heaven* a few hours before he started for Douglas. There is a legend that he painted the three last pictures there, but this is not true. I have heard another legend, that his brain was taken out and weighed by some learned society, and that he was laid out in state, with a jewel on his breast (possibly the Order of Leopold), but I have not been able to verify these stories.

So far as we know, he never went out of England. The furthest journey he appears to have taken was to the Isle of Man. It is strange that he did not visit at least those

galleries in France and Belgium at which his pictures were exhibited. But he was a true John Bull, a great lover of his own country, and cared little for any other. Travelling was not easy or cheap in his day, as it is now, and he had little time to spare for slow journeys by train and diligence in foreign parts. We have seen how his money melted away in the hands of friends and relations, and in the various schemes to which he lent it. So it is not very surprising that he spent none on travelling abroad and left his widow and unmarried daughter only sufficient money to keep them in comfort.

Some friends of mine who owned two small landscapes by Martin, wished to dispose of them, but before sending them to Christie's, wrote to his widow asking if she would like to buy them. The reply was that she could not afford to do so. They made £50 each in the sale. That was about fifty years ago.

(By the way, since I began this work I have had the offer of two steel engravings, *The Great Day of His Wrath* and *The Plains of Heaven*, in English gold frames, for the sum of £55, which seems a pretty good price for prints !)

I am informed by one of his descendants that John Martin's family came of Welsh stock originally, and another assures me that the family hails from Long Melford, in Suffolk, where their brasses may still be seen in the Martyr's Chapel of the chruch. The latter correspondent says that in a privately-printed account of Long Melford by Admiral Hyde Parker, one of these Martins is stated to have been Lord Mayor of London in the sixteenth century. Whether

either of these claims can be substantiated or not I am
unable to say. But the statement made by Leopold that
his grandmother boasted uninterrupted descent from Bishop
Ridley, the martyr,[1] is confirmed by Colonel Bonomi, who
believes it to be true. He has a very distinct recollection
that, when he was quite a youth, there was in the possession
of his aunt, Isabella Martin, a large genealogical chart setting
forth the descent of the Martin family from the fifteenth
century. But it does not matter whether John Martin
was descended from bishops, mayors, or tinkers. He
requires no ancestral glory, being himself so greatly dis-
tinguished from the mass of men. Descent from him may
well be a matter of pride to his family; they need not
seek any further. We know, at least, that John Martin
made no claim to be a Welsh or Sussex man, but declared
himself always a loyal Northumbrian.

There is a tablet on his father's cottage at Haydon
Bridge, I am told, but no such mark distinguishes Lindsay
House, Chelsea, where he lived from 1848. This old house
on the Thames Embankment was built in the reign of
James I. and bought by the Earl of Lindsay. It was after-
wards in the possession of the Brunels, father and son, and
later occupied by Bramah, inventor of the hydraulic press,
etc. So it has a certain history apart from its connection
with John Martin.

Leopold tells us that his father painted a landscape in
fresco on the high wall of the back garden, very effective
when seen through the doors upon entering the house. It
resisted the weather and retained its pure colour, he says,

[1] See Chapter III.

until the owner of the premises on the other side of the wall piled heaps of refuse against it and the moisture, percolating, spoilt the fresco. It was, however, still extant and ' attractive ' when Leopold wrote in 1889, and may be visible still.

I hear from a lady who lived next door as a child that the colours were quite fresh when she left in 1870, and that her father used to say John Martin intended it for a landscape of a spot " where man had never trod." My correspondent well remembers a great excitement one morning, when a number of men on horseback were before the house and the Prince Consort was calling on John Martin, who received him in his dressing-gown and slippers. It is not etiquette to keep royalty waiting, and this fact was impressed on her infant mind so vividly that she never forgot it.

There are several legends about Martin's mode of work ; how he would lock himself in his studio and make his first sketches on the floor ; how, when trying to conceive the effect of tumbling rocks in *The Deluge* picture, he was tearing his hair impotently, until the sound of coal being shot into his cellar suggested a bright idea. He had it thrown into his studio and painted his great rocks from it ! There are many other traditions, too many to set down here. But they show him to have been a man of surprises, not only to the world at large, but to his own family and intimate friends.

I have seen a copy from an interesting sale bill stating that :

" Four small windows of stained glass
by J. Martin
will be sold by auction, by
Messrs. Christie & Manson
at their Great Room, 8, King Street, St. James's Square,
on Tuesday, June the 6th, 1848.

Martin. 122 Three subjects, painted on glass, burnt in.
,, 123 The Companion Window.
,, 124 A stained window in nine compartments, the
centre by Martin.
,, 125 The Companion Window."

Of the same date (1848) there is an account of the Duke of Buckingham's sale of pictures, at which Martin's *The Destruction of Pompeii and Herculaneum* was bought at the price of £800 (I believe that a Reynolds was sold at the same time for £80 !) This is the picture now at the Tate Gallery, and formerly in the National Gallery, after being for a long time in the Manchester Art Gallery. It has not been shown for many years, and is in a disgracefully neglected condition. Although by no means one of Martin's best pictures, it is very impressive, and gives an idea of the artist's power ; especially that remarkable power for which he was noted, of conveying a sense of vast space and distance to the mind. The frame is inscribed in large gold lettering, " 793 The Destruction of Pompeii by John Martin. B. 1789. D. 1854. English School." But that ' English School ' is obviously considered of no account to-day !

John Martin lies in the picturesque churchyard of Kirk

Braddan, of which Harrison Ainsworth wrote in 1825 :
" Took a nag horse and rode to Kirk Braddan Church—
beautifully situated, embosomed in trees, built of grey
stone with a singular, antique steeple." [1] There are no
pilgrimages to this grave, as so confidently prophesied by
his admirers in 1854, and it would probably be hard to find
his headstone to-day. But if I be not another of those
deluded prophets, that lonely and neglected grave will
not always remain so.

[1] *Life of Harrison Ainsworth*, by S. M. Ellis.

CHAPTER XVII

What is to be the future verdict on John Martin's work ? Some Verdicts of the past and present. Were the art critics of his day all ignorant and deluded ? Heine's comparison of him with Berlioz. Articles in *The Library of Fine Arts*, 1833, and *The Artist*, 1901. Summing-up and last words.

SINCE the death of John Martin in 1854, there has been, at least, one gallant attempt to rescue his name from the oblivion into which it has undeservedly fallen, and it is but fair to acknowledge here the stimulus my work has received from the enthusiasm of an artist and critic who believes that a day must come when Martin will take his place among the immortals. He is not the only one who has written to me—" a life of Martin is long over-due and should be written," but he is, so far as I know, the only man of our day to come forward boldly as champion of the forgotten painter, to challenge his adverse critics and stoutly maintain his right to be enrolled on the list of British artists who have shown exceptional power and originality.

This doughty champion is Mr. E. Wake Cook, the well-known painter and art critic, author of *Anarchism in Art*, etc. He first thrust a lance on Martin's behalf at the time of Queen Victoria's death, when a letter from him to the *Times*, a column long, was published in the funeral number of that paper, advocating Martin's claim to distinction. This met with a sympathetic response all over England.

Mr. Cook received a large number of letters, and among them an invitation from the editor of *The Artist* for an article on John Martin. *The Artist* was at that time in its prime. It set forth to be " an illustrated monthly record of arts, crafts, and industries, and the authorised official medium of the art schools of England and the Society of Designers." It was published in London, Paris, and New York. The article duly appeared, fully illustrated, and seemed at first likely to produce some effect. But the seed was sown in stony ground and died down without apparently rousing any practical interest. Who shall say, however, that it is not, even now, germinating ?

When the once-famous pictures, *Belshazzar's Feast* and *Joshua Commanding the Sun to Stand Still*, came into the market recently, Mr. Cook wrote to the directors of the National Gallery offering to buy them (if possible) and present them to the nation, on condition that they should be shown to the public. His offer was not accepted. The reason urged was that they would take up too much room. They are indeed large pictures. *Belshazzar's Feast* is 62½ in. by 98 in., and *Joshua* 58 in. by 88 in. But is their size much greater than others exhibited in our national galleries, whose claim to such honour rests on authority perhaps more questionable than that once afforded to John Martin ?

Mr. Cook's contention is, briefly, that John Martin represents a creative type of artist of whom we have only too few in our country. In his article in *The Artist*, after describing him as " the Dante of painting, who shared with Turner the honour of having made the greatest advance in that art the world had ever seen," he continues :

" Of our many contributions to art, none are so great, so original, or so peculiarly English as those of these great idealists. The need of the new century is for giants like Martin to save us from the reactionary influences which are degrading art to the hoardings and to turn us from the cult of the eccentric to central progress ; men who will dare difficulties, or Titanic labours, to wrest from Nature new possibilities of art.

" The dominant art of the future will, I believe, be a higher form of creative Idealism. . . . On the plane of Realism we are imitators, selectors, interpreters, what you will ; but we are not creators. The painter's quest is always for an ideal beauty he never finds. Then why not boldly create, with a musician's freedom ? The poetic seers of all ages have created ideal works, and the demiurgic mantle fell on two great Englishmen—John Martin first, and then on Turner. Martin was a veritable Titan, who gave us thunderous epics, apocalyptic visions of appalling splendour and stupendous dramas of man and the elements, such as were never dreamt of in the wide world before they flashed from his colossal imagination. Turner, inspired by this fiery genius, but keeping in closer touch with nature, and with finer art, created new worlds of light and beauty."

Further on Mr. Wake Cook protests strongly and bravely against his country's neglect of Martin. " Turner," he says, " has the grandest of all of monuments in the poetic prose of John Ruskin, who lavished laudation on his idol's faults and beauties alike, but had only a contemptuous word for Martin. The same unfairness is shown by all ; Turner's works are everywhere in evidence, Martin's might

be non-existent. None have been shown in the winter exhibition of the Royal Academy and none at the Guild Hall ; while he is only misrepresented at South Kensington. This unequal distribution of honours is as remarkable as it is discreditable, because no artist can deny the originality of Martin's works, or their imaginative and dramatic power."

John Martin's position remains as it was when the above " plea for justice " was written. His work is still unrepresented in our galleries,[1] it is scattered far and wide, nobody knows where ; his name is unknown to the majority of his countrymen ; and yet in his day he was reckoned a great man and Mr. Wake Cook does not stand alone in ranking him with our greatest British landscape painter, Turner. I have already called attention to the statement in Chambers' *Encyclopædia* that " for twenty-seven years the suffrages of the public were divided between John Martin and Turner," and in art criticism as late as 1849, when his fame is said to have been on the decline, we see his work still ranked with that of Ruskin's idol.

In the *Illustrated London News* of that year, dated February 24th, referring to Richard Wilson and Gainsborough as having established the English school of landscape painting, an anonymous critic writes :

" Since then we have produced Mr. J. M. W. Turner and Mr. John Martin (the most imaginative of the school)."

And Richard Redgrave, R.A., in *A Century of Painters of the English School*, affirms that " Martin is an artist so thoroughly original that he opened up a new view which,

[1] The one in the Tate Gallery not shown.

in his hands, yielded glimpses of sublime dreams and visions that art had not hitherto displayed."

Even when, as in the case of Hazlitt and Charles Lamb, Martin's work is unfavourably criticised, there is obviously no question raised as to his high rank as an artist. Although Lamb held him up as an example of a particular school of art to which he objected, he did not grudge him such a title of honour as " this mighty artist " ; nor did Hazlitt disdain to write at great length about him, but bestowed a reluctant meed of praise upon Martin's " very singular and, in some things, very meritorious pictures." [1] That he recognised Martin as an original genius is obvious from the context in which the above appears ; and it is equally obvious that a pretty lively controversy raged about him at this period.

A critic in the *Edinburgh Review* observed that " the interest excited in the British public by *Belshazzar's Feast* and others of Mr. Martin's works is such as, we believe, never before was awakened by those of any other painter. It is true that, by a certain class of critics, he has been charged with considerable faults, but though we admit the justness of their censures, it must be evident that for the production of an admiration so enthusiastic in the greater number, including many equally competent to judge aright, he must be allowed the possession of excellencies of a very high, if not, indeed, of the highest class. That which chiefly distinguishes Mr. Martin from other artists is his power of depicting the vast, the magnificent, the terrible, the brilliant, the obscure, the supernatural, and the beautiful. . . .

[1] *Hazlitt's Works*, vol. vi., p. 39.

" No painter has ever, like Martin, represented the immensity of space—none like him has spread forth the boundless valley, or piled mountains to the sky—none like him made light pour down in dazzling floods from heaven, and none like him painted the darkness visible of infernal deeps. With our feelings warmed and our imaginations expanded by such subjects, they excite in us emotions of a nature far nobler than those with which we contemplate the utmost perfection of mechanical skill." [1]

The Victorians loved to exercise a grandiloquence that raises a smile to-day, and the confused wandering of their journalists in prose seems to us forced and affected. But it is easy to read through such misty verbiage as the above a very real and dazzled admiration. There must have been a magic in the art of John Martin that thrilled the nerves and stirred the emotions of the impressionable, even when they most desired to view him with a critical eye, to see the flaws pointed out by colder judges. To the religious, naturally, his pictures made a profound appeal; but it was not to the religious only that his work was significant and impressive.

Professor Waagen, Director of the Royal Academy at Berlin, wrote of him :

" I know now, and perfectly understand, the extraordinary approbation which Martin's pictures have met with in England, for they unite, in a high degree, the three great qualities which the British require above all in works of art—effect, a fanciful invention, inclining to melancholy, and topographic, historical truth. In no work of art that

[1] See also Appendix.

S

I have ever seen is the contrast between the modern and antique way of conception of the arts so striking as in these."

Writing to Sir George Beaumont about the picture which had electrified London, *Belshazzar's Feast*, David Wilkie expressed his admiration as follows :

" Martin's picture is a phenomenon. All that he has attempted in his former pictures is here brought to maturity. Belshazzar's feast is the subject ; his great element the geometrical proportions of space, magnitude, and numbers, in the use of which he may be said to be boundless. The contrivance and display of the architecture is full of imagination."

Heine compared his art with the music of Berlioz, which, he said, suggested rather " the stupendous passions of the early world " than any known form of classic or romantic art.

" We find elective affinity allied to the most perfect resemblance between Berlioz and the wild Briton. In the one are startling effects of light and shade, in the other a crash and clang of instruments ; the latter with little melody, and the former almost without colour. In either little beauty and no tender natural feeling whatever." He adds : " And what a common-sense, every-day, modern man beside these two madmen of genius (*fous de génie*) is Felix Mendelssohn Bartholdy ! " [1]

The German obviously detected something untamable in the " wild Briton," differentiating him from all other artists of his time ; and, being a rebel against convention

[1] Vol. iv., p. 406. Leland's Translation.

himself, offered him, with Berlioz, the homage one free spirit feels for another. For nobody can deny the fact that Martin was a free spirit, working as his will listed, in the medium he had made his own, and challenging the world fearlessly. He was nothing if not a great adventurer in art.

I believe I have already quoted the French critic Charles Blanc, who, in his work on painting, said :

" Martin à fait parler de lui dans toute l'Europe, et c'est, peutêtre, de tous les peintres anglais, celui qui fut le plus renounné sur le continent. En Angleterre, aussi, un moment, il semble être un des plus grands génies de l'art Britannique et Bulwer s'est hasardé jusqu'à écrire que Martin etait plus original, plus *soi-même* (self-dependent) que Raphael and que Michael-Ange. C'est, dit-il, le plus sublime, le plus durable d'entre les génies de notre siècle."

This impression he created of imaginative power, is again expressed in Christopher North's *Noctes Ambrosianae*, where he puts into the mouth of his " Shepherd " (James Hogg) the words : " That Martin, to my fancy, is the greatest painter o' them a' and has a maist magnificent imagination."

But it would be a grave error to conclude that John Martin's technical skill was always unequal to the demands made upon it by his exuberant fancy and unbounded ambition. I am assured by those who can offer an expert opinion, that his drawing was, as a rule, extraordinarily fine. Writing of *Belshazzar's Feast*, one says : " It is luminous, and the figures beautifully drawn and painted, much better than Turner's. . . . The things on the banquetting table are exquisitely finished. Martin is unique in uniting the

most powerful effects and vastness of subject with most minute and delicate finish. One of his most wonderful works is *The Repentance of Nineveh*. It is the fullest as regards subject matter, yet as broad and simple as the slightest sketch—a triumph of art. It has a myriad figures, many so small as to need a magnifying glass, yet they are full of life and action."

I find all this true of a little sepia drawing of Martin's that I have the happiness to possess. It is the scene in *Ivanhoe* where Rebecca on the Tower of Torquilstone Castle, defies the Templar, and was evidently done for an illustration to some Annual, as the text is written beneath in Isabella Martin's fine handwriting. The two central figures are full of spirit ; a tree in the middle distance so perfectly drawn that it is instantly recognisable as an oak, and the fighting men outside the castle are clearly to be seen, although but tiny dots. It is altogether a very dainty little work of art ; but its distance from *The Deluge* and other works of John Martin is so great that it seems almost impossible he could have painted them both !

The stern professional critic will tell you to-day that when any work of art commands immediate admiration from the impressionable crowd of men, its real merits are doubtful. It is unlikely to be inspired by genius and executed with perfect art, but is rather the production of a superficial talent and meretricious skill. The truly great artist, he will say, is rarely, if ever, recognised at first by the larger public, which must be trained and led " to know the highest when they see it." And there is undeniable truth in this statement. But it is also true that the popular

verdict has occasionally been the right one, endorsed by posterity, when the critics of a later date have poured the vials of ridicule upon their predecessors. And it is possible this may be the case with Martin.

We know that a man may be greatly inspired and yet not a supreme artist ; may be gifted with unlimited conceptive and creative power yet lack a certain discriminative quality necessary to the achievement of finished art. Without the instinctive knowledge of what to take and what to leave of the material from which a work of art is built, the artist wavers and his work suffers. It may be that John Martin was somewhat lacking in this instinctive knowledge. We know that, in his passion for expression, he flung upon the canvas everything that took shape in his superlatively fecund imagination, with almost frenzied energy, and perhaps he did not give himself time to sift values and choose the exactly right medium of expression from all possible ones. If only there were not fifty ways of painting, or saying, the same thing, and only one perfect ! But the *idea* was, I certainly believe, more to him than the perfection of its presentment. And on such a powerfully creative mind time presses heavily. He had so much to say, so little time to say it in ! Life was too short for him ever to execute in art all the glorious visions that haunted him. When this occurs the critical faculty has little space to work in.

And, moreover, Martin was piteously hampered, at the outset of his career, by lack of technical instruction and the grim necessity of making enough money to keep himself and a growing family. He was hampered even more by

his too wide interest in matters outside the sphere of art. The time and effort he wasted on schemes for the improvement of London and other matters must ever be regretted.

But he needs no apology for any shortcomings the captious critic may find in his art. Whatever those shortcomings, he stands, a profoundly impressive figure, among the giants of the Victorian age. And whatever rank may be assigned to him in the future—whether the highest, as in his own day, or that of a mere ' phenomenon,' a splendid meteor dazzling the minds of his generation—he was an Englishman of whom we should be proud. It will be an eternal disgrace to us as a nation if his pictures are allowed to remain in obscurity, his name forgotten. Lesser men are honoured in our archives and represented fairly in our galleries.

Why not John Martin ?

LIST OF WORKS BY JOHN MARTIN

SUBJECT PICTURES

Sadak in Search of the Waters of Oblivion. Royal Academy, 1812.

Adam's First Sight of Eve. Royal Academy, 1813.

The Expulsion of Adam and Eve from Paradise. British Institution, 1813.

Clytie. Royal Academy, 1814; British Institution, 1815.

Salmacis and Hermaphroditus. British Institution, 1814.

Joshua Commanding the Sun to Stand Still. Royal Academy, 1816; British Institution, 1817, and again in 1849. Exhibited in the International Exhibition, 1862. Size 58 in. by 88 in.

The Bard. Royal Academy, 1817; British Institution, 1818.

The Hermit. British Institution, 1818.

The Fall of Babylon. British Institution, 1819.

Macbeth. British Institution, 1820.

Belshazzar's Feast. British Institution, 1821. Exhibited in the International Exhibition, 1862. Size 62½ in. by 98 in.

Revenge. Royal Academy, 1821.

The Paphian Bower. Royal Academy, 1823.

Adam and Eve Entertaining the Angel Gabriel. British Institution, 1823. Size 52 in. by 72 in.

Syrinx. British Institution, 1824.

Design for the Seventh Plague of Egypt, Royal Academy, 1824.

The Deluge. British Institution, 1826 ; Royal Academy, 1837. Size 66 in. by 102 in.

The Fall of Nineveh. British Institution, 1828. Size 84 in. 134 in.

Leila. British Institution, 1833.

Alpheus and Arethusa. British Institution, 1833.

The Death of Moses. Royal Academy, 1838.

The Death of Jacob. Royal Academy, 1838.

The Last Man. Royal Academy, 1839.

The Eve of the Deluge. Royal Academy, 1840.

The Assuaging of the Waters. Royal Academy, 1840.

The Celestial City and River of Bliss. Royal Academy, 1841.

Pandemonium. Royal Academy, 1841.

The Flight into Egypt. Royal Academy, 1842.

The Curfew Time. British Institution, 1842.

Christ Stilleth the Tempest. Royal Academy, 1843 ; British Institution, 1844.

Canute the Great Rebuking his Courtiers. Royal Academy, 1843.

Goldsmith's Hermit. British Institution, 1843.

Morning in Paradise. Royal Academy, 1844 ; British Institution, 1845.

Evening in Paradise. Royal Academy, 1844 ; British Institution, 1845.

The Judgment of Adam and Eve. Royal Academy, 1844.

The Fall of Man. Royal Academy, 1844.

The Destruction of Herculaneum and Pompeii. In the Tate Gallery. Formerly in the National Gallery. Bought by the Duke of Buckingham and Chandos. Sold at Christie's in 1848.

Arthur and Ægte in the Happy Valley. Royal Academy, 1849 ; British Institution, 1851.

The Last Man. Royal Academy, 1850.

The Forest of Arden. British Institution, 1851.

Moses Viewing the Promised Land (original design for large picture). British Institution, 1851.

The Destruction of Sodom and Gomorrah. Royal Academy, 1852.

The Destruction of Pharaoh's Host.

A Girl at Her Devotions.

The Seventh Plague of Egypt.

The Coronation of Queen Victoria. Sold at Christie's, 1861.

The Bowers of Bliss. Sold at Christie's, 1861.

Adam and Eve Praying at Sunset. Sold at Christie's, 1861.

Adam and Eve Mourning over the Loss of Paradise. Sold at Christie's, 1861.

The Pilgrim and Hermit in Conversation. Sold at Christie's, 1861.

The Crucifixion. In the Victoria and Albert Museum.

Edwin and Angelina.

Love Among the Roses.

The Fall of Jericho

The Last Judgment.

The Plains of Heaven.

The Great Day of His Wrath.

LANDSCAPES

(*Exhibited at the Royal Academy and British Institution.*)

A Landscape Composition. Royal Academy, 1811.

Landscape. Royal Academy, 1812.

Scene on the Sea Coast. Royal Academy, 1812.

View of a Lane near Hampstead. British Institution, 1816.

Carisbrooke Castle. British Institution, 1816.

View in Kensington Gardens. British Institution, 1816.

Another View. British Institution, 1816.

View of the Entrance to Carisbrooke Castle. British Institution, 1816.

Evening (illustrating Gray's *Elegy*). British Institution, 1817.

Landscape Composition. British Institution, 1817.

View in Kensington Gardens. British Institution, 1817.

View of Fountain, Temple and Cave on the estate of Sir C. Cockerell, Bt.

View of Farm on the estate of Sir C. Cockerell, Bt.

View of Fountain on the estate of Sir C. Cockerell, Bt.

View of South Flank of Seizincot House on the estate of Sir C. Cockerell, Bt. These four pictures exhibited at the Royal Academy, 1918.

A Design for a National Monument to commemorate the Battle of Waterloo, adapted for the north end of Portland Place. Royal Academy, 1820.

A Study from Nature. British Institution, 1826.

Another Study from Nature. British Institution, 1826.

Stanmer Church, Sussex. Royal Academy, 1839.

View from Clapham Common. Royal Academy, 1839.

Lane near Holland House. Royal Academy, 1839.

Another View. Royal Academy, 1839.

Lane near Hangar Hill, Middlesex. Royal Academy, 1839.

The Corn-Riggs : View over the Valley of the Wandle. Royal Academy, 1840.

View over the Valley of the Wandle, with Part of Wimbledon. Royal Academy, 1840.

View from Horsingden Hill. Royal Academy, 1840.

View near Croydon, Looking over Beckenham. Royal Academy, 1840.

Scene in Brudgate Park. British Institution, 1840.

Another scene in Brudgate Park. British Institution, 1840.

Valley of the Tyne. " My Native Country from near Henshaw." Royal Academy, 1841.

View of the Western Coast of Guernsey. Royal Academy, 1841.

View in the Vale of the Wandle: Spring. Royal Academy, 1841.

View in Coombe Wood : October. Royal Academy, 1841.

View in Hampshire, Looking upon Alton. Royal Academy, 1841.

View of the Grounds of the Duchess of Buccleuch (on the Thames at Richmond.) Royal Academy, 1842.

View in Earl Spencer's Grounds at Wimbledon, in May. Royal Academy, 1842.

View on the River Brent : June. Royal Academy, 1842.

View on the River Brent : July. Royal Academy, 1842.

View from Leith Hill, Surrey, Looking towards the South. Royal Academy, 1843.

View from Leith Hill, Surrey, Looking towards the West. Royal Academy, 1843.

View over the Green in the Village of Oakley, Surrey. Royal Academy, 1843.

Study from Nature on the Sussex Coast. Royal Academy, 1843.

Richmond Park, near Ham Gate. Royal Academy, 1844.

Runnymede, View towards Cooper Hill and Egham. Royal Academy, 1844.

Richmond Park, View towards Kingston. Royal Academy, 1844. In the Victoria and Albert Museum.

Richmond Park, View towards Teddington and Windsor Royal Academy, 1844. In the Victoria and Albert Museum.

View on the River Wye, Looking towards Chepstow. Royal Academy, 1845.

Cornfield : Sitting on a Stile. Royal Academy, 1846.

Evening : Coming Storm. Royal Academy, 1846.

The Brook. Royal Academy, 1846.

Solitude. Royal Academy, 1846.

The River. Royal Academy, 1846.

The Farm. Royal Academy, 1846.

View in Richmond Park. Royal Academy, 1847.

View of the Wynn Cliff on the Wye. Royal Academy, 1847.

View of the Old Encampment upon Wimbledon Common, Looking South. Royal Academy, 1848.

View on the Brent : Spring. Royal Academy, 1848.

Hangar Hill, Looking towards Richmond Hill. Royal Academy, 1848.

The Entrance to Ilfracombe Harbour. Royal Academy, 1848.

View on the North Coast of Devon. Royal Academy, 1848.

Lindsay House, Chelsea. Royal Academy, 1848.

View from Wyndcliff. Royal Academy, 1850.
View, Looking towards Wyndcliff. 1850.
Valley of the Thames, Viewed from Richmond Hill. Royal
 Academy, 1851.
The Banks of the Thames, Opposite Pope's Villa. Royal
 Academy, 1851.
View near Pembroke Lodge, Richmond Park. Royal
 Academy, 1851.
Scene in a Forest Twilight. Royal Academy, 1852.
View in Richmond Park. Royal Academy, 1852.

In a collection of thirty-two pictures by John Martin,
the property of Mr. Charles Scarisbrick, sold at Christie's
in 1861, we find the following landscapes, in addition to the
above :

A Landscape, with a cornfield near a stream.
The Dell.
A Cornfield.
The Tarn (1845).
A Bay Scene : Evening.
Twilight, a romantic landscape (1843).
Solitude, a beautiful landscape.
A View near Richmond, with figures under the shadow of
 trees in the foreground, the Thames seen in bright
 sunshine in the distance (1850).
A Romantic Woody Landscape, with vistas of distant view.
 Jacques seated in the foreground.
Solitude. A beautiful small specimen of the picture ex-
 hibited in the Royal Academy, 1846.
A Beautiful River Scene.

A River falling among Rocks, with richly-wooded banks. Dated 1815.

Another Romantic River Scene.

A Lake Scene, with romantic distance, 1845.

A Romantic Landscape, illustrative of Gray's *Elegy*. The sun is sinking behind the battlements of a ruined castle and throwing a magical effect of twilight over a valley in the centre. Size 52 in. by 83 in., 1842.

Four landscapes in the possession of Colonel J. I. Bonomi.

Two landscapes of the Wye Valley, formerly in the possession of Mr. Cross, sold at Christie's fifty years ago for £100.

Illustrations to the *Bible* (engraved and woodcut), *Paradise Lost, Forget-me-not* and *Keepsake* annuals, *Wonders of Geology, The Wars of Jehovah*, by T. Hawkins, F.G.S., *Poems*, by Bernard Barton, and designs for stained glass windows.

Sepia drawings, three of which were recently sold at Christie's. One, *The Tournament* (from *Ivanhoe*) has hundreds of tiny figures in it, all exquisitely finished, and many so minute as to need a powerful magnifying glass to see them.

APPENDICES

APPENDIX (I)

ON THE GENIUS OF JOHN MARTIN

(From the *Library of Fine Arts*, Dec., 1833, vol. iii.)

" . . . It would be worse than false to attempt to set up a standard of artistical comparison between John Martin and any other artist of the present day, or between his works and the works of any other artist. In this respect John Martin resembles Sir Joshua Reynolds ; he can be judged of only by himself, and not by comparison with another. It would be, in our opinion, doing him the greatest wrong and injustice were we to compare him (as has been done) with the late lamented President of the Royal Academy, Sir John Lawrence ; for the only argument, which in our opinion could be used in common justice to both, is that the one excelled precisely in those very great points of personal beauty and attraction in which the other almost universally fails, and *vice versâ*. The critic, therefore, who could set up a standard of comparison between these two great artists must have been, we think, especially blinded to the great merits of each. . . .

Every picture of this artist may be truly looked upon as a separate invention, and we claim for him, therefore,

T

this faculty in its highest sense of interpretation, without the fear of one dissentient voice.

Genius, rich and abundant as his, could never have stooped to *follow* in the footsteps of greatness ; he has chosen a high path in art, and he has *led* the way to it. The late venerable Benjamin West was among the first to perceive the great originality of our artist's genius, and, with a noble frankness which did as much honour to one as it served for inspiration to the other, he predicted (and truly so) his future high career in art. . . . His pencil and his brush appear dipped in colours of fire ; and whether the scene represented be of Earth, of Heaven or of Hell, the same supernatural and magnificent effect is thrown over the whole. His cities, his towers, his walls, and his palaces are of such wide extent, such height and breadth, that the spectator who gazes on them for the first time, involuntarily calls up and associates them in his mind with the splendid imagery of some Arabian tale, or with the dreams he has dreamed of Memphis, Tyre and Thebes of old. The boundaries of space, extent and dominion, which have been assigned to the usual rules of art, have been broken down by John Martin, and, wide as his pencil has traversed the canvas, new powers and new creations of supernatural glory and beauty have sprung up beneath it, until the whole canvas has glowed with the lightning of some mighty and magnificent creation. . . .

The subjects of his pictures are not taken from the common everyday scenes of life ; his name is never attached to any ' portrait of a gentleman ' or to any picture of ' still life,' the scenes which inspire his pencil are the vast, the

terrible, the gloomy, the grand, the awful, the powerful, the supernatural, the mighty, the magnificent ; and these are as diversified as they are beautiful and are all delineated with the hand, the power, and the skill of a master, whether the scene be of an immortal bower of paradise, or a glittering and magnificent city, or an old and solemn realm of ruin, the impress and the attributes of genius are alike stamped upon each. . . . The highest range of imaginative genius, and the richest powers of invention, are therefore qualities which none will dispute him possession of.

Whilst, however, we grant him the free abundance of these great powers, we must, at the same time, remark, that in many of his pictures there are evidences of a cautiousness and littleness of handling his brush, which, when noticed, detract much from the general grandeur of effect which his pictures do most unquestionably possess. Crowding, as he does, so many myriad beings in one picture and including in the same space such an immensity of territory, a thousand dots stand in the place of as many human forms, and a dash of the brush covers a wide extent of dominion : yet, if we examine these dots and dashes, we shall find them all finished off with the same careful, cautious touch of the pencil that, the more extended and prominent parts of the picture are. And from this part of our subject the transition is easy to another portion of it, in which that greatness of genius which is Martin's own, is rendered still more proudly conspicuous.

We allude to the splendour and extent of his architectural perspective ; and in the rich sum of knowledge which he possesses of this subject he ranks superior to any

artist living or dead . . . and we need scarcely tell our readers what rich and abundant proofs of this he affords in his paintings—it is a portion of his art in which he appears absolutely to revel with delight. Turner's perspective is rich and golden ; but Martin's is more rich and varied and dazzling still—it gives splendid and mighty extent of vastness to his landscapes, and spreads them out into such long, rich vistas of light and shade that their extent and altitude appear almost lost.

It has been said that the vast realms of perspective which he places on the canvas are only the media through which he realises to the eye of the spectator the grandeur of the subjects which he employs for his pictures, and that the greatness of their extent are not present to his mind, but as he paints column after column and dome upon dome in the picture. We take leave to differ *in toto* from so hasty and crude a conclusion. We believe that the artist has the whole picture stretched upon the retina of his mind before he embodies it in actual colours before him upon the canvas. On this point we are ready only to concede that upon carefully going over every part of his picture, an artist may find many points which may be heightened in effect and beauty—many dispositions of figure which it would be well to alter ; and many effects of light and shade which might be increased or softened down ; and in this latter opinion we are purposely borne out by the fact that the artist himself, whose works we are now considering, did alter and amend the disposition of some of the figures in the engraving from what they were in the painting of the *Fall of Nineveh.*

No one can look upon and admire the pictures of this artist without being struck with the true and apparent fact that in painting one picture he paints a thousand, and that the faults with which he has been charged by some, of minuteness of detail, and of heightening up every part of a picture to such an exquisite degree of finish as almost to dazzle the spectator, may rather be considered as errors on the right side. Every column, every temple and every vase of gold is a separate study in itself ; and, if one large picture were to be cut up and divided into several smaller ones, they would each form a most exquisite and beautiful bit of art : and, if our memory serves us right upon this subject, such an idea as this was contemplated one time. Every picture which he paints is as a whole ; there is nothing left out which would militate against the general effect that the spectator is to have of the scene represented —all the detail and design serve to one grand end. We will remark a little upon some of his pictures in corroboration of this fact.

In his *Belshazzar's Feast* there was represented a magnificent hall in which there were a thousand guests revelling at a banquet-feast ; but this was not all. ' The vessels of silver and gold ' in which the feast was served, had been desecrated from the service of the Almighty for that very impious purpose, and, accordingly, the artist has displayed an immense variety of these in all parts of the hall, as serving to illustrate more particularly the character of the feast, and this is still made out in a more mysterious and wonderful manner by the mystic letters written with a pen of lightning upon the wall . . . where they blaze in all

their supernatural glory upon that impious, regal board, whilst all around, save one, are suddenly struck with dreadful fear, terror, and dismay, and the attitude of every single figure in the picture is made more or less to express this one general feeling throughout the whole of that vast assembly.

In *Joshua Commanding the Sun to Stand Still* there is the same general concentration of design towards one great and mighty effect. Had Joshua stood *alone* on the wide plain without the city, all the effect would have centred in his attitude and bearing and a total failure in the general end would, and must have been the result—even had the figure of Joshua been done by Etty or Haydon, who, as we shall show presently, are far superior to Martin in the *figurative* department of their art. But in the picture Joshua does not stand alone—he is at the head of a mighty host, who stand fearfully watching the event of the sun standing still upon Gideon and the moon in the valley of Ajalon.

Combining still to render the effect more imposing, there is a mighty tempest and whirlwind of the elements introduced, and the distant city seems to stand in awful solitude during the mysterious hours of that awful phenomena of Nature.

Again, if we examine the *Fall of Nineveh*, we shall find that the artist had abundant scope afforded him of concentrating many mighty conflicting passions into one general and great effect.

The feelings which this painting depicts are of a more varied and conflicting nature than in any other painting by

this artist. . . . The time represented is at the " siege and
sacking of a mighty city "—there existed, therefore, no
positive necessity for introducing any crash or conflict of
the elements, the mighty warfare around and within the
city would have been sufficient to concentrate the entire
effect of the picture in the spectator's mind. In the dis-
tance is seen the dim magnificence of Nineveh. In the
centre is represented the principal scene of the assault of
the besiegers—there is a wide breach made in the city wall,
and the galleys of the enemy are seen rapidly approaching.
This prepares the mind for the scene in the foreground
where Sardanapalus, his wives and concubines, are seen
lingering awhile on the marble gallery before they go to the
vast funeral pile of gems and gold which has been raised
for their destruction. . . .

We have heard an opinion given that Martin never
stooped to copy a fine figure, or ever embarrassed the keen
and rich temper of his imagination by the study of artistical
anatomy. We are willing to grant that to him this might
have been a matter of great drudgery, and that, whilst
employed in the acquisition of so important and essential
a branch of his art, he might have lost many a valuable
hour in which the graphic ideas of his imagination might
have been employed in some rich scene for another *Nineveh*.
Yet we cannot absolve him from, nor can he clearly dis-
prove the charge of, wilful negligence and ignorance which
might here be brought against him, for not devoting his
attention to a branch of art, ignorance in which is not only
culpable but must have proved highly injurious to him.
In the drawing, colouring, and attitude of his figures, he is

always found to fail—the first is generally incorrect, the second is cold and statue-like, the third is almost always unnatural. It has generally been asserted that the figure of Sardanapalus in the *Fall of Nineveh* formed a great exception to the sweeping asseveration which we have just made ; but, for our own part, we could never be brought to give our unqualified admiration to this figure. The attitude was stiff and formal, and the whole seemed to our eye to glare viciously on us from the canvas. . . . We trust, however, that it is not yet too late for these great errors which we have pointed out to be remedied by this great master. . . .

We have thus endeavoured to point out to our readers what we consider to be the prevailing claims which Mr. Martin has to take a very high and distinguished rank among the artists of Great Britain ; and we have now to inquire, and very briefly, in what way those claims have been received and acknowledged—first by his brother artists, secondly by those who rejoice in the title of Patrons of British Art. By the first of these classes, taking them individually, we are happy to say that our artist has been judged according to the full award of his merits and has had every claim which justice could award him ; yet, as if to add another proof to the true inconsistency of man, or of the nature which rules within him, as if to shew, we had almost said, what the overbearing spirit of jealousy and power can do—what shall we say to that great body of British artists who constitute the members of the Royal Academy when the truth stares them and the whole world in the face—*that John Martin is NOT a member of the*

Royal Academy? But if this be a blot and an indelible stain of disgrace upon the Royal Academy, what shall we say to those *pseudo* patrons of British Art, who profess their anxiety to support the *Fine Arts* in this country? What shall we say to them when they own, as own they must, that they never yet gave Martin one single commission and never yet purchased one of his pictures? The only excuse we can naturally offer for the insanity of their conduct is, that the magnificent conceptions of our artist are of far too exalted a nature for their grovelling comprehensions.

But the time is now gone by and, as if in illustration of the old proverb of a prophet receiving no honour in his own country, justice—tardy justice has at length been done to John Martin, but not by his own countrymen;— no, an infant kingdom has been the first and hitherto the only one to do justice to our artist. Early in the summer artists were invited to send their pictures to the ensuing exhibition of Art in Brussels, and our artist was among those who availed themselves of this invitation, and immediately forwarded his *Nineveh* with some other pictures to the scene of exhibition. The result was one highly gratifying in every respect to this excellent artist himself and flattering likewise to those amongst whom he was here as a brother. The King of Belgium immediately honoured him with the Order of Leopold—he was elected, without solicitation, a member of the Belgic Academy and the Belgian government purchased at his own price (2,000 guineas) the *Fall of Nineveh.*[1]

[1] A mistake. The picture was returned.

Though whilst writing this we feel a deep and bitter regret that our government and our country have not been first to *set* so noble and honourable an example for others to follow, yet for the artist's sake, and for the sake of Art in general, do we rejoice that that justice which he has so long and so richly deserved has been at last done him. Let the Royal Academy pause and consider of these things—let the patrons of British Art visit the studio where *Nineveh* was conceived—then let them digest and own our remarks and our own judgment true.

APPENDIX (II)

Letter from M. Feuillet de Conches.

MON CHER MONSIEUR,

. . . J'ai été Samedi dernier, à la Manufacture Royale de porcelaines de Sèvres où le Directeur, le savant professeur Brougeriart, l'ami et le collaborateur de Georges Cuvier, et l'ami-né de tous les artistes, m'a montré le plus grand empressement, à choisir quelque chose qui vous fût agréable. Nous avons tous deux éprouvé, dans cette circonstance, au milieu des richesses céramiques qui nous entouraient, que quelque fois l'abondance de bien peut nuire—le choix nous a paru difficile.—En effet, vous m'avez exprimé une préférence marquée pour un service à café. Or, les services à café un peu riches que l'on exécute pour le Roi n'ont jamais ni cafetière ni sucrier en porcelaine : ces deux pièces-là sont toujours en or, en argent, ou en vermeil. Comme il s'agissait d'un cadeau de porcelaine, nous sommes trouvés embarrassés pour répondre à votre désir, sans nous écarter de la volontè du Roi, qu a recommandé de ne point vous envoyer une chose ordinaire. Pour tout concilier, voici ce que nous avons arrêté, sauf votre avis qu'il est couvenu entre nous que je prendrais confidentiellement :—

S'il est d'usage de ne point employer la porcelaine pour les deux pièces principales des services à café de grand luxe,

il n'en est pas de même à l'égard des services ordinaires ; ou, mon cher Monsieur, il existe un *service complet pour douze personnes*, forme étrusque, à côtes, sans autre ornement, qu'un filet d'or dans le fond de chaque côte. Les formes sont très pures, la matière est également d'une grande pureté ; mais c'est là un cabaret très simple, puisqu'il est dénué de riches ornements.[1] I'l s'agit, nous sommes-nous dit, d'envoyer à Mr. Martin un cadeau royal et non de monter son ménage. Mais, j'ai ajouté : je mets de côté ce service qui pourra devenir un objet usuel, et qui d'ailleurs, sans être un objet de haut luxe, sera, aux yeux de Mr. Martin un produit remarquable par l'élégance et le goût des formes et la pureté de la porcelaine. Ceci fait, nous avons notè deux très-beaux vases, objets de luxe, dont le fond est bleu et dont les deux faces sont chargées de fleurs et de fruits peints par le plus habile décorateur de Sèvres. Nous avons noté également deux tasses riches à café avec leur soustasses dans le style oriental :—pièces détachées qui servat ornement à la fois et le service de la table.

Notre choix se compose, donc, en résumé, de

1° Une paire de vases de luxe richement décorés,

2° Une paire de tasses orientales

3° Un cabaret à café étrusque pour douze personnes.

Mais ce choix-là est subordonné toute fois au vôtre, car nous avons aussi avisé au service à thé pour deux personnes : théière, sucrier, pot-à-lait, et deux tasses avec un présentoir à manche central, le tout en porcelaine. Ce petit service est richement décoré. Si vous le préfériez au service

[1] The colour is that of the service uniform of the French army, known as ' horizon blue,' a very delicate tint in the porcelain. The handles are of gold.

étrusque plus simple, vous n'avez qu'à parler. Ou n'a qu'un desir, celui de vous être agréable.

Je comprends à merveille que de loin et sans voir, vous soyiez embarrassé pour répondre ; mais c'est à vous de décider s'il vous est plus convenable de recevoir un objet riche pour deux personnes ou un simple pour douze ; bien entendu que les autres articles (vases et coupes orientales) vous sont acquis dans tous les cas. Je les ai fait mettre à part. J'ai fait pour les mieux ; quand vous aurez prononcé, on placera les objets sous les yeux du Roi, et l'envoi vous en sera fait par l'ambassade de Sa Majesté. . . .

Un mot donc, cher Monsieur, et mille civilités.

F. FEUILLET DE CONCHES,
*Chef du protocole au departement des affaires
ètrangères.*

Paris.
27 Mai, 1835.

London, 30, Allsop Terrace, New Road.
June 1st, 1835.

MY DEAR SIR,

. . . I cannot express how much I regret the trouble you have had respecting the service of porcelaine. Believe me, that I esteem so distinguished a mark of the approbation of His Majesty the King of the French, as so high an honour, that I found it difficult and did not like to name a preference where I scarcely had any. If I found it difficult to do so when you wrote before, the difficulty is anything but diminished now. I, therefore, beg to entrust the choice entirely to you, at the same time concurring

in the justice of your remarks respecting the simple taste of Artists ; and, for myself, I have always had a particular affection for the pure Etruscan.

But how am I, my dear Sir, to thank you sufficiently for all the trouble you have taken on my account ? When I attempt to do so, words fail me ; and I am obliged to trust to you to imagine what I feel and would say, but rest assured I shall ever remain

Faithfully yours,

J. MARTIN.

APPENDIX (III)

In the year 1827 I published a plan of supplying London with water from the River Colne, which plan appeared in the Report of the Committee of the House of Commons upon Metropolis water supply 1828.

The object becoming of daily greater moment, I made further inquiries and surveys towards the practical execution of the Colne Plan, and published the result in the summer of 1828, with explanatory maps and plans and likewise " the details of a proposition for *securing the Thames from the admission of the sewage, and rendering it available as manure.*"

It is most essential to observe that this is *the very first time* any proposal for preserving the River from pollution by diverting the Town sewage and applying it to agricultural purposes was advanced and laid down as a principle.

In order to meet any opposition that might arise to the Colne Plan, I published in 1829 a second illustrated Plan " for supplying London with a purer water by a weir across the Thames at Chelsea," and a " Plan for more effectually draining certain marshy lands contiguous to the Thames."

Being more impressed by the importance of the object,

the more I reflected upon it, and becoming rapidly better acquainted with its various [word omitted] I published in 1832 and 3 farther illustrated Plans for improving the air and water of the Metropolis by preventing the sewage being conveyed into the Thames and for using the manure for agricultural purposes; containing also a plan of house and sewer traps, and mode of ventilating the sewers. This plan subsequently appeared in the House of Commons Report upon the sewers of the Metropolis, 1834; and in the same year, in the House of Commons Report upon Metropolis water supply, together with a plan for supplying water from the Thames at Teddington, the chymist analyses, and engineers' surveys and estimates in full being furnished.

In 1836 an endeavour was made by a Committee of influential gentlemen to carry out the Thames Improvement Plan in the entire state as it then stood, and both the Government and the city authorities gave a favourable hearing, but the proceedings adopted by some of the parties with whom we were associated caused me, in justice to my generous friends, and to my own character, to withdraw; and the whole consequently fell to the ground.

In 1838 the entire [word omitted] with all the additional details furnished by the assistance of the Admiralty and the Commissioners of Sewers, appeared in the House of Commons Report upon Metropolitan Improvements.

In 1840 I was prepared with the plan, with certain required alterations, to facilitate the accomplishment of the work by portions, each conforming with the general whole, but the Thames Embankment Committee rose after a few sittings only and I was obliged to reserve it until

1842, when I published the plan in detail with various additions, and, amongst others, a comprehensive description of the mode of distributing the sewer water by high pressure pipes and hose. In this year Mr. Chadwick's Sanitary Report appeared, containing no mention of distribution by hose—but strongly recommending *water meadows* as the most effective mode of applying the sewage.

In 1843, this plan was submitted to the Metropolis Improvement Commission and such portions as suited the immediate purpose of the inquiry appeared in its Report.

In the same year the entire remaining parts of the plan were submitted to the Health of Towns Commission which received it with great attention ; but though the notes of my evidence were taken and revised by me for the printer, this evidence never appeared in the final report.

In 1845-6-7 and the present year I published reiterations of my plans with various improvements in the details, and all entirely at my own expense ; and now at this very time the Commissioners of Sewers and their officers are urging principles and plans originated as stated above, but without one allusion to me, their originator

<div style="text-align: right">

JOHN MARTIN,

Lindsay House,

Chelsea.

</div>

July, 1849.

APPENDIX (IV)

MARTIN'S METROPOLIS IMPROVEMENT PLANS (WITH MAP)

No.

1. General Plan.
2. Sewer Plan, on Commissioners' map.
3. Self-relieving sewer.
4. Collecting, conveying and distributing sewage.
5. Do. water.
6. Sewage application to the land.
7. Section and ground plan of Pump Well.
8a. Engine house.
9b. Water and sewage supply.
8. Section of Embankment.
9. Elevation of Embankment with Railway at Thames St.
10. Embankment and Public Walk.
11. Section of Main Street sewer.
12. Section of Railway at the Bridge.
13. Embankment and Public Walk.
14. Connecting Railway.
15. Do. small with Description.
16. Railway Bridge.
18, 19, 20, 21. Westminster Bridge.
 Three pamphlets.

PLAN OF THE GREAT METROPOLITAN CONNECTING RAILWAY AND PUBLIC WALK

BY JOHN MARTIN SEP 1845

p. 306

INDEX

INDEX

PRINTED BY THE ANCHOR PRESS, LTD., TIPTREE, ESSEX, ENGLAND.

CPSIA information can be obtained
at www.ICGtesting.com
Printed in the USA
BVHW090920010223
657610BV00013B/259